A Primal Spirit

Organized by
the Hara Museum of Contemporary Art, Tokyo,
and the Los Angeles County Museum of Art

A Primal Spirit

Ten Contemporary Japanese Sculptors

Howard N. Fox

with a preface by
Toshio Hara
and contributions by
Judith Connor Greer and Kiyoko Mitsuyama

Los Angeles County Museum of Art

Distributed by Harry N. Abrams, Inc.,
Publishers, New York

Exhibition Itinerary
Hara Museum ARC, Gunma Prefecture
March 10–April 15, 1990

Los Angeles County Museum of Art
June 17–August 26, 1990

Museum of Contemporary Art, Chicago
October 25, 1990–January 1, 1991

Modern Art Museum of Fort Worth
February 17–April 28, 1991

National Gallery of Canada, Ottawa
June 28–September 22, 1991

Published by the Los Angeles County Museum of Art,
5905 Wilshire Boulevard, Los Angeles, California 90036.

Distributed worldwide by Harry N. Abrams,
Incorporated, New York, A Times Mirror Company,
100 Fifth Avenue, New York, New York 10011.

This book was published in conjunction with the
exhibition *A Primal Spirit: Ten Contemporary Japanese
Sculptors*, which was organized by the Los Angeles
County Museum of Art and the Hara Museum of
Contemporary Art. It is supported in part by grants from
the National Endowment for the Arts, the Japan-
United States Friendship Commission, the Japan Foun-
dation, Baring Securities (Japan) Limited, and the
Asian Cultural Council.

Works commissioned for the exhibition are made possible
by a grant from the Lannan Foundation.

Edited by Susan Caroselli
Designed by Jeffrey Cohen
Photography supervised by Steve Oliver
Typeset in Stempel Garamond and Univers by
Andresen Typographics, Tucson, Arizona
Printed by Toppan Printing Company, Tokyo

Library of Congress Cataloging-in-Publication Data
A Primal spirit: ten contemporary Japanese sculptors/
 Howard N. Fox; with a preface by Toshio Hara and
 contributions by Judith Connor Greer and Kiyoko
 Mitsuyama; organized by the Hara Museum of
 Contemporary Art, Tokyo, and the Los Angeles
 County Museum of Art.
 Includes bibliographical references (p. 120).
 ISBN 0-87587-150-X
 1. Sculpture, Japanese—Exhibitions. 2. Sculpture,
Modern—20th century—Japan—Exhibitions.
1. Fox, Howard H. II. Hara Bijutsukan (Tokyo, Japan).
III. Los Angeles County Museum of Art.
NB1055.P75 1990
709'.52'07479494—dc20 90-5521
 CIP

ISBN 0-8109-2467-6 (Abrams: pbk.)

94 93 92 91 90 10 9 8 7 6 5 4 3 2

Contents

Foreword

As contemporary art becomes an increasingly global affair and its audience grows commensurately more cosmopolitan, museums must respond to the challenge of presenting significant artistic developments wherever they may occur. There is great international interest in Japanese art today, and the exhibition *A Primal Spirit: Ten Contemporary Japanese Sculptors* was conceived to address the need, both in Japan and the United States, to see and interpret Japanese art as a unique cultural expression in an international context.

It is a testimony to the vitality of contemporary Japanese art that to know it at all, we must focus on only a little at a time. The Japanese art scene is too complex and diverse to be represented in any single exhibition. Thus, when originally developing this project, we acknowledged that the most valuable insight this exhibition could offer would be an in-depth exploration of one significant aspect of contemporary Japanese art. We believed that the exhibition should be organized by someone who, though familiar with Japanese contemporary art, did not have preconceptions about or prior involvement with the Japanese art world and who could thus bring an independence and objective curiosity to the project.

Howard N. Fox, curator of contemporary art at the Los Angeles County Museum of Art, enthusiastically accepted the invitation to serve as curator for the exhibition. The exhibition's distinctive approach, elucidating what Mr. Fox has called a "primal spirit" that characterizes an important strain of Japanese sculpture, is his own, formulated after extensive study and research facilitated by the staff of the Hara Museum, followed by meetings with individual artists.

The ten sculptors represented in this exhibition, though working independently, share a clearly discernible sensibility. For them the artist, the material, the act of creation, and the work of art are indivisible aspects of an encounter with the universe. Generally, their art is a direct response to nature, natural materials—wood, metals, minerals, fibers, and stone—and the natural processes of growth and decay. It is at once an innovation and a continuation within Japanese artistic traditions.

This is but one of many approaches that might be suggested by a study of contemporary Japanese art. We believe it is among the strongest and most provocative, both for the quality of the art and for the cultural, aesthetic, and spiritual values embodied by it. It is our hope that *A Primal Spirit*, which marks the Hara Museum's first involvement in an exhibition in the United States, will encourage other museums and curators in the West to probe the diversity of contemporary Japanese art, so that other voices and other viewpoints will emerge.

Toshio Hara
Director
Hara Museum
of Contemporary Art

Earl A. Powell III
Director
Los Angeles County
Museum of Art

Preface

Toshio Hara

An imagination that can still perceive the world in terms of symbol and archetypal imagery constitutes an essential part of the Japanese identity. In the course of the rapid postwar redevelopment of Japan, and the rise of her international status and economic power, the need to preserve that peculiar sense of national identity has become more important. From the late 1950s to the present day, artists, writers and performers in Japan have been searching for a style that confirms their identity, and reflects their assimilation—and ultimate rejection—of Western influence.[1]

The history of Japanese art has been a history of the adoption, assimilation, and "japanization" of cultural influences from abroad. In the ancient past these influences came primarily from China and Korea, but since the Meiji Restoration in 1868 the Western world has served as the model and measure of cultural development in Japan.

For more than one hundred years the techniques and theories of Western art have dominated the artistic curricula of Japanese universities, and the work of Japanese artists has seemed, at least superficially, to follow trends from abroad. Yet a mastery of Western artistic styles has proved no guarantee of acceptance by an international art world centered on Europe and America. With the exception of a very few artists who left Japan to live abroad, the Japanese have never achieved more than footnote status in the history of modern and contemporary art.

1. Mark Holborn, "Butō," in *Tokyo: Form and Spirit* (exh. cat., Minneapolis: Walker Art Center, 1986), 176.

International and domestic criticism of contemporary Japanese art has been almost equally severe, directed toward a perceived lack of cultural focus:

> Contemporary Japanese art is not only lacking uniqueness but also any central belief or unifying theme. If there are a hundred different artists, there will be a hundred different styles, and not a single artist willing to participate in any exhibition around a major central theme. Whether painting is in traditional or Western style, each of the artists seems content, satisfied to remain in his own little isolated world. Since the Japanese art world decided to follow the movements in the West, they have lost themselves and given up their own uniqueness.[2]

Contemporary Japanese artists have, in fact, never completely "lost themselves" or "given up their own uniqueness," if only because, having long ago mastered Western techniques, they have never wholly mastered the spirit of the theories of Western art, which are based on cultural and aesthetic traditions often diametrically opposed to Japan's own. There has been little recognition by either Japan or the West of the issues faced—sometimes unconsciously—by Japanese artists or of the way in which the cultural differences have always been an influence, albeit often a subtle one.

Japanese artistic and cultural traditions have clearly helped direct the development of modern and contemporary art. A process of selection has always affected which styles, techniques, and theories are taken up and which are ignored, as well as how they ultimately become part of the Japanese artistic vocabulary. These selections have been influenced by a vast body of traditional assumptions and artistic conventions with which the West is unfamiliar, such as a lack of distinction between art and craft, the conventions of decorative painting and Buddhist sculpture, and the implications of the aesthetics of space.

Likewise, while many Western artistic techniques have been absorbed into the Japanese consciousness, they have been divorced from the Western cultural assumptions that gave rise to them. Without a centuries-old tradition of realist oil painting, how can Japanese artists be natural participants in artistic movements that have continuously sought to redefine painting since the impressionists? Not having lived in a society based on individualism and self-determination, the Japanese do not naturally acknowl-

2. Toshiaki Minemura, "Contemporary Japanese Painting," in *Contemporary Japanese Art* (exh. cat., Taipei: Fine Arts Museum, 1986), 8.

edge the very Western ideas of individual creativity and the artist as romantic hero. Also important is the crucial difference between art founded on the Judeo-Christian tradition of the West and art informed by the Japanese Shinto-Buddhist worldview.

The search for a form of expression that acknowledges cultural roots while achieving a certain universality or "internationalism" has been a preoccupation of Japanese artists for many years. But few artists have been comfortable with persistent demands from abroad for a "Japanese" quality in Japanese art. Until recently most Western critics have looked for a *japonisme*, the exotic flair of the Orient that is perceived simply as different from (and therefore marginal to) prevailing Eurocentric movements.

Serious Western scholarship and appreciation essentially stops at the Edo Period (1603–1867), the final age of "traditional" Japanese art. And yet, without benefit of even the minimal research accorded minor movements in Western art, experts from abroad have felt qualified to label most contemporary Japanese art imitative and derivative, second-rate copies of superior "original" art created in the West. This willingness of the Western art world to accept its own aesthetic criteria as the universal standard has only recently been called into question.

Now that the West has openly acknowledged Japan's challenge to its economic hegemony, the Western cultural establishment has turned to Japan with renewed interest. Since the mid-1980s artists and art professionals from around the world have been visiting Japan at an unprecedented rate, while exhibitions of Japanese art are seen more frequently abroad.

Paradoxically, a misunderstanding of contemporary Japanese art is often fostered by the Japanese themselves. Striving to escape the pitfalls of provincialism or the even more abhorred trap of nationalism—a concern that has plagued artists since the postwar period—Japanese artists have rarely examined the deeply ingrained and largely unrecognized cultural assumptions that color their work. Until quite recently it was not uncommon to hear artists claim to be "international" rather than "Japanese," as though one necessarily excluded the other.

Their dilemma has been complicated by the pervasive belief that "Japanese" and "Western" are mutually exclusive categories. In this equation *Japanese* means history and tradition, spiritualism, a rather intuitive emotionalism, a love of and respect for nature, while *Western* signifies internationalism, modernism, the separation of humanity from the environment, and a coldly logical intellectualism.

The Japan evoked by images of Mount Fuji, cherry blossoms, and kimono-clad women remains a part of the popular cultural myth, much as America still cherishes its frontier spirit. But if Westerners have tended to

look for superficial signs of Japanese character, so too have the Japanese largely failed to acknowledge the growing superficiality of their belief in a pure "Japaneseness" untainted by the West or the equally untenable, though supposedly more progressive, position that the Japanese are no longer truly Japanese.

The intellectual and emotional importance of this issue is attested to by the very frequency with which it continues to be raised. In extreme terms there is a polarization into those who believe that the Japanese remain almost genetically bonded to their culture and those who insist that Japan is the quintessential postmodern society, where an undiscerning blend of cultural influences has stripped true "Japaneseness" from the Japanese. Clearly the truth lies somewhere in between. Both positions are equally dependent upon the traditionally assumed diametrical opposition of Japan and the West, and both ultimately disregard the possibility that a genuine cultural identity can be constructed from a blend of the two.

> Whatever attributes can be ascribed to Tokyo in the mid-1980s, stylistic purity is certainly not among them. McDonald's yellow arches and the Colonel's goateed countenance have become indispensable icons in the pantheon of adopted symbols, of which Mickey Mouse is the indisputable godhead.[3]

For most Japanese the uninhibited, exuberant blend of East and West characteristic of modern Japan is simply the only culture they know. In daily life, in the reality that most people experience, there is no contradiction in terms. Though the question of what it means to be Japanese continues to dominate both domestic and international discussions of contemporary Japanese culture, behind these arguments is the growing realization that an even larger issue is at hand: more than the supposed loss of Japanese identity through Westernization, the real problem facing Japan is the loss of cultural and social values that plagues every postindustrial society in the world. Although political and social issues are rarely openly addressed by Japanese artists, an intuitive, rather private concern for this current state of affairs underlies much recent Japanese art. Artists, thoroughly conversant with Western art history and current trends but no longer self-consciously involved with questions of cultural identity, are now freed to draw from a rich variety of influences in a form of expression that posits new alternatives in the search for meaning in art and life. It is from this search that a new source of creative energy and aesthetic strength is emerging in Japanese art.

3. Martin Friedman, "A View from the Outside," in *Tokyo: Form and Spirit*, 8.

While contemporary Japanese art remains highly diversified and pluralistic, distinct trends are discernable. The artists represented in this exhibition show a commonality of approach and vision, in spite of the great disparity in their ages, careers, and backgrounds. Using simple, natural materials—wood, stone, fired clay, and minerals such as iron, copper, and sulfur—these artists have directed their concern toward our growing separation from the world that surrounds us.

> A world in which images have been objectified by representation is, for that very reason, an indirect world . . . congealed as man wants and not left as it is, [in which] we are confronted not with the world itself but with human will. The world is no longer telling us about itself but has been transformed into an "object" that tells of man's image.[4]

In these words influential Mono-ha theoretician and artist Lee Ufan criticized the Western artistic tradition in his seminal 1970 article, "In Search of Encounter." In the words of Toshiaki Minemura, "the word *Mono-ha*, whose literal meaning is 'school of things,' designates a group of artists in Japan who were active both before and after the year 1970, and who attempted to bring out some artistic language from 'things' as they stood, bare and undisguised, by letting them appear on the stage of artistic expression, no longer as mere materials but allowing them a leading part."[5] While there continues to be much debate about who were and were not Mono-ha artists and the relative importance of their ideas, it is clear that the movement generated a new awareness of the discrepancy between Western art theories and Asian sensibilities.

Of great importance was the Mono-ha artists' attempt to create through their art a situation in which a clear view of the world was made possible. Shunning the idea of individual creation, they sought instead to present natural materials in unprocessed forms so as to allow an experience of the "original" and, by implication, of limitless nature—a universe much greater than that which could be subjectively conceived by humanity.

Mono-ha was a short-lived movement, and by the mid-1970s most of the artists had returned to more orthodox forms of painting and sculpture. Still, much of the art in the 1980s has been seen in terms of its

4. Lee Ufan, "In Search of Encounter" (in Japanese), *Bijutsu Techo* 22 (February 1970): 15–16; translation by Yumiko Yamazaki published in Masahiro Aoki, "Towards the Presentation of a New World," in *Lee Ufan: Traces of Sensibility and Logic* (exh. cat., Gifu: Museum of Fine Arts, 1988), 73.

5. Toshiaki Minemura, "Mono-ha," in *Mono-ha* (exh. cat., Tokyo: Kamakura Gallery, 1986), 6; translation by Jean Campignon.

acceptance or rejection of, or simple reaction to, Mono-ha ideas.[6] In conversations with many Japanese artists, words used by Lee Ufan and other Mono-ha artists—especially *encounter*, *will*, and *cosmos*—occur with an almost uncanny frequency. The use of these words, and their underlying implications, reveals how different is the approach of Japanese artists from that of their Western contemporaries.

Although few Japanese artists today will accept the abandonment of individual creation as did the Mono-ha artists, for many the role of individual will in the creation of a work of art is conceived in terms very different from those used by the West. Less a matter of individual expression achieved through the imposition of an artist's will on the chosen materials, artistic creation is seen as an intuitive, emotional process of exploring and exposing the potentialities of the materials themselves.

For these artists it is the actual physical process of creating their art, rather than the finished product, that is important. This process becomes a form of spiritual exploration, "in search of encounter," of their materials and, through those materials, of the greater universe.

That many artists work in an installation format is also revealing. The work is temporary, related to a specific site that through the artist's efforts becomes animated: a symbolic locus of meaning where, as in a Zen stone garden, an abstracted composition of natural materials fosters contemplation and a reconsideration of the worldly values to which we subscribe.

Discussions of contemporary Japanese art are fraught with the dangers of oversimplification and misunderstanding. Words such as *nature*, *cosmos*, *universe*, *encounter*, and *spiritualism* invariably carry overtones of religious dogma or an intrinsically nostalgic view of the world. But this is not an art about religion, nostalgia, or, as is often suggested, a return to the legendary past where the Japanese lived in harmony with nature. For the artists represented in this exhibition nature itself is a symbol of the cosmos as it is perceived in Japanese thought, where, contrary to the Western anthropocentric viewpoint, humanity is a minor part of a greater, unified whole. Firmly rooted in contemporary realities, their art seeks new forms of encounter and new links with the world in which we live.

6. Tokyo: Seibu Museum of Art, *Art in Japan since 1969: Mono-ha and Post Mono-ha* (exh. cat., 1987), 188–96; translation by Alfred Birnbaum.

Introduction

Howard N. Fox

Japan is an ancient and historically persevering civilization in a state of radical, prolonged change. Since the time of the earliest chronicles in the third century B.C. the recorded history of Japan has been one of successive waves of externally imposed political, economic, and cultural influences, originating in China, Korea, Europe, or the United States, and associated waves of modernization, alternating with phases of determined, self-imposed isolation. More recently, certainly since the end of the Second World War, sustained, dramatic economic and social change and involvement in world affairs have profoundly affected Japan's domestic life as well as its position on the global scene.

Japan has been catapulted to the forefront of world economic power and political influence. Indeed, scarcely a day goes by without front-page headlines recording Japan's role in world affairs. Business and human interest items abound in the Western press: we can easily learn about Japanese investments, Japanese science and technology, Japanese factories, even about Japanese recreation, toys, golf courses, the latest in pet grooming. We have no dearth of reports on the changes affecting the daily life of its people.

But if we want to learn about the cultural life of Japan today, especially about developments in contemporary art, there is almost nowhere in the West to turn. Despite the cultural exchange programs sponsored by such organizations as the Japan Foundation, which fosters research on Japanese culture, and the Japan-United States Friendship Commission, which promotes binational cultural projects, and cultural research conducted by smaller, specialized organizations and institutes, what we in the West know of Japanese activity in the field of contemporary art is primarily confined to

reports such as a Japanese corporation having paid the largest sum in history for a work of art or a new auction record having been set by an anonymous Japanese bidder; fundamentally, the art news from Japan is about the importation of Western art into Japan.

To learn about contemporary Japanese art Westerners must go to Japan and study it firsthand. But once there, they find little that discloses the existence of the extremely vital art world that thrives, unplanned and unsupported but increasingly consequential, throughout the country. According to established cultural norms in Japan, contemporary art is of marginal importance. Indeed, the very notion of "fine art"—a Western hierarchical notion that views painting and sculpture as severed from and elevated above the rest of the arts—is only about a century old in Japanese culture, having been introduced largely as a result of Western interest in Japanese *ukiyo-e* prints, particularly as they related to the impressionists' fascination with flat pictorial space. Traditionally, Japanese painting was a craft, and sculpture the creation of religious (specifically, Buddhist) artifacts. Architecture, ceramics, clothing design, calligraphy, even flower arranging, were created with the same deliberation and aesthetic concentration that characterized "fine art" in the West, but they were the result of a different impulse and a different regard for the function of these activities in daily life.

Even though their numbers are formidable, contemporary Japanese "fine artists" constitute only a tiny segment of the population, and they operate fairly much in a vacuum and without an indigenous tradition. The situation begs comparison with that in the United States until about thirty years ago, when the audience for contemporary art was not only minuscule but insular. Perhaps this is destined to change, as has so much else in Japan.

For now, contemporary Japanese artists have relatively few forums in which to share the products of their creativity with society at large or even with one another. Outside Tokyo, Osaka, and Kyoto the only public venues for exhibitions are smaller prefectural museums, comparable to regional art museums in the United States. Although these museums, many of which are very new (more than two hundred have been built in the last decade), are reasonably well-off because of Japan's extraordinary wealth, there is almost no governmental patronage for individual artists, nearly all of whom must do something else to earn a living. This pattern of official support for the arts clearly reflects the traditional Japanese esteem for institutions and the cultural establishment, with apparently far less regard for individual talent and its development.

In the largest cities there are commercial galleries—seemingly as many in Tokyo as in New York—many of them showing contemporary art. Yet to one accustomed to the system of creation and distribution that

drives the Western contemporary art establishment the Japanese art world seems undermobilized and unorganized. This is owing in part to the fact that in Japan an overwhelming percentage of galleries operate on a space-for-hire basis; only a handful of galleries have adopted the Western system wherein the gallery director takes the role of entrepreneur: choosing the artist, promoting the work, cultivating the market, and, of course, sharing the profit. While it is prestigious for an artist to be selected by a Western-type gallery, there is no stigma attached to renting a gallery for a show.

Normally the artist pays not only for the space, but also for the announcements, photodocumentation, and a catalogue, if he or she (although few women are artists in Japan) can afford it; the artist then virtually camps out during the run of the exhibition, receiving guests. Any works that remain unsold must be stored at the artist's expense, often far from the large cities, where the cost of storage space is prohibitive.

For their part, the galleries in Japan provide some hospitality—tea or, occasionally, whiskey for a special guest—but they do not generally promote the artist, maintain the works, or make them available for viewing when they are not on exhibition. Often, to call upon a rental gallery for information about an artist is to be given the artist's address or telefax number. Nor does the gallery usually receive a commission on any work that is sold, for selling is the artist's job, and sales are so rare (collectors being so few) that the gallery could not survive on sales any more than the artist could.

Gallery shows in the West typically run for three or four weeks, sometimes longer; in Japan they usually last five days. They can be longer—indefinite for that matter—but that requires additional rent for the space, and the five-day standard is about all that most artists can afford if they wish to show their work every year or two. Most galleries in Japan are single rooms, many no larger than the living room in a suburban American house and some a good deal smaller. The sort of works that can be accommodated in such quarters are usually small objects or paintings or graphics less than six feet on a side. But they may be temporary, site-specific constructions that push at the limits of the gallery space, such as the works in *A Primal Spirit*.

These short-lived exhibitions are well attended, since they constitute the major ongoing forum for contemporary art in Japan. Forces that play so potent a role in Western art circles—museums, collectors, critics—are relatively minor factors in the Japanese art world. Public museums are demonstrably conservative, reserving solo exhibitions for only the most established figures (invariably older males[1]) and relegating their coverage of other con-

1. Isamu Wakabayashi, the oldest artist in this exhibition, made history in 1987 when, at age 51, he earned the distinction of being the youngest Japanese artist to have a solo exhibition at the National Museum of Modern Art in Tokyo.

temporary artists to annual group shows. There is evidence that Japanese museums collectively are showing more contemporary art, but there are no full-time curators or departments of contemporary art in the public museums.

There are, happily, some noteworthy exceptions. The Hara Museum of Contemporary Art in Tokyo, founded in 1979 by Toshio Hara, was the first museum in Japan devoted exclusively to the collection, exhibition, and documentation of contemporary art, and its programs—exhibitions of Japanese art alternating with international exhibitions—and excellent bilingual catalogues have served to place contemporary Japanese art in an international context and have functioned as a primary source for information on the latest developments. The Hara Annual Exhibition of contemporary Japanese art, like the Biennial Exhibition of the Whitney Museum of American Art in New York, is looked to as a controversial, lively register of activity among emerging artists throughout the country. In 1988 the Hara Museum opened a second facility, designed by Arata Isozaki, in Gunma Prefecture, where *A Primal Spirit* will have its Japanese inauguration.

In Tokyo the Hara Museum's activities are complemented by those of the Sagacho Exhibit Space. Founded in 1983 by Kazuko Koike, Sagacho sponsors exhibitions and special installations by many young Japanese artists and serves much the same programming function as an "alternative space" in the United States. The Institute of Contemporary Arts in Nagoya, a large and well-designed space adapted from an industrial site by its founder, Keitaro Takagi, has become an internationally significant venue for contemporary art since its opening in 1986, although its exhibitions so far have concentrated primarily on established Western artists such as Giulio Paolini and Jannis Kounellis.

In Western art circles private collectors, whose influence and power are often regarded so ambivalently by artists, critics, and ideologues, are a formidable force. In Japan, however, collectors play almost no role in the dynamics of the art scene. Such aficionados as do collect contemporary Japanese art are distinctive for the privacy of their collecting. Some observers explain that the Japanese tax laws discourage collectors from making their activities common knowledge, but it is more likely that so few collectors are known because there are so few of them, and their collections are likely to be modest, due to the lack of space even in the most affluent homes. Also, collectors would be thought impolite to boast of something that demonstrated their personal wealth, and it is not the Japanese custom to entertain at home, where their collections would be seen.

What is surprising to a Western visitor is how little discussion there is about Japanese contemporary art. The creation and experience of art are conceived as fundamentally personal activities, comparable perhaps to medita-

tion or contemplation. The creative process is revered as an ineffable mystery, and there is little expectation that one's experience of art should or even could be comprehended by another individual. Japanese artists generally do not speak much about art, not even about their own: even those who are accomplished social conversationalists may suddenly be at a loss for words when asked basic questions about their artistic intentions. Reason and rationality are not regarded as part of the artistic impulse, which is understood to be intuitive, solitary, and inexplicable.

Art criticism in Japan, like the "fine art" tradition, is thus anomalous. The practice is limited mainly to theoreticians writing in scholarly publications and to reviewers for the daily newspapers, whose coverage of the five-day exhibitions has approximately a twenty-four-hour shelf life. There are several popular art magazines, such as *Bijutsu Techo*, but they seem not to be regarded by Japanese artists as representative of any particular viewpoint or consistent voice. Curiously, many Japanese artists regularly look at Western art journals and seem to be more conversant about developments in America and Europe than within Japan.

What has the art world in the United States done to acquire and disseminate a knowledge of recent Japanese art? It is possible to find some representation of Japanese artists in galleries in the larger cities, but it is scant, sporadic, and collectively uninformative. There is no across-the-board effort to present and understand contemporary Japanese art that compares with the intense scrutiny that American galleries, critics, collectors, and museums have trained on German, British, or Italian art in recent years, generating countless solo exhibitions, group and theme shows, and a virtual library of journalistic and critical speculation on national and international cultural mandates, stirring up demonstrable artistic influences.

Most of the current Japanese visual culture that has filtered into the United States is largely design, and much of it is to be found in commercial galleries oriented more to the interior-design trade than to established collectors of art. What little we see of contemporary Japanese painting tends toward pristinely executed, sweetly colored abstract compositions; the sculpture is sleek and "corporate." Little of it has compelled the imagination of American artists or the art world in general.

There have been some serious-minded efforts in the United States to learn about contemporary Japanese art. At P.S. 1, the studio and exhibition space operated by New York's Institute for Contemporary Art (formerly the Institute for Art and Urban Resources), numerous Japanese artists have participated in the international studio program during the 1980s; among them are Tadashi Kawamata (represented in *A Primal Spirit*), Junko Suzuki, and Kaoru Hirabayashi, whose work has become known here because of their

temporary residence in New York. But this acquaintance is limited to those young Japanese artists who were selected on the basis of individual merit and who wished to come to work and study in New York; it does not reflect the larger world of Japanese art.

Except for a handful of slender books and brochures on individual artists and two or three other publications mentioned later in this essay, there is virtually no general information published in English or any other Western language on contemporary Japanese art; for that matter, no such publication exists in Japanese. There are some volumes on Japanese modernism and its counterparts to twentieth-century Western avant-garde movements such as surrealism, dadaism, new realism, and abstract expressionism,[2] but these trace the twentieth-century developments of Japanese art as a subset of Western modernism. Occasionally articles appear in American art magazines, but more often than not they deal with some facet of Western artistic influence on contemporary Japan. The consistent pattern among Western publications is to approach modern and recent Japanese art as if it were a colonial manifestation of Western art, addressing the "Japaneseness" of the work primarily as local coloration, a circumstantial variant, like an accident of birth or upbringing.

American museums have not helped the situation: presentation of contemporary Japanese art has been almost negligible. In 1966 the Museum of Modern Art in New York organized *The New Japanese Painting and Sculpture*. The first significant survey of Japanese art of the postwar era, it was a miscellany of works by forty-six artists, many of whom were Western-influenced. The next large exhibition came four years later, in 1970; it was also the last full-scale survey of contemporary Japanese art presented in the United States. Organized jointly by the Solomon R. Guggenheim Museum in New York and the Japan Art Festival Association, *Contemporary Japanese Art* included the work of thirty-three artists, exhibiting in the categories of painting, graphics and photographs, and sculpture. Significantly, most of the objects included in that exhibition appear to have been selected for their unmistakable resemblance to artistic modes whose ascendancy is specifically associated with the United States, namely, color-field painting, minimalist sculpture, and process art.

In his essay in the exhibition's catalogue Edward F. Fry, the Guggenheim curator who selected the works of art with the cooperation of a committee of the Japan Art Festival Association, although acknowledging

2. See, for example, *Japon des avant-gardes, 1910–1970* (Paris: Éditions du Centre Pompidou, 1986); Michel Tapié and Tore Haga, *Avant-Garde Art in Japan, 1945–1965* (New York: Harry N. Abrams, 1962); and Mildred S. Friedman, ed., *Tokyo: Form and Spirit* (exh. cat., Minneapolis: Walker Art Center/New York: Harry N. Abrams, 1986).

that "the tenets of Japanese culture rest upon foundations that are totally separate from the individual idealism and self-conscious historical dynamics of Europe," predicated his remarks about contemporary Japanese art—and presumably his selection of art for the exhibition—largely on the work of "Japanese artists [who] have been intensely involved during the last decade with Western, and above all American, art."[3] And though he cautioned the viewer/reader to be mindful of the inadequacy of understanding Japanese art through the Western, specifically Hegelian "historicist values of reaction and innovation so instinctively important to European and American artists, art critics, and art historians" and further warned that "complete Westernization [of Japanese art] would demand a form of cultural suicide," Fry concluded that it is only "by a creative fusion of its living traditions with the new problems and opportunities confronting it and the rest of the world that Japanese art and society may continue to offer ever wider perspectives for the future."[4] Astute and perhaps correct as Fry's evaluation may be, it remains essentially colonialistic and parochial. It presumes that the future of Japanese art depends on its assimilation of Western norms. Even if this proposition could be proved true historically, as a postulate it reflects a clear Western-centrism. Fry could logically have argued correlatively that the fate of American, German, Italian, or any other Western art depended on its assimilation of Japanese traditions, but he did not.

The next major museum exhibition of contemporary Japanese art in the United States, titled *Against Nature: Japanese Art in the Eighties*, was organized in 1989 by the Grey Art Gallery and Study Center, New York University; the List Visual Arts Center, Massachusetts Institute of Technology; and the Japan Foundation. Touring six American museums, it presented works by ten young Japanese artists and was the first American exploration of the art and attitudes of the generation of artists emerging in the mid-1980s. The exhibition and its provocative catalogue, including the transcript of a roundtable discussion among five American and Japanese curators and art critics, represented a major advance over the usual Western writing on Japanese art. Kathy Halbreich, one of the organizers of the show, stated that the exhibition embodied "a search for ideas about cultural identity. . . . We've tried to figure out what the particular conditions were that made Japanese art Japanese."[5]

3. Edward F. Fry in the introduction to *Contemporary Japanese Art: Fifth Japan Art Festival Exhibition* (exh. cat., New York: The Solomon R. Guggenheim Museum, 1970), n.p.

4. Fry, *Contemporary Japanese Art*, n.p.

5. Kathy Halbreich in "Against Nature: A Roundtable Discussion Recorded in April of 1988," in *Against Nature: Japanese Art in the Eighties* (exh. cat., New York: New York University, Grey Art Gallery and Study Center/Cambridge: Massachusetts Institute of Technology, List Visual Arts Center/Tokyo: The Japan Foundation, 1989), 14.

This is a major theme in Japanese studies and an area of considerable speculation among cultural historians. In a certain sense, it is also a basis for the present exhibition, which seeks to discern the expression of indigenous Japanese ideas, attitudes, and forms in the work of the ten sculptors represented. Whether it is a valid theme remains to be seen. The organizers of *Against Nature* explored this issue deeply, and "along the way we stumbled on the idea that perhaps this notion of 'Japaneseness' was no longer even viable."[6] As evidence they discussed the disinterest and occasional distrust that many young Japanese artists profess on the subject of "Japaneseness," preferring to think of themselves as "Asian" or "international" artists. *Against Nature* concentrated on the erosion of the idea—or, more accurately, on the erosion of the authority of the idea—that there is a purely Japanese culture and questioned whether there ever was such a thing. The curators suggested that Japanese culture itself, whose artistic styles and content historically have been imported from China, Korea, and the West, "always has been akin to an assemblage or collage."[7] The exhibition was built on the premise that Japanese culture is and always has been essentially hybridized and that Japan today is in a state of profound and pervasive change. Accordingly, the artists in the exhibition were those whose art reflected that hybridization and change: artists who have borrowed heavily from the West and made a deliberate point of juxtaposing unlike elements, clashing aesthetics.

It may well be that *Against Nature* was a historically necessary exhibition and that the direction it documented is the future of Japanese art in the 1990s: the pronounced Westernization in some strains of Japanese art may have as lasting and deep an effect on the art of twenty-first century Japan as the American importation of early European modernism had on the development of our own art in the twentieth century. But this presentation of contemporary Japanese art, like the Guggenheim exhibition in 1970, was first and foremost a demonstration of external influences on Japanese art.

In 1987 there was a small but important exhibition of sculpture titled *New Work Japan* organized by the Brattleboro Museum and Art Center in Vermont. Although it included the work of only six Japanese and Japanese-American artists and made no claim to be a "major" exhibition, it made a significant contribution to the study of contemporary Japanese art. It approached the subject not as defined by the history of modern art in the West but as part of the ongoing progression of the visual arts in Japanese culture since prehistoric times. In her catalogue essay telescoping that history Aya Louisa McDonald observed, more trenchantly than other Western commentators, that "Japanese Modernism was a deracinated, reified, artificial whole

6. Halbreich in *Against Nature*, 14.

7. Halbreich in *Against Nature*, 21.

22

whose constituent parts corresponded to nothing in the Japanese experience."[8]

If the lessons of Western modernism enabled Japanese artists earlier in the century to formulate a sense of individualism, McDonald explained, it did so in opposition to a sense of loyalty to an idea of an inherited Japanese culture. For the post-Hiroshima generation of artists and their apologists, however, the situation is somewhat different: "They assume their right to be in the international spotlight without question or backward glance. . . . On the other hand, [they] are quick to speak proudly of difference, of a Japanese originality and creativity independent of the modern West. They want to separate and preserve Japanese characteristics from the otherwise undifferentiated, international character of contemporary art."[9]

This position finds the creative strength of recent Japanese art less in a hybridization and injection of non-Japanese form and content than in an independent-mindedness that allows Japanese artists both to pursue their own creative intuitions and to acknowledge their active participation in inherited Japanese tradition, an approach that appears to be at odds with the limited but firmly established viewpoint of Western critics. It may very well be that these positions are not fundamentally contradictory or incompatible; each seems to define an aspect of contemporary art in Japan.

We must question whether it is Western-derived forms in Japanese art that should most command our attention. The clashing aesthetics that have hitherto been the focal point of Western observers of recent Japanese art are indeed an important issue, but if Westerners should become preoccupied with inspecting Japanese art to find out, almost as a matter of clinical curiosity, what happens when one tradition (ours) is spliced to another (theirs), it would be an exercise in provincial, blinkered cultural self-affirmation. In searching the world for art that defines itself by the engagement or assimilation of Western culture, we mock the West's own high valuation of originality and neglect what is authentic in a foreign culture.

It is instructive and rewarding to look at aspects of contemporary Japanese culture of which we have no prior knowledge and in which we have no predisposed (self-)interest and to encounter art that does not participate in the intramural dialogue of critical issues that are of consuming interest to the parochial West. If the world of contemporary art is, as everyone likes to say, truly international, then it behooves us in the West not to seek corroborating evidence of our own practices but to consider the artistic achievements of other cultures on their own terms. That is the intention and aspiration of *A Primal Spirit: Ten Contemporary Japanese Sculptors.*

8. Aya Louisa McDonald, "Japanese Sculpture: A History of Defining Form in Space," in *New Work Japan* (exh. cat., Brattleboro, Vt.: Brattleboro Museum and Art Center, 1987), 12–13.

9. McDonald, "Japanese Sculpture," 13.

A Primal Spirit

Howard N. Fox

It is impossible to characterize contemporary Japanese art—the range of activities is simply too diverse, the pace of developments too rapid. Indeed, it is tempting to describe its eclectic nature as a defining characteristic in itself. Cosmopolitan and restless, the Japanese art community is emerging as a vital arena in the international art world and has begun to attract considerable attention in the West, whose art has often figured as a strong stimulant for recent Japanese art. Western-influenced art is in fact commonplace in Japan today, as is the artists' and critics' fascination with a culture in transition, a fascination that frequently finds creative expression in artworks demonstrating provocative, sometimes outlandish juxtapositions of Western style and Japanese subject, or vice versa. Only the smallest sampling of Japanese art of the mid- to late 1980s has been shown in the West, most of it reflecting a deliberate internationalism, however tentative or unresolved, and it may well be that the accessibility of such Japanese art and its apparent relationship to recent Western art has in part motivated its presentation to Western audiences.

There are, however, other significant and compelling directions in contemporary Japanese art that are all but unknown outside Japan, and, given the role that Western influence plays in the Japanese art world, some of these indigenous directions are not much more astutely observed within Japan. By exercising some resourcefulness, however—hunting down obscure group exhibition catalogues, investigating the activities of regional art museums and lesser-known galleries, combing through Japanese art magazines, and soliciting, almost indiscriminately, artists of every ilk for their slides—it is possible to discern many areas of pronounced artistic interest and creativity that do not dance the cakewalk of Western influence.

A Primal Spirit identifies a thrust in Japanese art that is unique in contemporary art internationally. The ten sculptors represented in this exhibition, though working independently and without a special goal to establish a patently "Japanese" style, nonetheless share a clearly identifiable and uniquely Japanese sensibility. Their work, while assertively innovative in form and style, sinks its roots deep into ancient Japanese traditions and cultural attitudes.

Generally, their art is a direct engagement of forces in nature and natural materials. The works, often large-scale, labor-intensive constructions, demonstrate radical transformations of natural materials and distortions of natural forms, complex arrangements of parts in space and time, and the embodiment of forces or processes of both creation and destruction. Within this broad range of expression, however, their individual responses to nature are anything but uniform: Chuichi Fujii bends huge tree trunks into dramatic contortions; Takamasa Kuniyasu arranges thousands of small ceramic blocks into vast, complex formations; and Toshikatsu Endo builds elemental geometric structures from wood or rocks and sets them on fire so that they are charred and severely distressed. But these and the other artists included in *A Primal Spirit*, as well as many other Japanese artists who could not be included, deliberately engage the essence of their materials to manifest and reveal man's relationship to nature.

Their art draws upon ideas and aesthetics that are not only traditional but dominant in Japanese art, including Shinto attitudes—that man is equivalent to and involved with nature and the spirits and life force embodied therein, that the art object is the locus of the individual's spiritual encounter with nature, that the artist works "with" the materials to discover their "inner being," rather than against them to impose his technical virtuosity—and Buddhist concepts—that man is not at the center of the universe, that the art object represents a microcosm of that universe, and that the function of art is fundamentally meditative. Though the work in *A Primal Spirit* is altogether secular, its deep spiritual content is reflected in dark and terrible forms built from the elemental things in nature—trees, rocks, minerals—that reveal primal forces of growth and change, creation and destruction, life and death.

Significantly, none of the artists in this exhibition claims to be a "Japanese" artist, and all of them are wary of any attribution of nationalism to their creative intent. Indeed, there is nothing in their art that suggests either political or aesthetic nationalism; further, their works are entirely contemporary and resemble little else in the history of Japanese art. Yet these artists affirm that their art is created within, and not apart from, an ongoing Japanese artistic tradition.

That these ten individuals do not have associations as a group—in fact, some of them had never met nor heard of some of the others—testifies to the presence of a shared sensibility; that their work is so distinct from any discernible tendency in Western contemporary art suggests that their art emanates from a shared sense of Japanese culture inflected by contemporary experience. Viewed collectively, the ten artists in *A Primal Spirit* represent one of the clearest, most stirring directions in Japanese art today.

In order to comprehend the significance of this art and to speculate on what the example of these artists may portend for their colleagues, both Japanese and Western, it is useful to examine some of the traditional concepts, attitudes, and values that inform their art, particularly as they may be contrasted to Western ideas about the same issues. Some of these artists' fundamental philosophical and aesthetic premises, such as those concerning the artist's role as a creator or his relationship to the materials he uses, are antithetical to Western presumptions, while other ideas essential to Japanese sensibility, such as the conception of an inner being in inanimate objects, have no counterparts in Western thought.

In Western civilization most conceptions of the universe, religious and secular, support the principle of hierarchical order with God dominant over man and man dominant over nature, as well as the duality of an imperfect natural world distinct from a realm of divine perfection to which transcendence is possible only after death. Most other civilizations do not subscribe to such a dualistic conception. In Japanese culture the universe has been traditionally conceived as a single, indivisible manifestation of matter and spirit. The two major spiritual and philosophical currents within Japanese civilization, Shinto and Buddhism, stress the unity of divinity and nature. Shinto, a uniquely Japanese religion, affirms the presence of many deities in the physical world and their intervention in human affairs, and it exalts man's harmony with nature through ritual observances and the individual's experience of nature. Buddhism, which was introduced into Japan in the sixth century, is more metaphysical than Shinto, stressing the possibility of individual transcendence through meditation and higher consciousness, yet Buddhism, especially the unique Japanese adaptation and practice of Zen, shares something of Shinto's worldliness in presuming that transcendence can be attained in and through the habitable world and during a human lifetime.

Although the artists represented in *A Primal Spirit* do not profess to be creating religious or devotional art, deeply ingrained Shinto and Buddhist attitudes inform their work, as surely as Judeo-Christian concepts inform secular traditional and contemporary Western art. There are insights to be gained about the work of these ten artists by considering their art in the context of elemental precepts of Shinto and Zen.

What is most significant about Shinto is its location of the generative forces and spirits that created the universe within and throughout the natural world and its profound sense of man's total engagement with creation. So thorough was this involvement that in the development of Shinto "there was no word for Nature, as something apart and distinct from man. . . . Man was treated as an integral part of a whole, closely associated and identified with the elements and forces of the world about him."[1] The early Japanese "took it for granted that the natural world was the original world; that is, they did not look for another order of meaning behind the phenomenal, natural world."[2] There was no separate realm wherein the deities segregated themselves from the rest of creation, but a single universe suffused by spiritual and vital presences, or *kami*.

Motoori Norinaga (1730–1801), an oft-cited student of Shinto, wrote:

> Speaking in general . . . it may be said that *kami* signifies, in the first place, the deities of heaven and earth that appear in the ancient records and also the spirits of the shrines where they are worshipped. It is hardly necessary to say that it includes human beings. It also includes such objects as birds, beasts, trees, plants, seas, mountains, and so forth. In ancient usage, anything whatsoever which was outside the ordinary, which possessed superior power, or which was awe-inspiring was called *kami*.[3]

Shinto has sometimes been described as nature worship, but in fact it does not advocate the worship of natural things per se but of the spirit present within things, affirming "the sacrality of the total world (cosmos) permeated as it [is] by the *kami* (sacred) nature."[4] Only remotely related to totemism, which posits the existence of magical powers in the universe that can be summoned forth by a shaman and enter or take the form of objects, Shinto is more a devotional religion given to the ritual celebration of the forces that created nature and animate its great rhythms and cycles.

How different is this vision of man's innately empathetic existence with nature from the Judeo-Christian account of man's divine mandate to subdue and dominate an inhospitable wilderness through which he is con-

1. Shunzo Sakamaki, "Shinto: Japanese Ethnocentrism," in *The Japanese Mind: Essentials of Japanese Philosophy and Culture*, Charles A. Moore, ed. (Honolulu: University of Hawaii Press, 1987 edition), 24.

2. Joseph M. Kitagawa, *On Understanding Japanese Religion* (Princeton: Princeton University Press, 1987), 44.

3. Motoori Norinaga quoted in Ryusaku Tsunoda et al., eds., *Sources of the Japanese Tradition* (New York: Columbia University Press, 1958), 23.

4. Kitagawa, *Japanese Religion*, 44.

demned to roam in exile from Paradise.

It might seem farfetched, given the industrialized technocracy that Japan has become, to suggest that Shinto concepts of man's harmony with nature survive today as anything more than a quaintness—as a wistful nostalgia for a mythologized nature that has been all but obliterated from common experience by the Japanese megalopolis—or that its citizens' involvement with nature is any more substantial than enjoying the changes of the seasons and the festivals that celebrate them. Yet Shinto awareness of man's involvement with nature indeed survives, not merely in the Japanese love of nature but as an ethos and a basic element of cultural consciousness that extends to every aspect of domestic life, such as how space is arranged in a room, how food is prepared and presented, how a work of art is created.

A Japanese sculptor taking up a stone or a piece of wood performs an act very different from that of a Western artist confronting the same material. If it were possible that the two might independently create forms that were identical in every physical characteristic, the artists' individual perceptions would still be remarkably divergent, governed largely by a complex of interrelated, culturally ingrained presumptions about materiality—the physical "stuff" of art—arrangement and form, and the creative act itself.

To a Western artist material is usually envisioned as a crude resource to be exploited and manipulated, to bear the imprint of the artist's unique style and technique. Such an attitude stands in stark contrast to that of Japanese artists such as Chuichi Fujii, who asserts, "I believe that wood is, essentially, no different from humans: it breathes air, it cries. If I am responsive to the wood, then it will also be responsive to me."[5] Fujii has also stated that the tree "loves"[6] the extreme stresses to which he subjects it in order to achieve the spectacular contortions of its natural form in his art. It might impress a Westerner as discordant to describe the radical distortion of the tree's natural form, through a process of physical strain, as somehow sympathetic or harmonious with nature or as something that the tree could somehow "love"; the process would seem to inflict something more akin to torture. And such an affirmation is all the more surprising when we realize that Fujii does not work with living trees but with gigantic logs purchased from the commercial lumber industry: the fact that Fujii's felled trees are no longer alive does not diminish his regard for their intuitively known inner being.

5. Unless otherwise indicated all quotations from the artists have been taken from the transcripts of interviews conducted by Judith Connor Greer of the Hara Museum of Contemporary Art in 1989. More extensive passages can be found in the portfolio section of this catalogue.

6. Chuichi Fujii in conversation with the author, October 1988.

Indeed, the impulse that motivates most of the artists in *A Primal Spirit* is less an intent to coerce and manipulate the material as an aspect of artistic control than to engage and bring out what they describe—vaguely, but continually—as this inner being. The consistency with which these and other Japanese artists express this concept is remarkable. Kimio Tsuchiya, for example, states that his intention is "to bring out and present the life of nature emanating from this energy of trees."[7] He further reflects that "in using wood it is not that I am simply cutting and using trees that have lasted for hundreds of years. . . . It is as though the wood is a part of myself, as though the wood has the same level of life force. . . . Wood is not just matter."

A particularly graphic and emotional description of this inner energy and its relationship to human consciousness is related by another wood sculptor, Shigeo Toya:

> One stormy night, I was standing on a road beside a ravine, facing the woods. It had formed a huge black mass which groaned and raved. This raving was not a superficial phenomenon, but rather originated from within. This huge living being had already swallowed the storm. I quietly got into my car and drove away so as not to be noticed by the raging being.[8]

Toya has also described the extremely variegated surfaces of his sculptures, with their swirling gouges carved out by a chain saw and their thousand fingerlike stalks, as enabling the inner energy of the wood to interpenetrate—and be interpenetrated by—that of the rest of the world.[9]

Many contemporary Japanese artists use forms of the verb *ikasu* (to live) with respect to their materials. Emiko Tokushige, for example, so explains her handling of the palm tree thatching, husks, and tree bark with which she usually works:

> I want to leave more of the expression up to the material itself. . . . I have to take it into my hands, but I am not certain to what extent I should do this. I don't want to kill the material. . . . When I think about what I want to create, it is not so much that I feel that I must "consult" with the material, but it is rather like being manipulative in human relationships. I feel terribly guilty

7. Junichi Shiota, *Kimio Tsuchiya, Sculpture 1984–1988* (exh. cat., Tokyo: Moris Gallery, 1988), 3.

8. Shigeo Toya quoted in Toshiaki Minemura, "Leaving Woods to Create 'Woods,'" in *Shigeo Toya, Woods 1984–1987* (exh. cat., Tokyo: Satani Gallery, 1987), 10.

9. Shigeo Toya in conversation with the author, September 1988.

about it. . . . When I look at a completed work, it is apparent to me whether I stopped at a particular point to allow the materials to live [*ikasu*] or whether I stopped because I became fearful [of destroying the materials]. When I say that I want "to allow the materials to live," it sounds as though I am being very deferential toward them, but it is actually more of a struggle. And this struggle itself is enjoyable and interesting for me. It is this struggle that drives me in the creation of a work.

Like Tokushige, many contemporary Japanese artists regard their materials not as passive matter enlisted to receive, like a blank slate, the artist's imposed will but as part of the whole of the created universe. Such an idea is manifest in the ceramic-block constructions of Takamasa Kuniyasu: reflecting on the central influence of Zen philosophy on his art, he comments:

As a human being I do not constitute the center of the earth but exist only as a single point within nature's cycle. More than creating the works through my own volition, I feel increasingly passive, as though I am being driven to create them. . . . Natural materials often deviate from my original intentions. . . . By giving up control, I conversely make use of them. . . . I am more interested in those materials that are not obedient to my will.

Kuniyasu's passivity and Tokushige's struggle have virtually the same intent: the aspiration toward an intuitive and respectful engagement of their materials and of nature, of which they—artist and materials alike—are a part. The work of art is the locus and record of that engagement. As Shigeo Toya has said, "I want my work to be a place of encounter with something that is greater than I am."

Not all contemporary Japanese artists are content to attribute such spirituality to their materials nor to an engagement of natural forces, and some even resist the imputation of a special "Japaneseness" to their art. Tadashi Kawamata, surely the most self-consciously cosmopolitan artist in *A Primal Spirit*, makes a point of his reservations: "I don't subscribe to the notion [that the Japanese value the inherent spiritual qualities of wood]. Artists in other countries use wood. I think it is rather farfetched to assume that the use of wood in Japanese art is equivalent to animism. . . . Foreigners often depend on unusual interpretations in order to find something 'Japanese.'" Kawamata is firm in his assertions that his art has nothing to do with nature but is involved instead with urban architecture and the dynamics of urban growth. Yet for all his skepticism of such attitudes Kawamata readily

describes his artistic intent in words that sound strikingly similar to those of many of the other artists in *A Primal Spirit* and explains his art through the use of metaphors that deal not with cities and man-made things but with nature and natural materials:

> I try to be "submissive" to the materials that a site possesses. I use the space of a building or materials relating to the building, or I break up the interior of a building and [use] the scraps. . . . By using materials in this way, my work becomes assimilated with that from which the materials originate. This is a very important part of the concept underlying my work: the relationship is parasitic. I once said in an interview that my concept of materials can be compared with cancer. . . . My work can be called a cancerous or parasitic organization within an organization.

The common intent in all of these statements, Kawamata's included, is to see the work of art not as an independent, autonomous object, discrete in the world and divisible from everything not defined by its physical form, but rather as a living process that engages and assimilates and extends other processes and qualities, particularly natural ones, through time and space. The works are conceived and created with the aspiration that they will engage and participate in the larger forces of creation, growth, destruction, and decay in nature.

This is not a new concept in Japanese art; the aspiration toward engagement is in fact quite ancient and pervasive in Japanese culture, and there is a striking analogy between the contemporary art represented in *A Primal Spirit* and the traditional Japanese art of bonsai, the cultivation of trees or shrubs in small pots. Contrary to many Westerners' beliefs, bonsai trees are not miniatures: they are the same species that grow huge and wild in the forest. In bonsai the tree is continually pruned and trained to grow around stiff copper wires, not in order to subdue and dominate it but rather to engage and reveal, to draw forth and release the tree's inner nature, its characteristic form and life force. Whereas Westerners are wont to find something grotesque and "unnatural" in the human intervention into and distortion of the growth process of a tree, the Japanese perceive a beauty in the instance of man's engagement of nature, its rhythms and forms, revealed gradually through time and space. To Japanese sensibilities the bonsai tree is a microcosm of all life, revealed in a ritualized drama that requires extraordinary patience and contemplative recollection. It is highly significant that in this notion of deliberate intervention into and arrangement of nature man is not perceived as subtracting from the tree's inner essence, which abides un-

diminished and unadulterated. Its outward physical form is a contingency, a variable, a function of circumstance, and the visible register of the inner force's encounter with the rest of the world. Artistic form, then, is the momentary record of an ongoing process involving the artist's encounter of and participation in natural forces through his chosen material.

In modern Western art an object's form is its physical certitude, and though it might change over time—through deterioration or the artist's intent—its form is conceived as the sum of its absolute physical properties. We in the West generally define form in the visual arts in opposition to chaos and change; it is complete and static, the end product of many artistic decisions.

By contrast, form in Japanese sculpture is conceived to be generated by change or flux itself. Indeed, the concept of completion is antithetical to much contemporary Japanese art: form is an event within an ongoing process that never truly ends. This concept is not new in Japanese culture and can be found at its very heart. Near the city of Ise in south-central Japan is Shinto's most important national sanctuary, the Great Shrine. There, in the midst of a densely wooded and rugged terrain, a wooden wall encloses an acre or two of stark, perfectly flat land; within that sanctified place, a second wooden barrier ritually demarcates a sacred *kami* zone; at its center stands a wooden tabernacle or ark that for two thousand years has contained Shinto's most sacred objects: the mirror and the polished jewels that, according to the first imperial chronicles, were used to coax the sun goddess Amaterasu out of hiding, thereby restoring light to the world and ultimately enabling the creation of her descendants, the Japanese race and its imperial clan.

The Great Shrine is an ancient and enduring place, but every twenty years since the seventh century the shrine has been completely dismantled and rebuilt—identical in every detail—with new wood. This rebuilding is, of course, as much a ritual of renewal and rebirth as it is a maintenance activity, but it is also a manifestation of the Japanese notion of physical form as a provisional arrangement of parts in time and space. The sacred precinct of Ise remains a fixed and constant place; as a physical object the shrine has been discarded again and again for the past thirteen hundred years. To Western perceptions the rebuilding of the shrine causes another shrine to exist, but to the Japanese it is the same shrine in the same place, having the same function, suffused with the same holiness, containing the same *kami*.

The profound conception of arrangement that so pervades Japanese visual culture and daily life is an affirmation of unity in the created world, a unity revealed in the integrity of each of its divisible parts. Arrangement is practiced in myriad ways, from the disciplines of architecture and garden design, through the contemplative exercise of *ikebana*, floral compositions, to

the practical art of *bento*, the exquisite boxed arrangements of assorted morsels of food. Each of these traditions of creative expression is venerated for its satisfaction of various human needs and pleasures, but the constant is the cultivated regard for the relationship of the whole to its parts and of each part to every other—in other words, an apprehension of the whole, or macrocosm, read through its individual elements.

The concept of the collective, synthetic nature of the whole is implied in Kimio Tsuchiya's vision of a life force that suffuses all individual parts: "When a tree is cut, it doesn't mean that the wood is dead; life remains, even if it is cut into fine pieces, even if it is made into small boards— the life of the tree remains in each small division." Tsuchiya's art consists not of isolated fragments of trees or separated splints of wood, but of irregularly shaped pieces arranged in large, rudimentary shapes such as semi-circles and spirals. It is in the process of gathering and arranging random bits and pieces of irregular wood that Tsuchiya affirms the unity and coherence of the whole. Thus, while he and the other artists represented in *A Primal Spirit* surely look into the inner being of their materials, they direct their vision outward in the act of creation to assert a transcendent wholeness that can be discerned in the least division or unit of their arrangements.

It is, then, a Japanese sense of arrangement, much more than a Western sense of object-bound form, that characterizes their art. Koichi Ebizuka's multifaceted arrangements of wood and rocks, for example, are complex organizations of interdependent parts. Vertical and horizontal elements, tall and low forms, cleanly defined geometric shapes and craggy, irregular ones are juxtaposed. These compositions flow from part to part and have no particular vantage point, no single view, no central focus. Ebizuka is quite deliberate in not labeling his works as "objects"—that is, as static, immutable entities—or as "constructions," observing that, for him, the latter word has Western connotations of "something very solid" and fixed; rather, he speaks of them as "productions," preferring that word's suggestion of active engagement and organization. It is significant that Ebizuka sometimes cannibalizes or recycles the wood members of his compositions to create new ones, for he defines his art not in the absoluteness of any structure it generates but in the temporal arrangement of its parts.

For all the sculptors in *A Primal Spirit* arrangement, or the process of organization, is more significant than the particular form or structure that results. Kazuo Kenmochi's assertion that "I don't want to create something that has a definite form," succinctly expresses an attitude shared by these and other Japanese artists. Indeed, for many of them the form or structure of their works is often unplanned, sometimes accidental. Tadashi Kawamata relates that as an art student he realized that he was "really more

interested in arranging space" and materials than in painting and making conventional—that is, Western-type—art objects, and that "it seemed much more interesting to show this process of work, where things can change or happen by accident as the work goes along." Similarly, Chuichi Fujii explains that "I always start off with some idea, but when facing the actual work it may not turn out as I had planned in the beginning." Of course, for any artist, Japanese or Western, unanticipated creative opportunities and unforeseen results will be generated in the course of working; it would be rare indeed if a work of art were to turn out precisely as it had been conceived. But for many Japanese artists the moment of accident is an encounter with the wholeness of the world, with the conditions and processes that animate the totality of creation.

Often such accidents take the form of a material "emergency"— the wood that will not bend, the stone that breaks, the structure that cannot stand. But whereas for a Western artist such conditions might be thought to interfere with the realization of the envisioned work of art, for these Japanese sculptors it is precisely the unknown and uncontrollable factors that offer their fullest engagement with a universe in a state of perpetual animation. To be truly whole, and to truly reflect its universality, the work of art must be susceptible to and engaged in the conditions of the universe, even if that ultimately results in the transformation or destruction of the work: "I have no problem with accidental occurrences nor do I believe that a work needs to last a long time. . . . I think that it is sufficient for a work to last for only a moment." This statement by Ebizuka, reflecting a widely held Buddhist understanding of the universe as being in a perpetual state of flux, suggests that the completeness of a work is not to be found only in the integration of separate parts into an organized arrangement but also in its disintegration into fragments or debris.

Most artists represented in *A Primal Spirit* have affirmed that impermanence is an elemental physical fact of their works of art as well as an essential aesthetic factor in the perception of their works. Indeed, they are deeply attracted to impermanence, destruction, and decay. Kawamata says, "I want to concentrate on temporariness, not permanence," and is perfectly content to see his works dismantled or destroyed in the endless cycle of creation and destruction in the urban environment. Takamasa Kuniyasu's ceramic-block arrangements in gallery spaces are, for simple practical reasons, dismantled and moved away after the duration of the exhibition. But truer to Kuniyasu's vision is the much less perceptible but equally real impermanence of his outdoor works that sometimes are left to disintegrate and merge with their natural surroundings—the trees and vines that, in time, overgrow them, the rain, snow, and extremes of temperature that crumble them, the

wind that scatters them, the earth itself, to which they return. Kuniyasu reflects, "I never think of my work as something that will last forever. The materials I use are bound to decay and deteriorate over time. . . . I don't mind if, in the end, a work crumbles and decays, if that is what happens naturally."

Emiko Tokushige, whose chosen media are tree bark, thatching, and fiber, has considered using steel, not for its hard, "permanent" qualities, but because "I am attracted to its roughness and to the fact that it would become rusty and decay." Kazuo Kenmochi, pondering the fate of his towers, muses that "sometimes I feel that if the work fell over it would be equally satisfying to me. . . . I would like to go to the very limit. If it then falls over, it can't be helped." He further reflects:

> When I was a child, I lived close to the sea and made things from sand: mountains, pyramids, and Mount Fuji. When you create something from sand, your creation is being destroyed while still in the process of creation. No matter how much you continue to build something, the wind keeps breaking it down and it continues to crumble. Rather than making a perfect pyramid, I am more attracted to a work that shows such gradual changes. . . . I cannot defeat nature, and I am not even sure that I would dare to challenge it. I don't care if a work of mine is destroyed by the wind or rots in the rain. It is part of a cycle of life.

Clearly, for many of these artists, the viewer's recognition of the mutability of these works is as important—perhaps more important—to the proper understanding of the works as the physical form of the works themselves. Contrasting to Western modernist orthodoxies, which maintain that the art object shall be created according to aesthetic and formal precepts determined by the artist and shall exist in the world as an autonomous entity, the intent of many Japanese artists is to proffer their creations as aspects of the universe, functioning within and as part of a larger natural order that both includes the object and transcends the artist's engagement of that order. For the artists in *A Primal Spirit*, the very significance of their art is that it is conceived as having a destiny larger than whatever manipulations they as artists have imposed upon their materials.

Thus Kenmochi's vision of his works as existing within and as part of a greater "cycle of life" is more than just an acceptance of the perishability of materials; he implies that the cycle is the very mechanism whereby the work assumes its function in the universe and its significance in the minds of artist and viewer alike. The same concept is also articulated by Isamu

Wakabayashi, whose room-sized arrangements, which may include objects made of iron, lead, copper, or sulfur, often reveal the slow processes—rusting burning, corrosion—through which nature operates imperceptibly but surely. Wakabayashi speaks of a vaguely defined but all-important "cycle of existence," in whose slow processes he

> as an artist can become involved. Isn't this what making art means? . . . Perhaps it is a unique Japanese way of thinking. In Buddhist terms this would be described as the "coexistence" with materials. . . . Although it is the individual daily things and fragmentary things that one is involved with, it is the vision of the greater picture, and my involvement in that, that becomes one of the foundations for the creation of a work.

While these Japanese sculptors presume that their works are incomplete fragments of nature, they maintain always an aspiration to come to a comprehension, through their art, of the completeness of nature and man's place in nature. Toshikatsu Endo conceives his art as a kind of rite undertaken to fulfill man's perpetual desire for completeness and unity with the universe. Influenced by Zen teachings, Endo states that he believes "first of all that we exist in a state of incompleteness," and that his art represents "an urge or impulse to fill in . . . that part that [is] missing." As a youth, Endo recalls, "I didn't understand what I was searching for but was driven to search by a force that continues to move me to this day. . . . But, of course, I can never really fill in the missing part, so I must continue to create my works." Endo's art—his "search"—often takes the form of simple circular arrangements of stones, sections of wood, or, occasionally, bronze, steel, or iron, which he views not as industrial products but as ores rendered up by the earth in the fiery smelting process. Fire, in fact, almost always plays a role in Endo's work, for he deforms by burning or scorching the wood or stone elements that are not originally formed by fire. Water, too, often appears as an element that survives burning, contained in ringlike channels or wells within the large circular arrangements. Endo often lists earth, air, fire, and water among the media from which he forges his sculptural forms. These primal, generative "media" suggest both the origins and ends of the creation and all life-forms. "So," reflects Endo on the spiritual inspiration of his art, "it is all connected: the concepts underlying my work, the genesis of human life, the questions of life and death."

No aspect of this art more clearly differentiates it from recent Western sculpture nor, more important, better characterizes its distinctly Japanese spirituality than the belief that these works of art are connected—

physically and conceptually—to the farthest reaches of all that lies beyond the objects themselves. Each of the works in *A Primal Spirit* engages, is penetrated by, and corresponds to primal forces in nature over time and in real space. Even the most empirical and least overtly spiritual of the sculptors, Tadashi Kawamata, has expressed a profound belief in the "connectedness" of his architecturally generated structures to a wholeness that they engage:

> If you let your hand follow along the real walls of a gallery, eventually you will end up on the outside wall of the building. I began to think that the walls I made could also be continued: so from the inside of the gallery they could go to the entrance and from there outside to the external walls and then to the walls of the surrounding buildings. The space between the buildings could then become a space from which the work continued. Everything comes out from the inside; it is all connected. The gallery walls are connected to the exterior walls; the building walls are in a sense the location's inside walls; the location is part of a town; the town is part of the country. And so the circle widens. There is no limit.

Though he professes no spirituality in his art Kawamata shares the same sensibility and philosophical outlook of others who do assert the connectedness and the universality of their art. Takamasa Kuniyasu, for example, who acknowledges the profound influence of traditional Zen Buddhism on his own attitudes, expresses closely related concepts, particularly with regard to his perception of the individual's continuity with the external world and its realization through art: "I am trying to find a form of expression that allows me to feel the self as a single part of a greater circle. . . . It is perhaps an interpretation of the world or of the universe, the cosmos, that I want to create."

To find points of connection, to transcend the present moment in time and the present point in space, to discover the origins and ends of creation—these are the impulses that impel the artists in *A Primal Spirit*. Kazuo Kenmochi says, "I want to create something that goes beyond my imagination. It is like coming close to the gods [*kami*]—if indeed there are gods." Toshikatsu Endo describes his art as "one long story. We all have a story of genesis, a story of how the world began. Man has continued endlessly to produce these stories. Artworks are also stories." As if echoing the thought, Chuichi Fujii states his belief that art "must be something that calls to mind the starting point, the origin, of humanity." Takamasa Kuniyasu, reflecting on a philosophical, if not formal, affinity between his work and traditional Buddhist art, sees both as conveying a "spiritual message" that

"could be interpreted perhaps as a form of prayer or an even profounder philosophy, something that we all share deep down in ourselves." And Koichi Ebizuka finds in sculpture "a tool for contemplating the universe."

Many Japanese artists working today create work that, to Western observers, appears contemporary in form and execution and recalls episodes in recent Western art. The sculpture presented in *A Primal Spirit* and much other contemporary Japanese art, however, does not disclose its true content when submitted to modernist or postmodernist notions current in the West. As we have seen, it follows other traditions that remain generally unperceived by Western viewers. Yet the works themselves, elemental in material, direct in execution, and imposing in scale, certainly are accessible to any audience. In their deeper content they reflect profoundly ingrained Japanese cultural attitudes, and they perpetuate certain timeless values and beliefs. It might be possible to perceive in these works a general reactionary response to contemporary Japanese culture, but the artists themselves regard their art as progressive, current, and evolutionary; they are consciously working with Japanese artistic traditions in a fully contemporary manner.

The concept of culture implies a lore, a received body of knowledge, wisdom, and sensibility that explains the past and provides a context for the present and a basis for the future. By definition, culture is—or always has been—the continuity of a civilization and the perpetuation of its experiences and beliefs. Today, however, it appears that the pace of cultural developments may have outstripped our capacity to assimilate and comprehend our civilization. Perhaps culture is now to be conceived as an ever-shifting mass consensus, as new as this morning's newscast and as old as yesterday's, a consensus not physically fixed in a geographic place, but immaterial as information, evanescent and protean as communication itself. We must ask if there will be a viable concept of culture in the future. This is a question no one is prepared to answer, and it is surely not the primary consideration of the artists represented in *A Primal Spirit*. But though their purposes are artistic and spiritual, in choosing to look deeply into their own culture they demonstrate its vitality and the creative resources to be derived from its continuity.

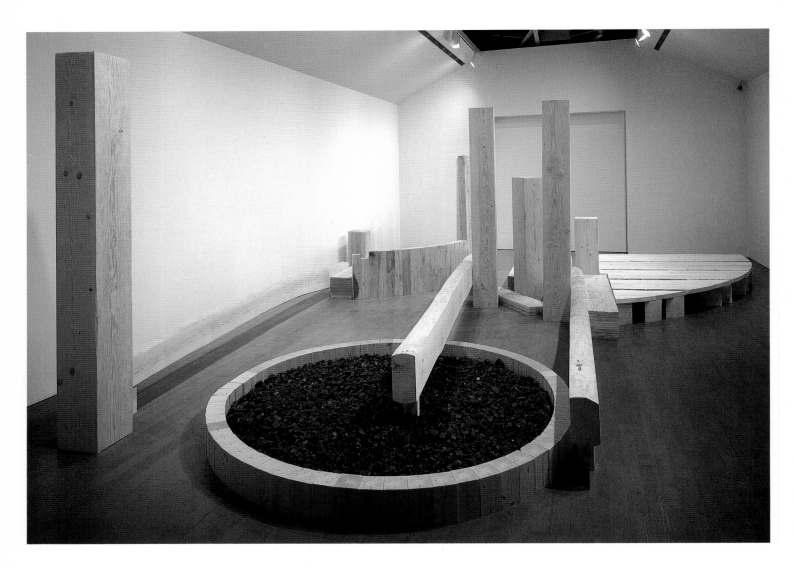

Related Effect S-90LA
Installation view,
Hara Museum ARC,
Gunma Prefecture
1990
Wood and coal; 255 x 623
x 770 cm (100³/₈ x 245¹/₄ x
303¹/₈ in.). Collection
Galerie Tokoro, Tokyo.
Photographer:
Tadasu Yamamoto.

Koichi Ebizuka

Note: The artists' statements are excerpted from interviews conducted by Judith Connor Greer in the autumn of 1988 and 1989. Assistance in transcribing, compiling, and translating the texts was provided by Katsunobu Horiguchi, Hiroko Nakayama, Yuko Tomita, Hatsumi Hiroi, Yoko Hayami, Nobuko Inagaki, Gennifer Weisenfeld, Yoshiko Okura, and Michelle Connor.

Although with computer graphics it is now technically possible to achieve representation of the fourth and fifth dimensions, it is really the second and third dimensions that are currently within our reach. While art has up to now generally been discussed in terms of two- and three-dimensionality, it would perhaps be more interesting to consider the dimensions that lie between. In this way the consideration of, for example, the 2.1 or 2.2 dimension would allow a critical reexamination of the history of what has been considered "good" art—a history that shows only what is "good"—and would perhaps lead to the recognition that there might be another truth in history.

The cave paintings of Lascaux, for example, are referred to as wall paintings, but these paintings are really very good reliefs, almost sculpture. They aren't, in fact, simply flat. By understanding how modern Western culture has regarded dimensionality, it becomes possible to consider a new horizon in art. By *new* I don't mean something entirely new but rather a new awareness of there being a horizon beyond what our concept of art has been till now.

Japanese perspective, for example, is completely different from that of the West. You can see this in *sumi* ink paintings, where you often find depictions of travelers walk-ing. These paintings are based on a method of perspective that essentially plots a map from the traveler's vantage as he moves. Interest is created by showing what lies beyond that vantage: a waterfall, a river, the scenery. You can see this in works like the Genji Monogatari scrolls and landscape paintings.

Sculpture is a tool for contemplating the universe. This can be seen in the work of an artist like [Constantin] Brancusi, whose "endless tower" is a good example. Though this tower actually has a finish-ing point, conceptually you can imagine it going upward to infinity. You can see the attempt of Western sculptors to reach infinity in the creation of planetaria, sacred images, the creation of work with a consciousness of the universe, the attempt to destroy or conquer gravity. And this consciousness remains. I wanted to get rid of this type of idea or at least push it aside. Rather than reaching upward toward the cos-mos, I find more meaning in the idea of spreading sideways or stretching outward.

By confronting these issues, I am trying to reexamine the Western methodologies that I learned in school in an attempt to dis-cover how I should work as an artist. I have been trying to erase, to eliminate the techniques that I have already mastered and to move on to a stage where I can discover

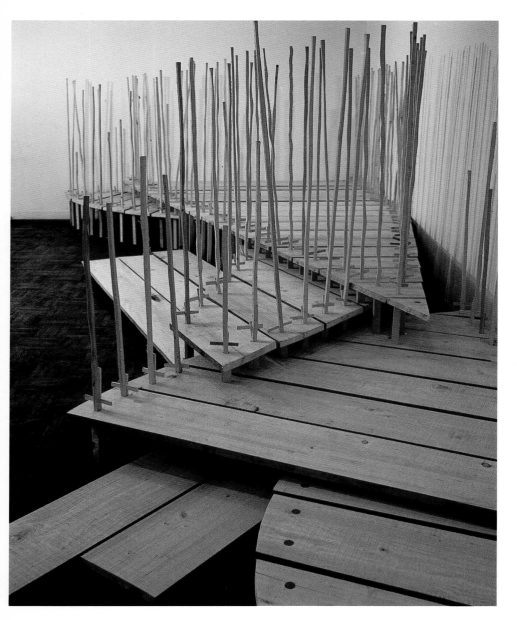

what I really want to think about and create.

I have often been told that my work resembles a traditional garden, but I am not interested in such gardens, and if there is an influence, it is not at all a conscious one. But if it is true that memory could have such a great influence on my hands or my thoughts, then perhaps this can only be described as an influence. The concepts that I am consciously thinking about are most important, and just because my work appears to have a certain form, it doesn't necessarily mean that this is my main concern. Just because [Paul] Cézanne painted an apple, it doesn't mean that he was interested in the apple but rather that the apple was a means for expressing another idea.

I started using wood mainly because it's easy to work with. It is light, and I can handle it on my own. When I was using steel, there were no galleries that were physically able to support my work, so I was limited to working on a small scale. I used to think that any type of wood was fine as long as it was wood. Over the past few years I have become increasingly aware of how great the differences are between various types of wood. Most Japanese artists working today don't think about why they are using a particular material. Without attempting any dialogue with the material, they

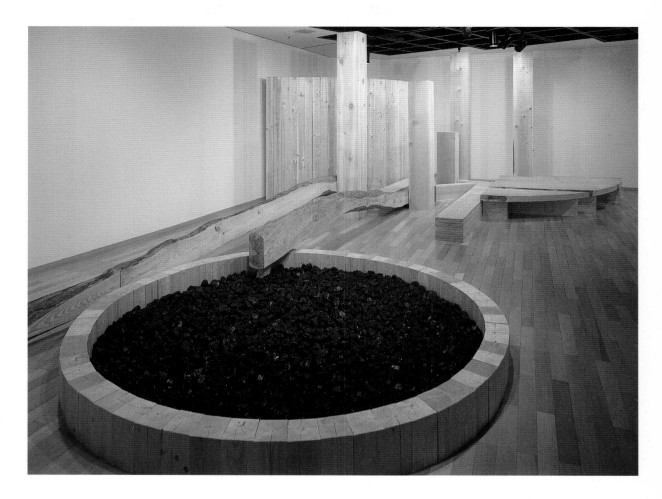

Related Effect S-86GT
Installation view,
Galerie Tokoro, Tokyo
1986
Wood and coal; 250 x 841
x 542 cm (98⅜ x 331 x
213⅜ in.). Collection
Galerie Tokoro, Tokyo.
Photographer:
Tadasu Yamamoto.

Opposite:
Related Effect S-85KO
Installation view, Soo
Gallery, Tae-ku, Korea
1985
Wood and oilclay; 201 x
310 x 900 cm (79⅛ x 122 x
354⅜ in.). Collection
Galerie Tokoro, Tokyo.
Photographer:
Masataka Yamada.

use it because it's available. I feel that it is important to think about and understand the history of a material, how one was taught about it, and how one uses it. It is only at this point that artists can have a true encounter with their materials. I can only use a material when I have stripped away the various levels of meaning and found its original form.

Although I haven't really thought much about whether the wood I work with actually has life [*seimei*], I do think every tree has a character of its own. It is rather like with people—we use the same word to describe all humans, and we are all shaped somewhat alike with eyes, noses, mouths, and intestines. Even so, each individual is

really quite different. Likewise no two trees are ever the same.

Every tree has an inherent, individualized expression that reflects such things as the place where it has lived. And although there is no actual north or south for a tree, if you cut a tree and look at its growth rings, you will see that the tree itself had been ordered in that way. That is part of the tree's personality or character. That specific character is revealed on its surface. This is even true of steel. While steel is always made the same way, steel made in one place is different from steel made in another. When I work with steel, I can see how very different the material can be.

While I am creating a work, it is impor-

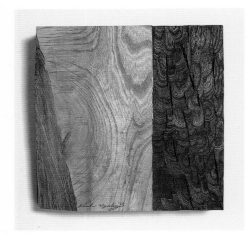

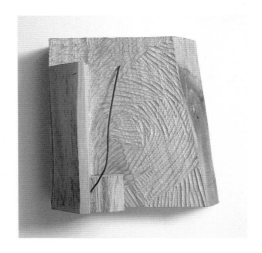

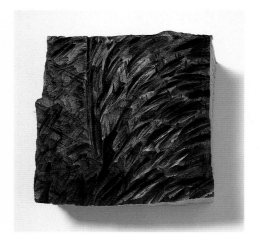

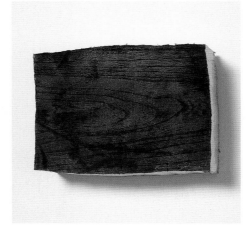

Upper left:
**Related Effect—
Phoneme PCO-5**
1988
Wood and paint; 29.5 x
29.5 x 5 cm (11⅝ x 11⅝ x
2 in.). Collection Galerie
Tokoro, Tokyo. Photographer: Tadasu Yamamoto.

Lower left:
**Related Effect—
Phoneme PCO-11**
1988
Wood; 21.8 x 21.5 x 9.5
cm (8⅝ x 8½ x 3¾ in.).
Collection Galerie
Tokoro, Tokyo. Photographer: Tadasu Yamamoto.

Upper right:
**Related Effect—
Phoneme PCO-1**
1988
Wood and wire; 36.5 x 36
x 12 cm (14⅜ x 14⅛ x 4¾
in.). Collection Galerie
Tokoro, Tokyo. Photographer: Tadasu Yamamoto.

Lower right:
**Related Effect—
Phoneme PCO-8**
1988
Wood and charcoal; 16.7
x 23.9 x 6.3 cm (6⅝ x 9⅜
x 2½ in.). Collection
Galerie Tokoro, Tokyo.
Photographer: Tadasu
Yamamoto.

tant for me to talk and think about this
sort of issue and to look at the material from
various perspectives. This brings about
changes in the work. I don't believe that I
am totally in control of the creation of a
work. If I think about cutting into some
material in a certain way, the material may
end up being harder than I expected, making
it difficult or sometimes even impossible
to cut. The attempt to make such a cut results
from lack of understanding of the material.
If I had made the cut in a different way,
it might have been quite easy. This sort of
thing is not well understood.

There are differences in how woods
tear or crack, how they can be cut or shaven.
There are various terms—carving, digging, hammering, breaking, cutting, tearing,
or splitting—that are established as specific types of expression within an actual
work. I wanted to try to establish a methodology for these forms of expression.

In the beginning I wasn't concerned
with these issues. I was working only with
those types of wood that were normally used
for sculpture and were readily available:
zelkova, magnolia, *katsura*, and oak. While
there are many other types of wood, these
we already know well how to work with. But
if you use another wood, it must be
handled in a completely different way. Some-

Untitled arrangement
of **Related Effect 87-B,
Related Effect 87-C,
Related Effect 87-A**
Installation view, XIX
Bienal Internacional
de São Paulo
1987
Wood; three pieces,
heights 185 cm (72⁷⁄₈ in.),
179.5 cm (70⁵⁄₈ in.), 215
cm (84⁵⁄₈ in.); each width
and depth 24 x 24 cm (9¹⁄₂
x 9¹⁄₂ in.). Collection
Galerie Tokoro, Tokyo.
Photographer:
Tadasu Yamamoto.

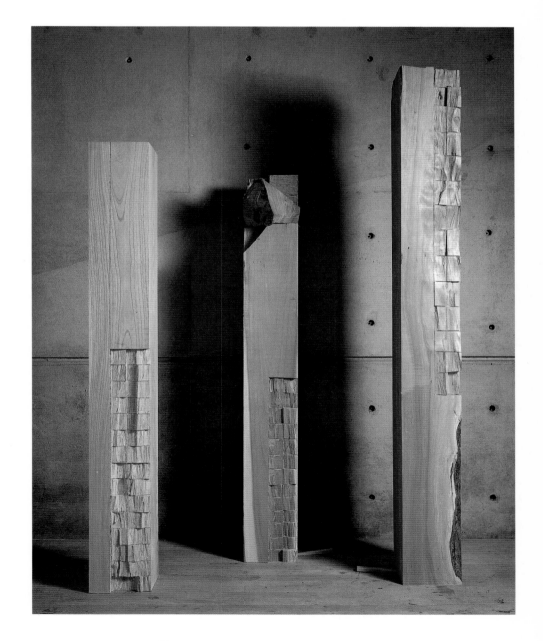

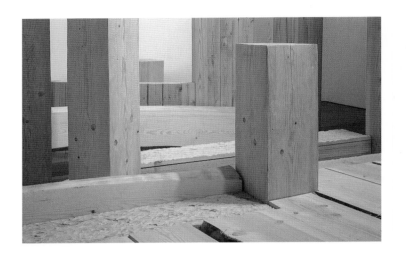

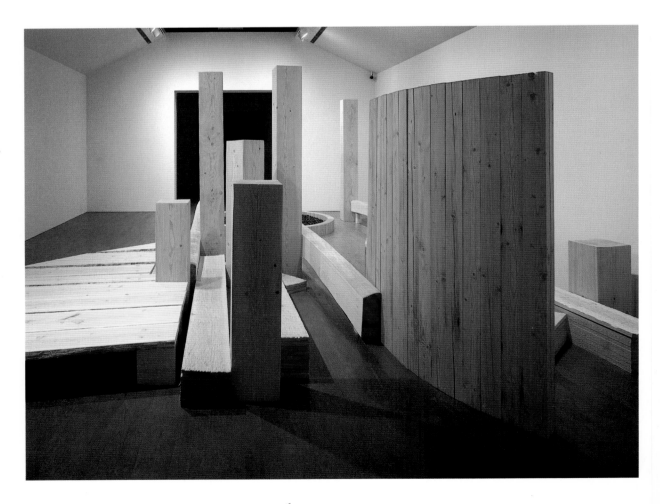

46

times, for example, a type of wood is much harder than I expect, and the tool I normally use for carving may suddenly break.

Working like this, I have gradually come to understand more about the different types of wood. In general we think of a material as something that has been used or something that simply exists for possible use. But once artists began to think that anything could become a material, then all materials became mere "things." This is close to what the Mono-ha group was doing. Their use of the word *mono* (things) allowed them to use freely various materials, or things, in their work. Yet because they were able to use so many different things, they didn't, in fact, place much importance on the actual materials. I think it is unfortunate that there are so many artists working now who have a similar attitude. While this also applies to Western artists, I feel that Japanese artists are no longer really aware of their materials. Since the Renaissance, artists have been more concerned with expressing their egos, while an awareness of their materials has virtually disappeared.

In my work I don't try to make an impressive expression but rather to achieve an almost nonexpressive form of expression. Step by step I try to veil my actions thinly, to immerse myself in the work.

Otherwise it is too easy for viewers to categorize my work quickly without any consideration for what my actual intentions were. I also want the viewers to "create" the work, to look at it and think about how they might change something or how they might do something differently. Only then is the work finally completed. Of course, that is what art is: until viewed, it is just an object. When it is seen, then it becomes for the first time a work of art.

■

Related Effect S-90LA
Installation view and detail, Hara Museum ARC, Gunma Prefecture 1990
Wood and coal; 255 x 623 x 770 cm (100⅜ x 245¼ x 303⅛ in.). Collection Galerie Tokoro, Tokyo. Photographer: Tadasu Yamamoto.

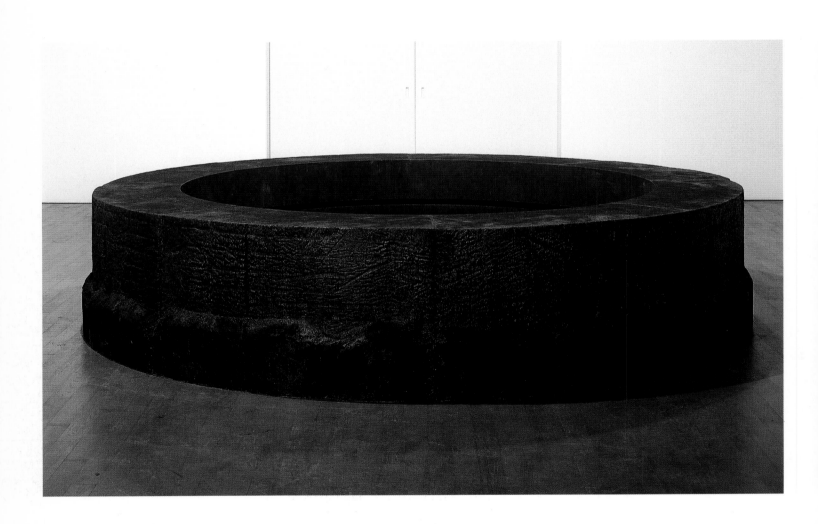

Toshikatsu Endo

My desire to work as an artist began from a certain sense of absence, a feeling of something lacking. I had an urge to fill in that missing part. I think everyone has this sensation—we all share the feeling—so when I succeed in putting a form to the image in my mind, I have for a fleeting moment the illusion of complementing, of compensating for, that absence. But, of course, I can never really fill in the missing part, so I must continue to create my works.

My works are not markedly individual in appearance. They are not the result of a desire to express my individuality. Rather I feel that they are something more universal. Of course, there is an implicit contradiction in this statement, but at least it applies on a conceptual level. I don't arrange my works by using any special, individualistic methods of formation. Most of my works are simple forms like circles.

A perfect circle goes beyond the level of symbolic imagery. It is the simplest and most primordial form. Circles appear at the most festive and ritualistic occasions as well as at holy places. I have often said that while a circle spreads horizontally in form, it extends vertically in meaning. Thrusting forth from the very base of the earth toward the sky, a circle is like a magnetic field. It is within this context that I create circles. Although at one time I thought about this in terms of symbolism and allegory, I am not so conscious of these aspects at the present time. Even so, my work could still be interpreted in this way.

From minimal art I learned about removing superfluous elements. The removal of unnecessary elements makes a given form more powerful. The idea of removing everything is also part of Zen thought. Zen Buddhist concepts permeate Japanese culture, and Zen Buddhism has had a significant influence on my ideas. After everything is removed, only the absolute remains. This principle is significant on the level of technique as well as providing a method for refining various concepts. I feel that this is very important. I did not adopt minimalism or conceptualism as a style, however, which is why my works are said to be romantic. It could be said that I am discussing literary matters, such as life and death, but these are important in the context of my reality. And however romantic that may be, it is only from that point that my works can be created.

You need a single message, but that message should have a wide range of interpretations. The most fundamental issue for human beings is life and death. It is the very existence of human beings, human

Lotus
Installation view,
Hara Museum ARC,
Gunma Prefecture
1989
Earth, air, sun, water,
fire, and wood; 75 x
diameter 360 cm (29½ x
141¾ in.). Collection
Hara Museum of
Contemporary Art.
Photographer:
Tadasu Yamamoto.

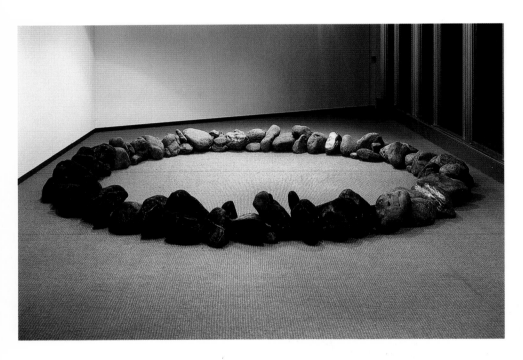

Untitled
Installation view, "Art
Today 1987," Museum of
Modern Art, Seibu
Takanawa, Karuizawa
1987
Stone, bronze, and fire;
50 x diameter 350 cm
(19⅝ x 137¾ in.).
Collection of the artist.
Photographer:
Tadasu Yamamoto.

existence, that I want to express in my work.

Among all living things only human
beings have a perception of death. Animals
avoid death instinctively, but they do not
have a sense of fear that originates from the
power of imagination. Human beings
can imagine death, their own deaths, and
from the power of imagination fear and anx-
iety are born. The deaths of those around
us threaten our existence. So we the threat-
ened, we the survivors, must resolve
this problem. We cannot live in a continual
state of anxiety, so within the grave we
must find a stable form to conceal ourselves,
conceal the fear. The burial of the dead
and the ceremonies that accompany it are like
the artworks of a community, of a people.

Anyone could make works like mine; they
are just drawings of circles. Anyone can draw
a perfect circle. Though on a superficial
level there may be differences in the art of
different individuals, if we dig deeper, at the
bottom we find something in common.
We can get to a point where we can identify
that particular form, show it, and say,
"This is my work," but it can also be your
work. That's the kind of work I want
to create. It is as though I am making the
work because no one else is making it.
Picasso's paintings could only have been
created by Picasso. That is because his works
display such distinct individuality. My
works do not show individuality in the sense
that Picasso's do.

The act of making these works has some-
thing to do with complementing the sense
of absence I referred to earlier. That is, they
may originate from personal circum-
stances, but I'm not creating them because of
my personal circumstances. The act of
putting the collective desire of the commu-
nity into concrete form happens to
coincide with my personal desire.

I am not interested in the formal aspects
of a work. What I want to create is a
place. We tend to think of places, or sites,
as the undifferentiated areas that spread out
around us, but when I say that I want to

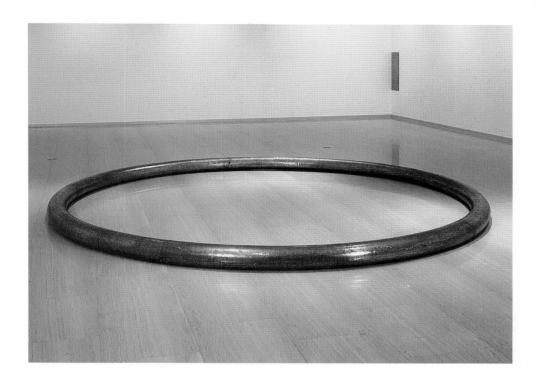

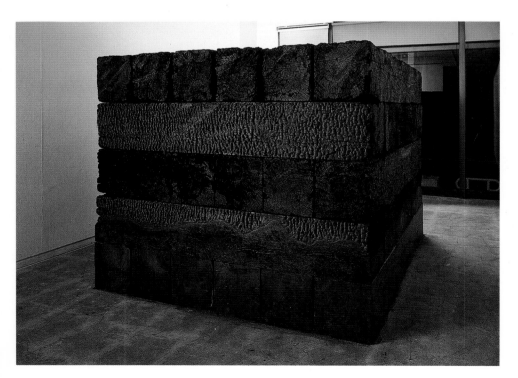

Epitaph
Installation, Gallery Yo,
Tokyo
1986
Wood, tar, water (inside),
and fire; 150 x 185 x 185
cm (59 x 72⅞ x 72⅞ in.).
Gallery Defet, Nuremberg.
Photographer:
Tadasu Yamamoto.

Above:
Untitled
1987
Bronze; 17 x diameter 400
cm (6¾ x 157½ in.).
Collection of the artist.
Photographer:
Tadasu Yamamoto.

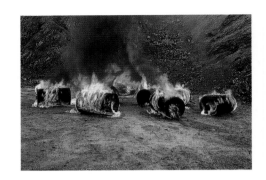

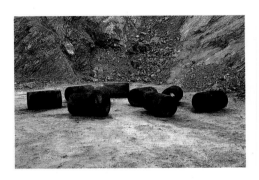

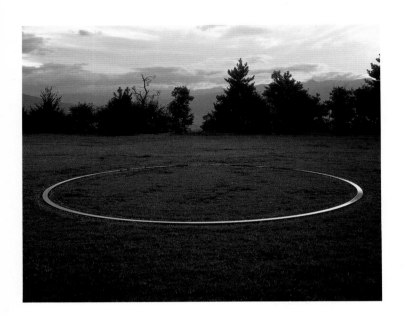

Above and opposite:
Fountain
1989
Earth, air, sun, wood, tar,
and fire; nine pieces, each
130 x diameter 75 cm
(51⅛ x 29½ in.).
Collection of the artist.
Photographer:
Mitsuhiko Suzuki.

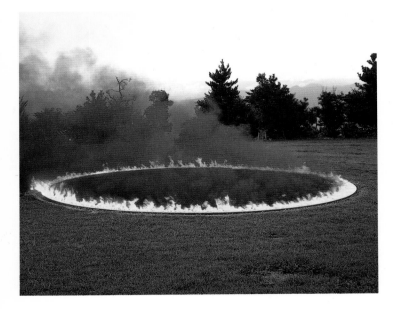

Untitled
Installation views,
Triennial Exhibition of
Contemporary Sculpture
'87, Shibukawa City
General Park, Gunma
Prefecture
1987
Earth, air, sun, and fire;
diameter 800 cm (315 in.).
Collection of the artist.
Photographer:
Tadasu Yamamoto.

Toshikatsu Endo

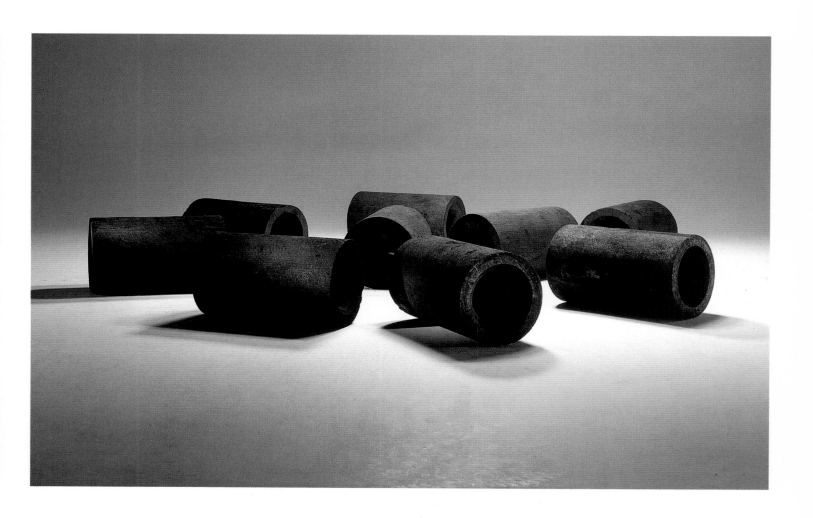

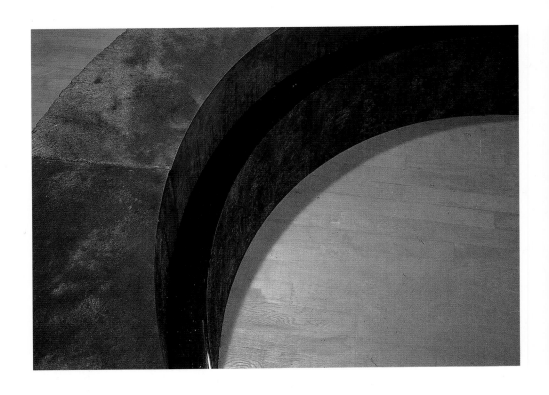

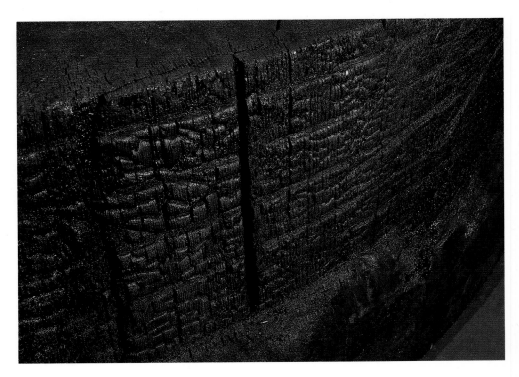

Lotus
Installation views
(details), Hara Museum
ARC, Gunma Prefecture
1989
Earth, air, sun, water,
fire, and wood; 75 x
diameter 360 cm (29½ x
141¾ in.). Collection
Hara Museum of
Contemporary Art.
Photographer:
Tadasu Yamamoto.

create a place, I mean one that is very dense. Every people, every community, has its own place, and it is from their common stories that its density is generated. When a place becomes dense, a vertical light appears on that spot. This may be a rather difficult concept, but it is the image I have.

Mono-ha, with its concept of the existence of materials as a matter of consequence, was something of an influence on me. Although my idea of substance is not as simple as that of Mono-ha, from their approach I learned to deal with substances as more than mere materials.

I am not sure whether my use of wood has any particular meaning. More important than the actual use of wood as a material are the methods used to create forms from primordial substances. In order to create those forms I use wood. At the same time I can't say what I could use instead of wood, so I suppose that the forms I am making now require wood. I never think about bringing out the life in wood, rather I use it as a substance to its fullest extent, and in the end I often burn my works to complete them. I think of this final burning as a form of burial, marking the completion of a work. It is as though I'm holding funerals all the time. Burning the wood feels cruel, like burning a sacrifice. It is a somewhat

sadistic act, but at the same time a holy one.

When I work with fire or water, I see them not simply as materials but as part of a phenomenon, and that phenomenon itself is the object of my works. I am not making some form, creating some figure, through the use of fire; fire as a phenomenon itself is what I'm interested in.

My criticism of the Mono-ha movement is that while Mono-ha artists claimed to strip away the superfluous, day-to-day meanings from substances, thereby allowing these substances to appear exclusively as phenomena, in reality this is simply not possible. We cannot apprehend something without attaching a meaning to it. We conceive of things by giving them names. For example, *soil* and *stone*. We cannot conceive of soil or stone unless we use these names. However hard you may try to remove the extra meanings, inevitably some meanings remain attached. There is no fire or water that exists as a phenomenon in the pure sense: there are images of fire and images of water that have been produced by humanity. Humankind actualizes reality by speaking about it, and thus develop the gaps between what is seen by different cultures. I learned this paradox from Mono-ha.

■

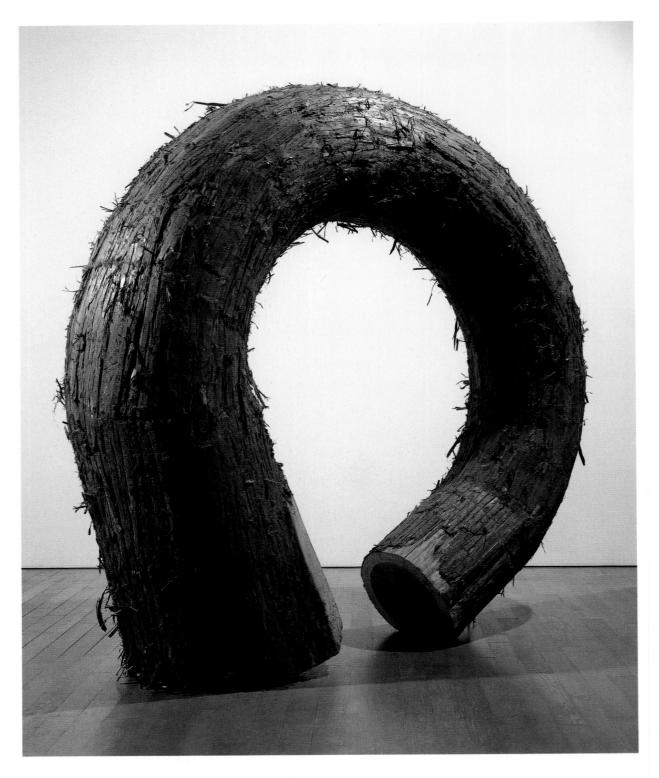

Chuichi Fujii

My family—my father and grandfather—were sculptors who made their living carving wood. I grew up surrounded by pieces of wood, so it has always been a very familiar material. I began working with wood when I was about twenty years old, but when plastics came into use as an artist's medium some thirty years ago, wood suddenly felt old-fashioned. The introduction of plastics seemed to signal the start of a new age of great possibilities in contemporary art. I immediately started to work with this new material. Later I moved on to work with steel and glass.

After more than ten years of working with such materials, I began to feel that my work had lost its meaning, so I decided to start over. I was about thirty-three or thirty-four at the time. I began working with wood once more. Returning to it after ten years, it suddenly seemed very refreshing, as though the wood I was using was different from that which I had used in the past. Starting over, I thought about what form was most basic to wood and decided to begin working with solid logs.

I didn't intend originally to create the bent-wood forms that I make now. Actually I started out by cutting into the wood, even though I had doubts as to whether or not work made in this way could really be

considered art. For an artist, cutting wood usually implies having it sawn, but I made my own tools—the wedges and steel hammers—and the wood was cut through actions of my own. I worked in a very considered way, gradually increasing the depth of the cuts, cutting into the wood as deeply as possible without actually cutting it in half. I had been seeking a means of expressing the life force of the wood, and it was this form that naturally emerged.

More than the actual process of working, for me the greatest point of tension is the search for the wood itself. Although some people view wood in generic terms, it is a living thing, and no two pieces are identical. So while each moment of the entire process is important, the most significant moment is when I encounter the raw wood that will become my material. I am not greatly concerned with color or other such "artistic" issues.

I suppose my work involves a certain level of confrontation with nature. You can see this in the type of wood that I choose. I don't use pine, for example, because pine trees grow naturally bent. If I did use pine, I would want to make it straight. But with a vigorous cedar or cypress the degree of tension in a work will depend on how strenuously I manipulate the

Untitled
Installation view,
Hara Museum ARC,
Gunma Prefecture
1990
Cedar; 230 x 230 x 80 cm
(90½ x 90½ x 31½ in.).
Collection of the artist.
Photographer:
Tadasu Yamamoto.

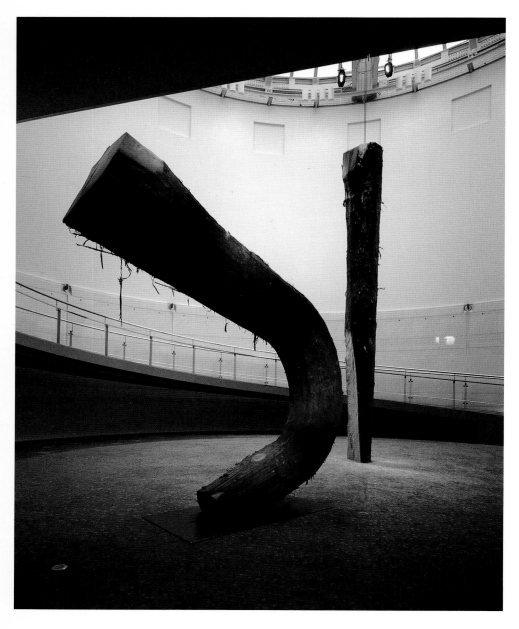

Untitled
Installation view, Spiral
Garden, Tokyo
1989
Cedar; two pieces, curved
piece: 370 x 350 x
diameter 90 cm (145⅝ x
137⅞ x 35⅜ in.); straight
piece: 500 x diameter
80 cm (196⅞ x 31½ in.).

Collection of the artist.
Photo courtesy of Gallery
Ueda, Tokyo.

material. I am trying to create a sense of
tension, and that is a major factor in my
choice of materials.

I search for my wood at timber auctions
alongside the old men from lumberyards.
Whether I acquire a particular piece of wood
or not is usually decided in about thirty
seconds. If I hesitate, unable to make a deci-

sion, the wood will go to someone else.

I can start working only when I have
come to terms with the material, after that
initial moment of encounter. When a
work is completed, I generally feel that the
wood has responded and that the work
is close to what I originally intended. While
some people perhaps see my work as
being very "natural," in the past I have
basically turned the trees I use upside down.
In a sense, this is in complete opposition
to nature.

Up to now I have basically tried to push
to the very limit the work's balancing
contact point with the floor. So while each
work takes form over several months of
my working and gradually finding a response
in the wood, in the end I will want to
make it more completely my own expression.
At this point, in an instant I will cut the
wood with a chain saw, making the final, de-
cisive cut that determines how the work
will stand. In a mere instant the work will
be completed.

This is a spectacular moment: if there
have been no errors in calculation, the work
will stand. If I were to use a manual saw,
it could take two hours, and during that time
various issues might arise and I might
become indecisive. But with a chain saw the
cut is made in the space of about three

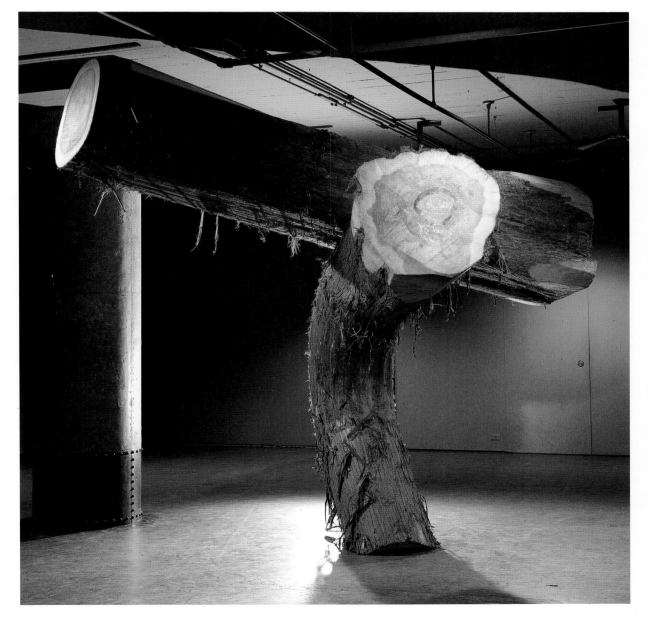

Untitled
1987
Cedar; 320 x 400 x 350
cm (126 x 157½ x 137¾
in.). Collection Otsuka
Pharmaceutical Company,
Ltd. Photo courtesy of
Gallery Ueda, Tokyo.

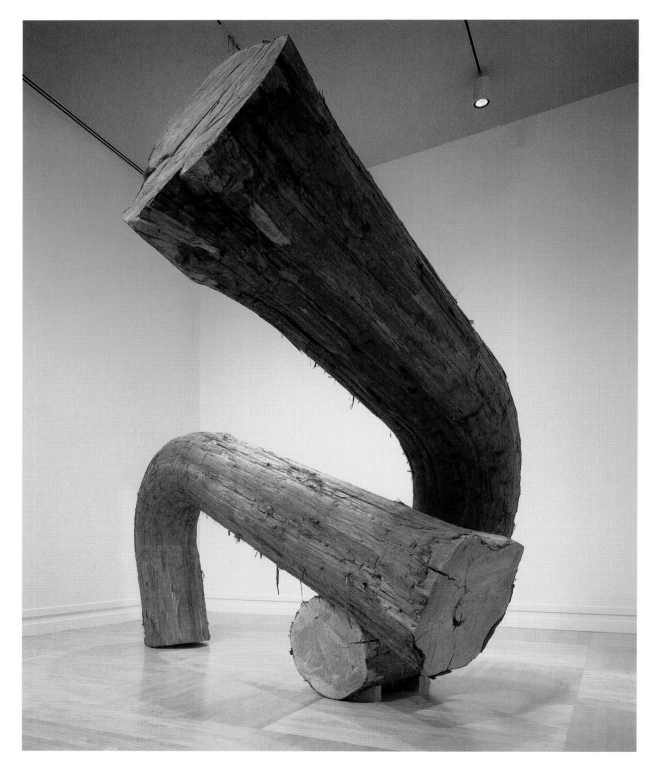

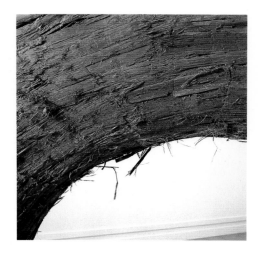

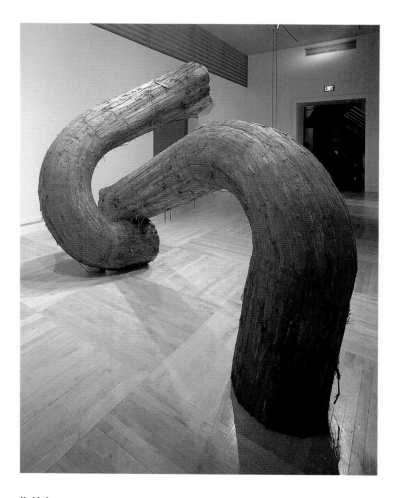

Untitled
1985
Cypress; 300 x 370 x 290
cm (118 x 145³/₄ x 114¹/₄
in.). Los Angeles County
Museum of Art, anon-
ymous gift (M.86.288).
Photographer: Steve
Oliver.

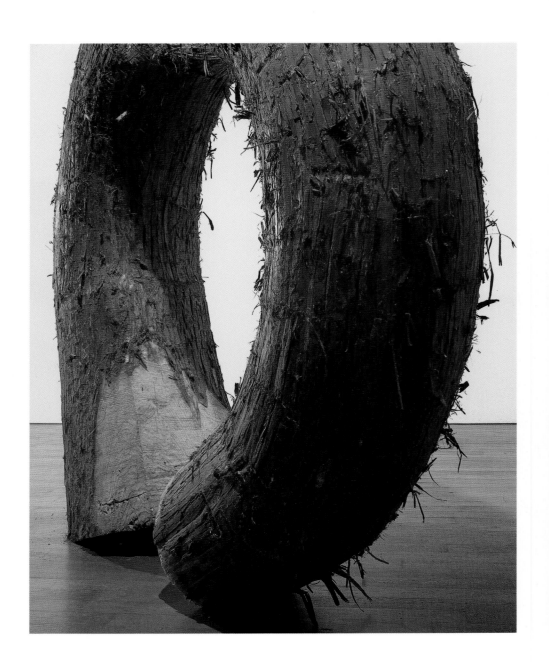

minutes. I find this thrilling.

If the work isn't right, at that point I give up. I won't go back and try a second or third time. If the first try is not decisive, the work loses its tension. I must cut the tree when I have reached that moment of encounter with the wood.

I think that traditional Japanese culture is quite impressive, but my own work, my own form of expression, has not emerged from there. It has a completely different basis, and although my work may appear to have some relationship with traditional arts, I am completely unconscious of it. *Artforum* published an article that described my work as showing a relationship with the sacred wood of Ise Shrine, but I have never said anything like that.

Without saying that we are American or Japanese, we carry our cultures within us, and that emerges in a work. Without being conscious of it, culture just naturally is an influence. I don't like it when artists use their culture as a selling point, and I don't like art that is based on images of Mount Fuji or geisha. Although my work may have a certain influence from Japanese traditional culture or Buddhism, I don't want this to become a major issue.

By separating myself somewhat from the center of contemporary society—I live in Nara, and my surroundings are completely traditional—it becomes easier to see what is important. By moving a little bit away from the center, I can communicate more clearly what I want to say.

Every Japanese has had the experience of sensing on a deep physical level [literally, "with their skin"] the fragrance of a tree. Without saying it, the Japanese understand that a tree has warmth; I believe it breathes air, it cries. At times I feel that nothing is more beautiful than a standing, living tree, but I continue working with wood because there is something that I want to express. As humans we have a basic desire to do something—this could be a conscious, deliberated act—and without this we cannot continue to live.

■

Untitled (detail)
Installation view,
Hara Museum ARC,
Gunma Prefecture
1990
Cedar; 230 x 230 x 80 cm
(90½ x 90½ x 31½ in.).
Collection of the artist.
Photographer:
Tadasu Yamamoto.

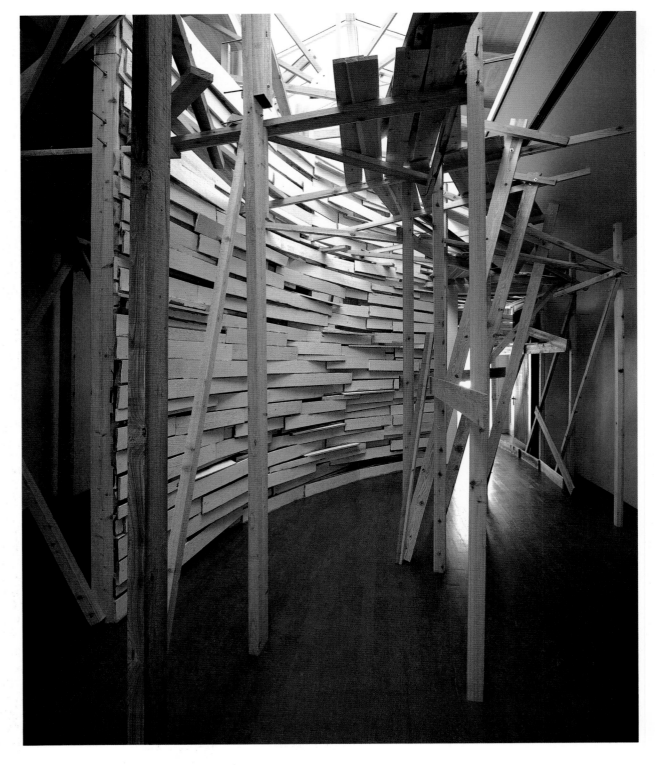

Tadashi Kawamata

Primal Project
Installation view
(interior), Hara Museum
ARC, Gunma Prefecture
1990
Wood and paint; indoor
section: 600 x 1,065 x 675
cm (236¼ x 419¼ x 265¾
in.); outdoor section:
520 x 1,900 x 360 cm
(204¾ x 748 x 141¾ in.).
Collection of the artist.
Photographer:
Tadasu Yamamoto.
This work was made
possible by a grant from
the Lannan Foundation.

I studied oil painting in college, but one day I realized that I wasn't interested in painting so much as the places where people paint—their ateliers and studios—that I was really more interested in arranging space. I began making walls and floors, spaces where art has been taken away. At first I did this in galleries and studios, but gradually the creation of installations with walls and floors inside galleries began to seen inconclusive and artificial. If you let your hand follow along the real walls of a gallery, eventually you will end up on the outside wall of the building. I began to think that the walls I made could also be continued: so from the inside of the gallery they could go to the entrance and from there outside to the external walls and then to the walls of the surrounding buildings. The space between the buildings could then become a space from which the work continued. Everything comes out from the inside; it is all connected. The gallery walls are connected to the exterior walls; the building walls are in a sense the location's inside walls; the location is part of a town; the town is part of the country. And so the circle widens. There is no limit.

My intention is not really to wrap something up. It is rather to extend the inside to the outside, to expand, to intervene. As I started working outside, the audience changed from art-world people to ordinary people, passersby, with no connections to the art world. What I had thought about as art began to take on a more social dimension. Communication with people living in the places where I work becomes the real purpose of work like mine. Obstacles such as laws, city codes and restrictions, forced me to consider things that had previously been outside my concerns. The extension of a work to the outside becomes a point of contact between what is private and what is public. I work in this point of contact: the site itself is public, but my working there can be seen as private or public. Making and showing, private and public, art or not art, sculpture or architecture: these contrasting qualities are introduced as the work extends outside.

From very early on it hasn't been possible for me to work alone, and sometimes I find this frustrating. Still I enjoy working with different people. Various opinions are expressed, things change, even as I explain my plans for carrying out a project. The work no longer depends upon my intuition. It becomes separated from the sense of being my sole creation. When I am working on a project, I use assistants from the area who know the character of the place. Still there are times when I don't understand

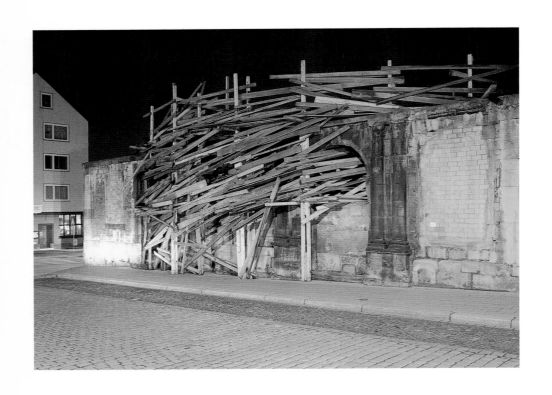

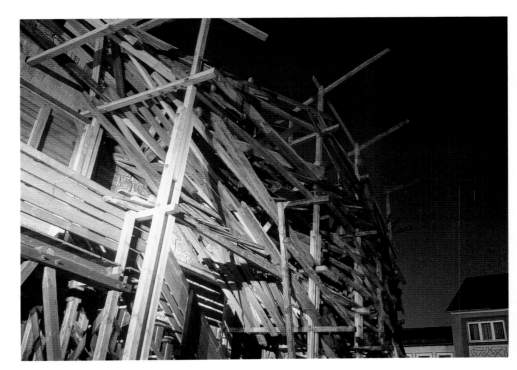

Destroyed Church
Installation view and
detail, "Documenta 8,"
Kassel, West Germany
1987
New lumber, scrap wood,
paint, bolts, and nails;
1,200 x 1,000 x 2,400 cm
(472½ x 393¾ x 944⅞
in.). Photo courtesy of
On the Table, Tokyo;
© Leo van der Kleiji.

the identity of a place or its people even
after a project has been completed.

I try to be "submissive" to the materials
that a site possesses. I use the space of a
building or materials relating to the building,
or I break up the interior of a building and
bring the scraps outside, or I build something
architectural out of architectural materials
(which doesn't necessarily mean that I am
making architecture). By using materials
in this way, my work becomes assimilated
with that from which the materials originate.
This is a very important part of the con-
cept underlying my work: the relationship
is parasitic.

I once said in an interview that my con-
cept of materials can be compared with
cancer. We all have cancer cells in our bodies.
The difference is whether the cancer is
benign or becomes malignant. If it is malign,
the cells change. This can be related to
my work. The various systems and rhythms
within a city spread naturally, conta-
giously, and create the overall organization
of the city. This organization derives from
the town itself, not from the outside, yet
the system suddenly mutates. Similarly mate-
rial salvaged from a building is equal to the
material from which the building is con-
structed. By using the salvage, I am making a
different organization within an already

existing organization. This organization
mutates, transfers to other sites, and multi-
plies. My work can be called a cancerous or
parasitic organization within an organization.

I use the same wooden material all the
time because I don't want to think about ma-
terials. It is easier to avoid being conscious
of materials when they aren't changed
so often. The main object then becomes *how*
to use that material. Artists who use
various materials are the ones concerned with
materials. I don't subscribe to the notion
[that the Japanese value the inherent spiritual
qualities of wood]. Artists in other coun-
tries use wood. I think it is rather farfetched
to assume that the use of wood in Japa-
nese art is equivalent to animism. That there
is a Japanese quality in Japanese art is
something that countries other than Japan
have invented. In any case, I don't think
Japanese [artists] have made anything with
a "Japanese quality."

There is no need to talk about na-
tionality in Japan. Foreigners often depend
on unusual interpretations in order to find
something "Japanese." There is a ten-
dency among Japanese artists working abroad
to create something japonesque just so that
foreigners can identify those works as
Japanese. That is very boring. I like the reac-
tion in New York. It is a melting pot, so

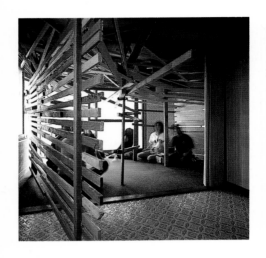
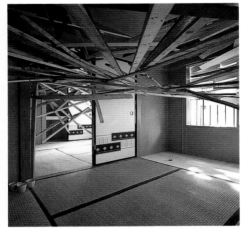

"Tetra House N-3 W-26"
Apartment Project
Installation views,
Sapporo
1983
Scrap wood, paint, bolts,
and nails. Photo courtesy
of On the Table, Tokyo;
© Shigeo Anzai.

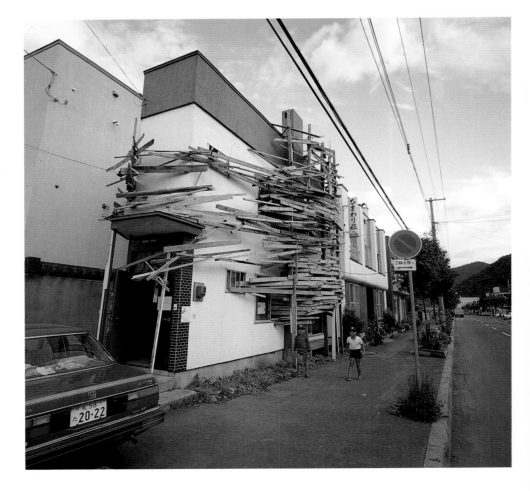

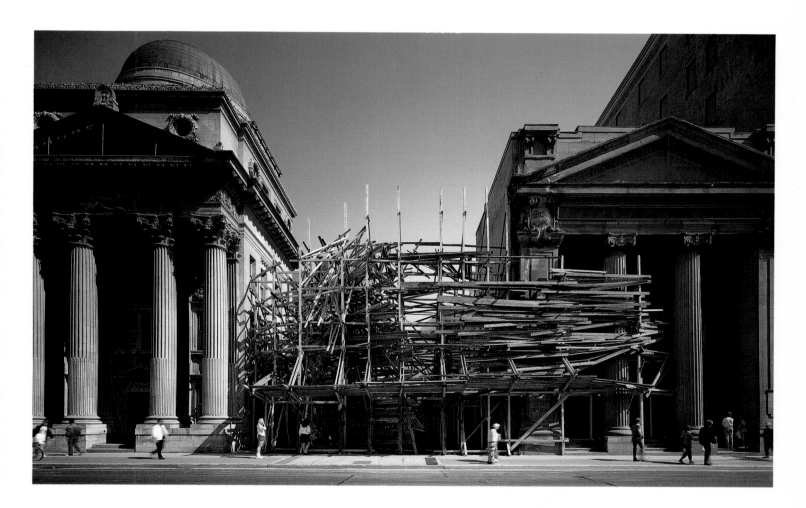

Project at Colonial Tavern Park

Installation view, Toronto 1989
New lumber, used wood, bolts, and nails; 1,829 x 1,372 x 3,200 cm (720 x 540 x 1,260 in.). Photo courtesy of On the Table, Tokyo; © On the Table, Tokyo, and Mercer Union, Toronto; photographer: Peter McCallum.

Primal Project
Installation views
(interior and exterior),
Hara Museum ARC,
Gunma Prefecture
1990
Wood and paint; indoor
section: 600 x 1,065 x 675
cm (236¼ x 419¼ x 265¾
in); outdoor section:
520 x 1,900 x 360 cm
(204¾ x 748 x 141¾ in.).
Collection of the artist.
Photographer:
Tadasu Yamamoto.
This work was made
possible by a grant from
the Lannan Foundation.

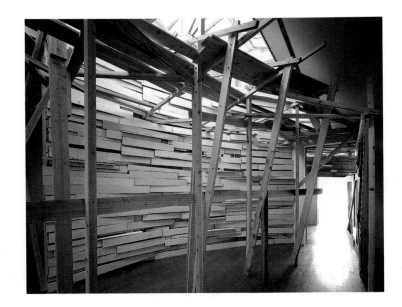

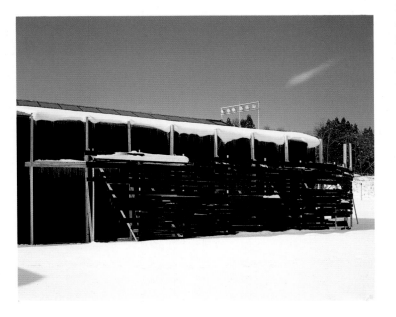

I don't get identified as Japanese; I am accepted as an artist.

Tokyo is constantly changing, but this is not surprising, and there is no harm done. Contemporary art is also changing in this current. Installation art is born from these constant changes. It has emerged from the system of rental galleries. It's the reality of working in the city. Sculpture, in a certain sense, is a reaction to installation. There is no history of sculpture in Japan. Sculpture developed recently from the desire of artists to create something more permanent than installation.

The difference between sculpture and installation is time. While sculpture is conscious of permanence, the creation of an installation work is based on its eventual destruction. This temporariness is "real time"; installations are made in real time. I want to concentrate on temporariness, not permanence. What I can make is what I can do right now. I am not terribly interested in what happens next.

■

Primal Project
Installation view
(exterior), Hara Museum
ARC, Gunma Prefecture
1990
Wood and paint; indoor
section: 600 x 1,065 x 675
cm (236¼ x 419¼ x 265¾
in.) ; outdoor section:
520 x 1,900 x 360 cm
(204¾ x 748 x 141¾ in.).
Collection of the artist.
Photographer:
Tadasu Yamamoto.
This work was made
possible by a grant from
the Lannan Foundation.

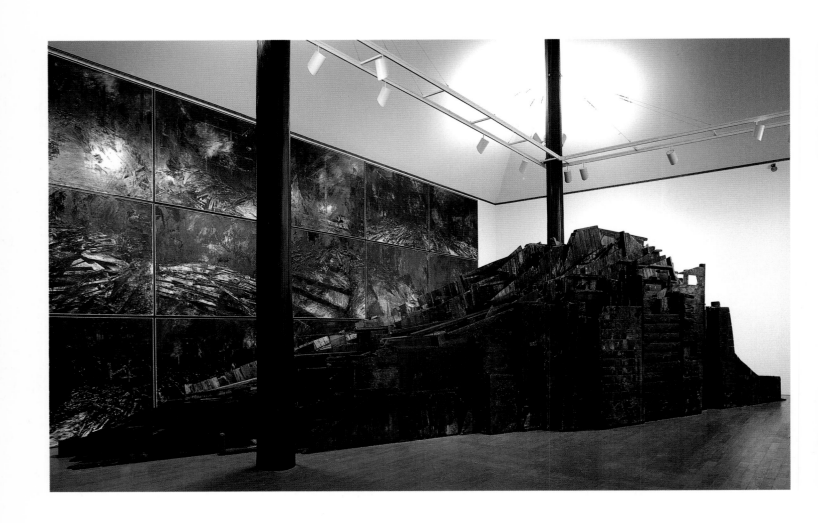

Kazuo Kenmochi

My reason for using natural materials like wood involves the issue of how things decay, the issue of time. Humans grow old, and wood, like humans, deteriorates and decays. When I was a child, I lived close to the sea and made things from sand: mountains, pyramids, and Mount Fuji. When you create something from sand, your creation is being destroyed while still in the process of creation. No matter how much you continue to build something, the wind keeps breaking it down, and it continues to crumble. Rather than making a perfect pyramid, I am more attracted to a work that shows such gradual changes. When you create something from stone or stainless steel, it will continue to exist even after you have died. It would probably remain for generations to come unless it were destroyed by man.

Sculptures, for example, are installed in front of train stations or in parks, and despite long exposure to wind and rain, the works remain shiny and new-looking. This is perhaps what the artist intended, but I can't help questioning the validity of this intention. I doubt that I could ever create something like that or that I would ever want to. I cannot defeat nature, and I am not even sure that I would dare to challenge it. I don't care if a work of mine is destroyed by the wind or rots in the rain.

I use old wood because, deep within, it carries memories of the past. There are artists who use driftwood and who probably wonder where the wood they are using came from, about how a tree perhaps fell into a river and was carried away by the current. I don't use that type of wood, but while I sometimes think about where the wood I use did come from, I don't want to be too concerned with this.

I am using the type of wood that is used on construction sites. It is wood that is a waste product of the city. So rather than being like branches or wood straight out of a natural setting, it is wood that is related to the urban environment. I use coal tar because of its smell and because it is inexpensive, although that is not so important. I don't really like the smell, but it is the smell of the sea where I was born. It reminds me of the small boats that I used to ride in or old tin roofs. I have borrowed that smell from my childhood. It connects with the sea, with nature. It is also a very aggressive smell.

The materials that I use are those that would normally end up being burned or used as fuel. It sounds strange when put into words, but it as though I am picking this wood up at the final stage in its cycle, and by

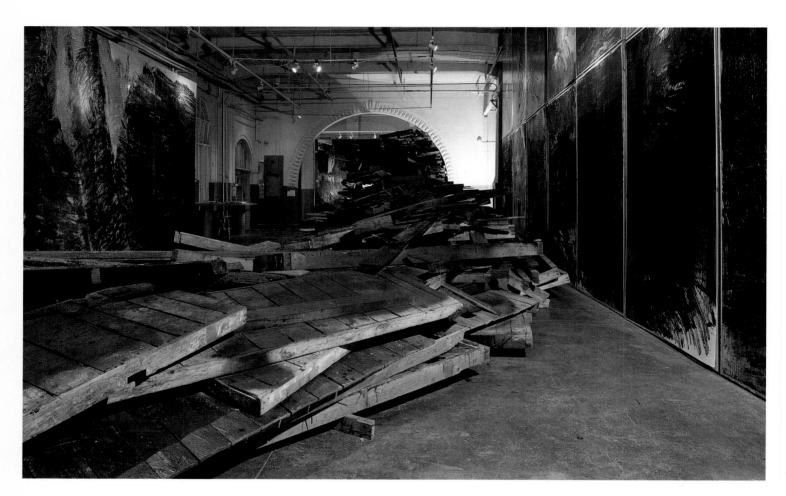

Untitled
Installation view, Sagacho
Exhibit Space, Tokyo
1986
Wood, coal tar, creosote,
and drawings (oil on
photographs); 380 x 2,205
x 506 cm (149⅝ x 868½ x
199¼ in.); drawings:
range of sizes 365 x 452

cm (143¾ x 178 in.) to
453 x 1,004 cm (178⅜ x
395¼ in.). Several
drawings: private
collection, Japan. Photo
courtesy of the artist;
photographer: Masaru
Okazaki.

Opposite:
Untitled
Installation view, Sagacho
Exhibit Space, Tokyo
1989
Wood, coal tar, creosote,
and drawings (oil on
photographs); 130 x 1,810
x 560 cm (51⅛ x 712⅝ x
220½ in.); drawings: range
of sizes 364 x 370 cm

(143¼ x 145⅝ in.) to 438
x 1,110 cm (172½ x 437
in.). Photo courtesy of
Sagacho Exhibit Space;
photographer: Masayuki
Hayashi.

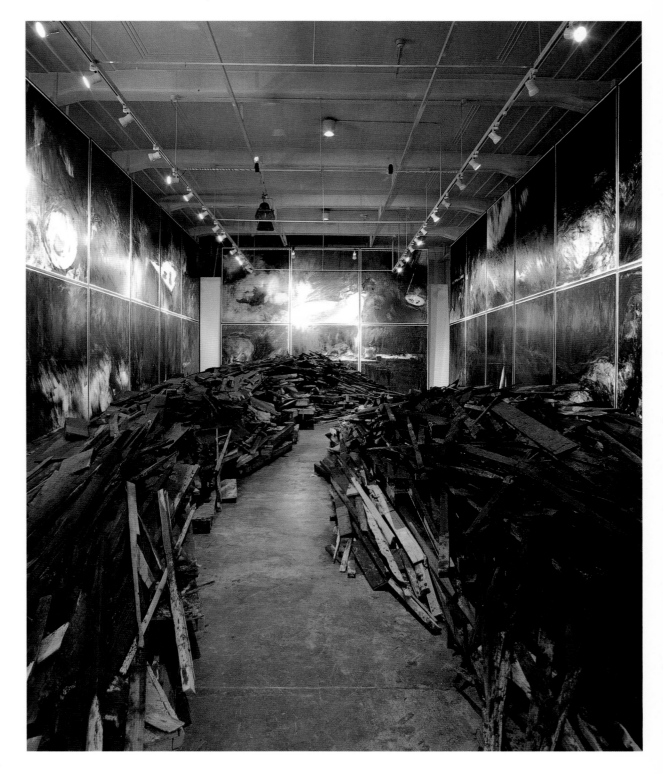

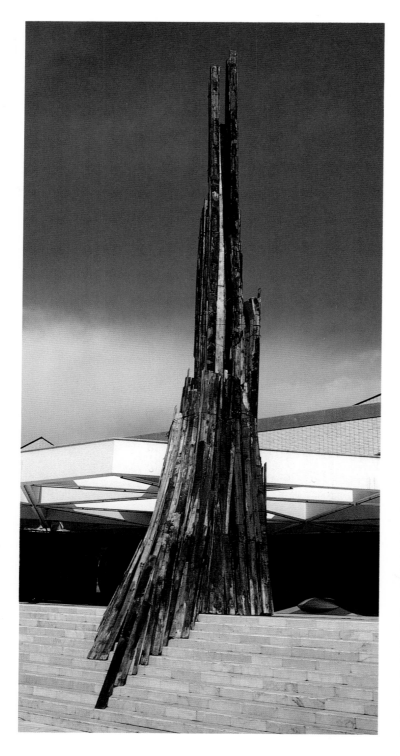

Tail of Earth
Installation view, "Art Document '87," Tochigi Prefectural Museum of Fine Arts, Utsunomiya 1987
Wood; 1,700 x 300 x 200 cm (669¼ x 118⅛ x 78¾ in.). Photo © Shigeo Anzai.

using it in my work, I allow it to stand on a stage once more.

I am not trying to create forms that are in any way symbolic, although I guess they might turn out that way. And although people talk about my "towers," if I intended to create towers, I would calculate more carefully and try from the beginning to form in my mind an idea of this symbolic form. Then I could make a drawing and work from there. But this is not how I work. Imagination is more important: the wondering what would happen if a work reached a certain height, for instance. Would it be dangerous?

When I am working, I try to imagine how far I could go, and my imagination just keeps growing. I might be working on something that has a boatlike shape, which keeps gradually getting larger and larger.

I start out with a very rough plan and try to work from that. But as I work along, things just start to happen by chance, or there are problems and things just don't work out as originally planned. I prefer to start a project without clearly knowing what I am going to create and then at the site itself experience the creation of the work as it develops through the relationship of the materials and my self.

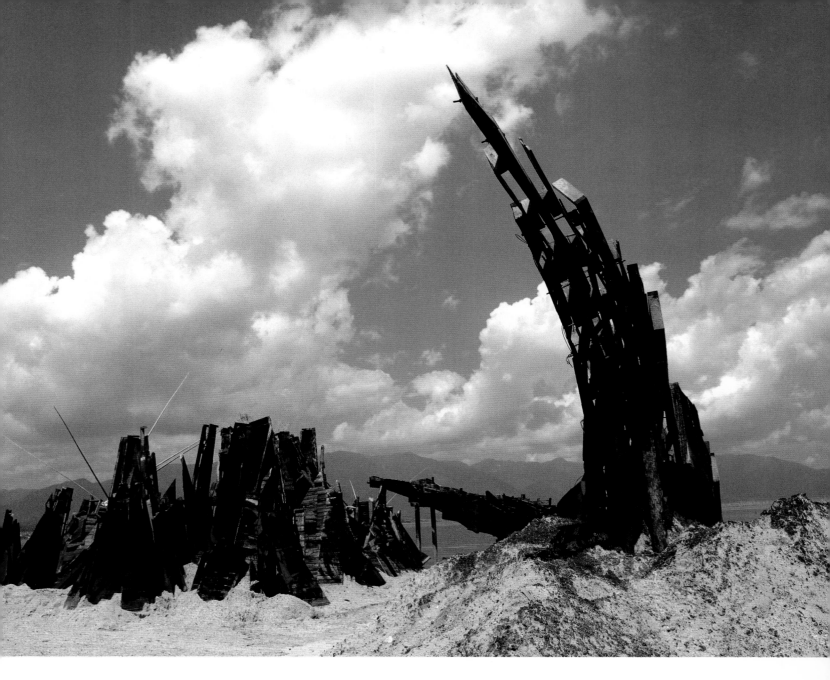

Sculpture Plan
Installation view, Lake
Biwa Contemporary
Sculpture Exhibition,
Moriyama, Shiga
Prefecture
1984
Wood and coal tar;
approximately 450 x
3,000 x 2,000 cm (177⅛ x
1,181⅛ x 787⅜ in.). Photo
courtesy of the artist.

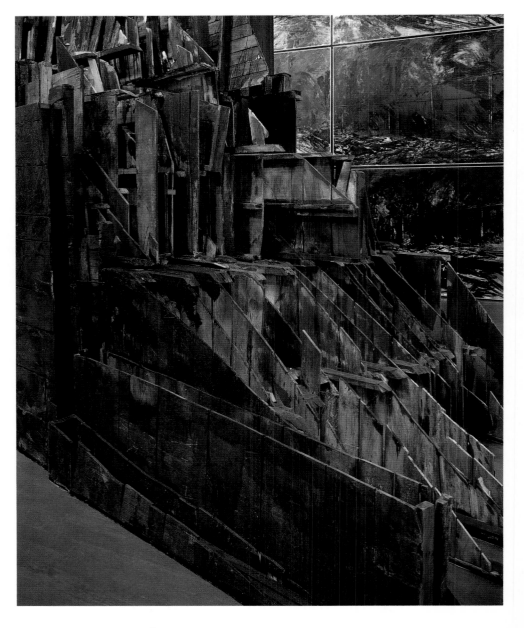

Untitled
Installation view (detail),
Hara Museum ARC,
Gunma Prefecture
1990
Wood, paint, and draw-
ings (oil on photographs);
approximately 330 x 1,260
x 280 cm (129⁷/₈ x 496 x
110¹/₄ in.); drawings: 498
x 1,330 cm (196 x 523⁵/₈
in.). Collection of the
artist. Photographer:
Tadasu Yamamoto.
This work was made
possible by a grant from
the Lannan Foundation.

When I work, there is always a struggle between my self and the space in which I am working. If I am working outside, it is a struggle between my self and the world around me. This struggle is absolutely essential to me. It is within the actual process of creation that my spirit reaches its highest point. Yet once I have completed the work, it seems almost as though it had been created by someone else. When I go to an opening for an exhibition of mine, I often feel like it is someone else's party. When the work is finished, it becomes totally separated from me.

From the beginning I feel that I don't have total control over the work. The work is not completed on the basis of my control. But the body can be controlled, so in a certain sense my form of expression can be viewed as a form of theatrical performance or dance.

It always seems that I want to create something that goes beyond my imagination. It is like coming close to the gods [*kami*], if indeed there are gods, but sometimes I feel that if the work fell over it would be equally satisfying to me. So my feelings about this are rather ambiguous. I will try to make a tower as tall as possible, build it to the very limit that it can go without falling over. If I wanted to create something ex-tremely tall, I could work through all the technical problems and perhaps build something as tall as the Tokyo Tower, but that is not something that I can or would particularly want to do. It is like piling up bricks, putting one on top of the other, wondering how far I can go. If I put on one more, will the entire structure collapse? But I would like to go to the very limit. If it then falls over, it can't be helped.

I would be pleased if my enjoyment of the process of work could be sensed during the work's exhibition, but I am not really concerned whether people think the work is good or bad. If my wife or my child likes it, that is enough.

Although my work is very personal, I am still involved in the art world, and of course I want to create something that is good. I would like to have people see the work, but that is not really my problem.

■

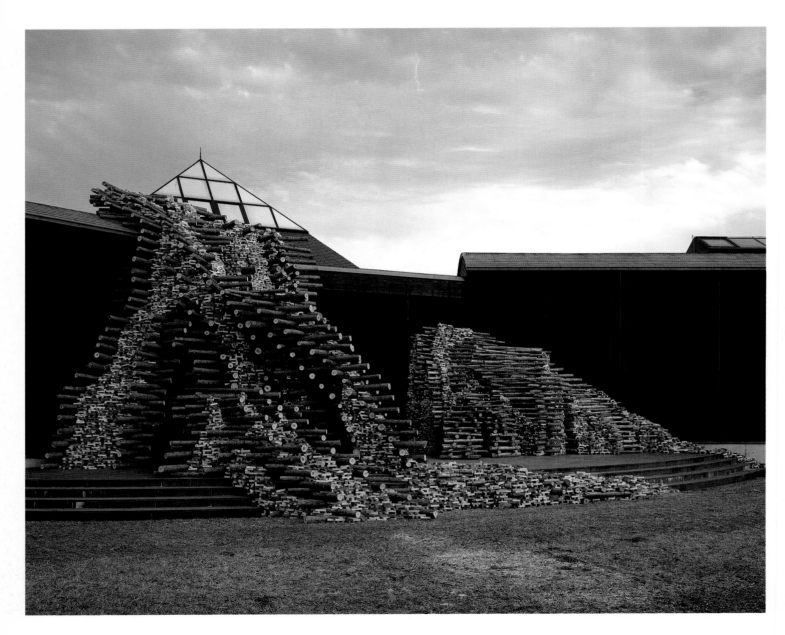

Takamasa Kuniyasu

My motivation as an artist is rooted in a desire to make the best of this life of mine, this life that I can only live once. This may sound somewhat grandiose, but I have always felt an urge to create. My works up to now have been born through the search within myself for the source of this powerful urge.

My working process involves simple physical labor, and although some people may find my work meaningless, through the repetition of this simple working process I feel enabled to liberate myself from the concerns and anxieties that always seem to bind me. I feel my spirit becoming increasingly free and open. It is here that my joy in creation lies.

I begin my work with a concept, which could be said to represent my ego; it emerges from my consciousness. Yet once the actual process of creating a work has begun, things don't necessarily turn out as I planned. Curiously, those works that veer from my original intentions are often the most successful. If I think about why this is, it seems that within me there is something deeper than the ego—what I would call the true self—and I am drawn toward this by an almost gravitational or magnetic force. There are great differences between the structures of consciousness in the East and the West. I am a Japanese with a structure of consciousness different from that of Westerners, and my work becomes a means of encountering the [Japanese notion of the] deeper, true self within through a simple process of work, of piling rectangular pieces one by one on top of each other.

Because I did not understand my inner impulse [when I was younger], I started with two-dimensional works and from there went on to making reliefs and to working with materials such as iron and aluminum. But I always felt a sense of unease. There was a lingering feeling that I was not doing what I really wanted to do, that there must be some other form of expression that could communicate more directly what I wanted to say. It was soil and logs that I finally came across.

Both soil and logs are natural materials, and in retrospect I realized that this was a crucial factor. While industrial materials such as iron or aluminum can convey my ideas in a direct way, natural materials often deviate from my original intentions. If I try, for example, to fire my ceramic bricks to attain a specific color, they won't always turn out that color. Rather than considering such deviations as mistakes, by giving up control, I conversely make use of them. Thus I am more interested in those

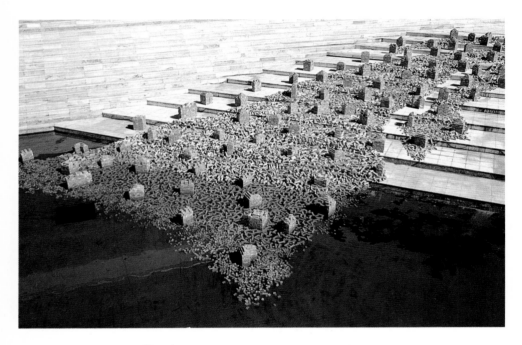

Return
Installation view, "Art Document '87," Tochigi Prefectural Museum of Fine Arts, Utsunomiya 1987
Ceramic; 45 x 800 x 2,000 cm (17¾ x 315 x 787⅜ in.). Photo © Shigeo Anzai.

Opposite:
Return to Self
Two installation views, Aomori Expo '88, Gappo-Park, Aomori 1988
Ceramic and logs; 750 x 1,200 x 1,100 cm (295¼ x 472½ x 433⅛ in.). Collection Aomori City. Photo courtesy of the artist.

materials that are not obedient to my will.

I began with the idea of using a rectangular shape and was searching for the best way to do this. Bricks, as a material, have architectural associations that are not consistent with my intentions. The proportions and colors of architectural bricks do not suit me, and there are problems related to their texture. But since a rectangular, fired substance is generally defined as a brick and because the proportions are similar, it seems almost unavoidable that my blocks are called bricks. Yet I do not fire them as bricks, nor do I consider them ceramics or earthenware.

Gaining more confidence allowed me to create larger works. My earlier, small-scale works were somewhat introverted, like shells that protected me. Yet as my inner self, my shell, has broadened, so too have my works increased in scale. This is not to challenge the limits of possible size, but more a question of personal feelings. More than just a change in scale, my work has changed in accordance with the changes within me.

If I could find words that explained the message I hope to convey, it would no longer be necessary to create art works. It is the very process of discovering the answers to these questions that constitutes the

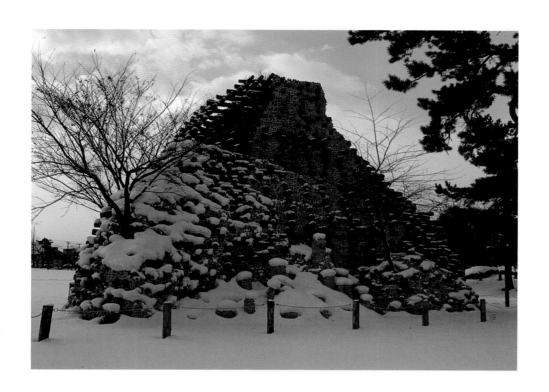

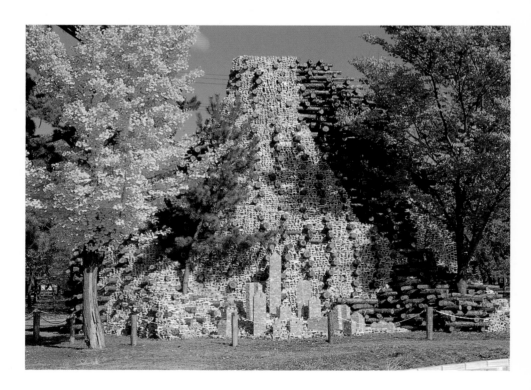

Return to Self
Installation view, Kaneko
Art Gallery, Tokyo
1988
Ceramic and logs; 300 x
200 x 100 cm (118⅛ x 78¾
x 39⅜ in.). Photo
courtesy of the artist.

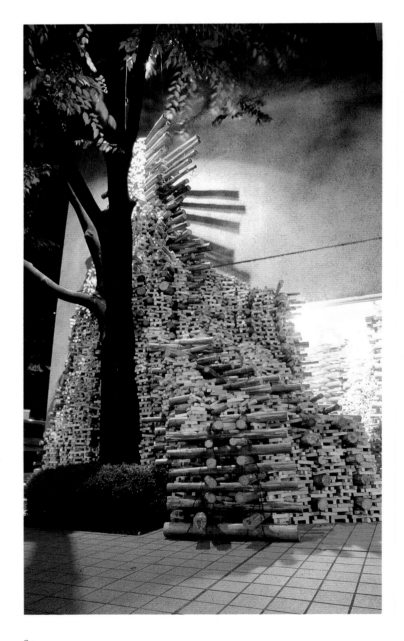

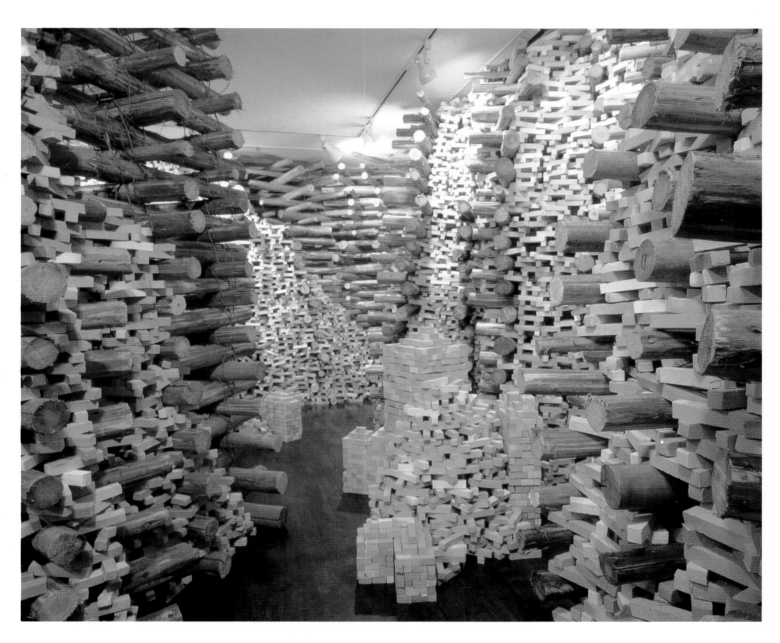

Above and opposite:
Return to Self
Installation views,
Hillside Gallery, Tokyo
1989
Ceramic and logs; 540 x
800 x 700 cm (212⅝ x
315 x 275⅝ in.). Photo
courtesy of the artist,
© Shigeo Anzai.

creation of a work of art. If I can feel
that each new work brings me closer to un-
derstanding what I am in search of, then
I can experience the joy of creation.

I would like viewers to be aware of
a kind of spiritual message that is conveyed
by my works, even though I cannot spe-
cifically define spirituality with words. In the

case of Buddhist arts this could be inter-
preted perhaps as a form of prayer or an even
profounder philosophy, something that
we all share deep down in ourselves. I would
like to try to come as close to that as
possible.

I want my work to express an existence
that surpasses my own self. Rather than

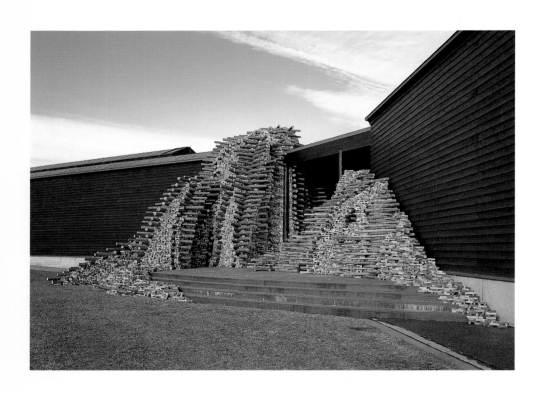

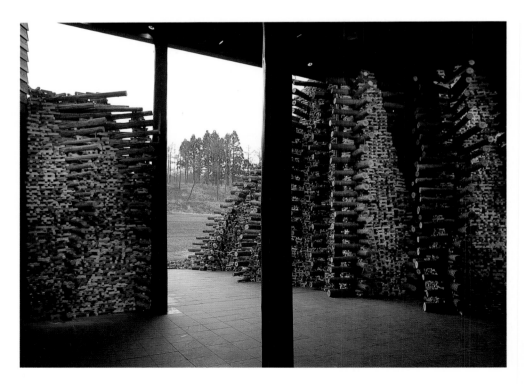

86

Takamasa Kuniyasu

Return to Self
Installation view,
Hara Museum ARC,
Gunma Prefecture
1990
Ceramic and logs;
approximately 800 x 700
x 1,500 cm (315 x 275⅝ x
590½ in.). Collection of
the artist. Photographer:
Tadasu Yamamoto.
This work was made
possible by a grant from
the Lannan Foundation.

the assertion of what is called the self, I am trying to find a form of expression that allows me to feel the self as a single part of a greater circle. As a human being I do not constitute the center of the earth but exist only as a single point within nature's cycle. More than creating works through my own volition, I feel increasingly passive, as though I am being driven to create them. I feel this very strongly as I stack the blocks I make. Overwhelmed by a sort of intoxication, I feel that the site or the space itself forces me to create the work. My work changes according to the site, which means that rather than being in control, I am entrusting my work to the control of something else. I entrust control over the work to the site.

When it comes to the subject of the work and how it relates to the surrounding environment, you really need to see it within a cycle spanning the whole year, the four seasons. Only then will you be able to understand what I wanted to say. A viewer who sees the work only at a particular time, a particular season, this is all he sees. But leave the work at the site for a long time, and it will reveal its various expressions in response to the natural surroundings.

It is perhaps an interpretation of the world or of the universe, the cosmos, that I want to create. Using materials such as bricks and wood, I want to reproduce at the site of a work the inner world that I have conceived, my view of the world. With bricks and wood I am constructing at each site my concept or idea of the world as a microcosm, a symbolic reconstruction of the cosmos.

I want my works to have an impact, not just on the eyes, but on the entire body. We tend to absorb information visually. We're more accustomed to understanding a message by reading or hearing words. That is how we try to understand other people and their works. But now I think we can go beyond that level, and by actually standing at a site we are able to receive or to feel something there. This is a crucial step.

The current state of art shows the place we have been led to by art that attempts to define logically what art is or by art that pursues originality and newness as its goal, in other words, art that employs Western logic and places the human ego at its center. I want to create an art that is different from that, an art based, not on the self as the center of the cosmos, but on the self as a part of nature within which it has been given life. From this type of art I feel that something new may emerge.

■

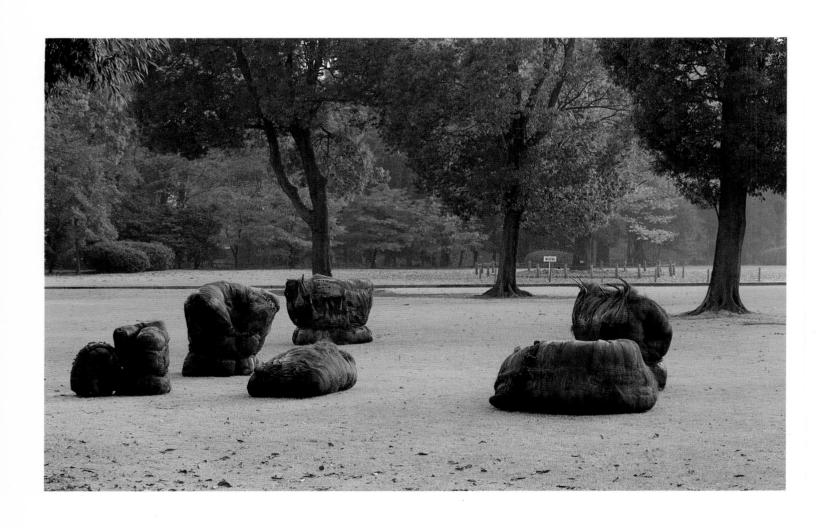

Emiko Tokushige

In school I studied graphic design, but half-way through I realized that as a profession it didn't suit my character, so I quit. I had a vague idea that I should perhaps do something with weaving. At that point I was only thinking about ordinary weaving—making fabric, not making objects—but there were few people working in weaving at that time, and I had no idea how to begin. A friend suggested that I could learn at the Kawashima Weaving factory in Kansai, and there they told me that while they didn't teach weaving, I could watch and learn by myself so long as I didn't get in the way. So I watched and learned how to weave, how to take up the thread and how to wind it. I then went to work for Tatsumura, a company that specialized in the restoration of antique textiles. But wanting to learn how to do a job and actually joining a company are two different things; I soon realized I had made a mistake. I immediately quit my job and began working on my own.

At Tatsumura there was a small library with many magazines from abroad. Although the terms *fiber art* and *fiber work* were not in use at the time, in these magazines there were photographs of fiber art created in the United States. It was quite a discovery to realize that such work was being done, nevertheless I did not feel particularly sympathetic toward the rough manner in which the yarns were used.

For a while I continued to make ordinary woven fabrics that were used for interiors, things to hang on the wall like tapestries, but I grew increasingly dissatisfied with the two-dimensionality of my work. I recalled the strange, three-dimensional, relieflike works that I had seen in the American photographs. I became more and more interested in creating three-dimensional work; it allows a wider range of expression. By study and imitation, through trial and error, my work gradually developed.

The materials used in a work determine its final form of expression. It is as though in work that is two-dimensional I am trying to express that part of myself that is quiet and hidden. For example, the strength of cotton, silk, or linen can be brought out in a fabric, whereas with ropes or tree bark I will want the work to be more substantial, more protruding, and the material to be more assertive. I want to leave more of the expression up to the material itself. If you ate vegetables every day, you might suddenly wish to eat meat for a change. It's rather like that. Working on a three-dimensional piece is like deciding to eat meat. Both types of work are complementary, and both are satisfying to me. Both

Untitled
1983
Stocking and palm rope;
24 x 12 x 12 cm (9½ x 4¾
x 4¾ in.). Collection of
the artist. Photographer:
Masaru Nozawa.

Untitled
1983
Stocking and cotton rope;
25 x 20 x 20 cm (9⅞ x 7⅞
x 7⅞ in.). Collection of
the artist. Photographer:
Masaru Nozawa.

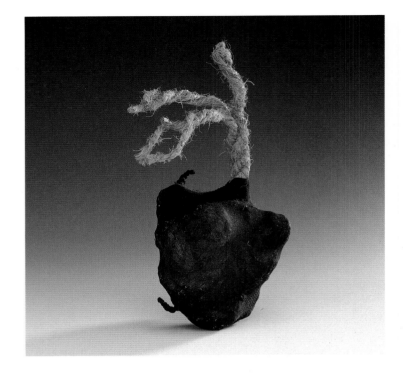

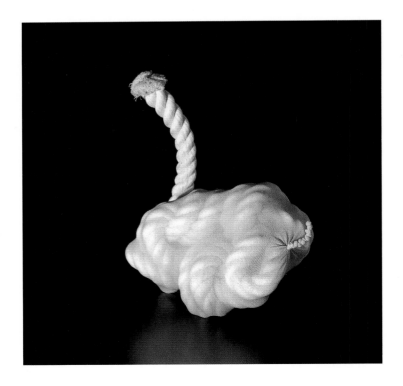

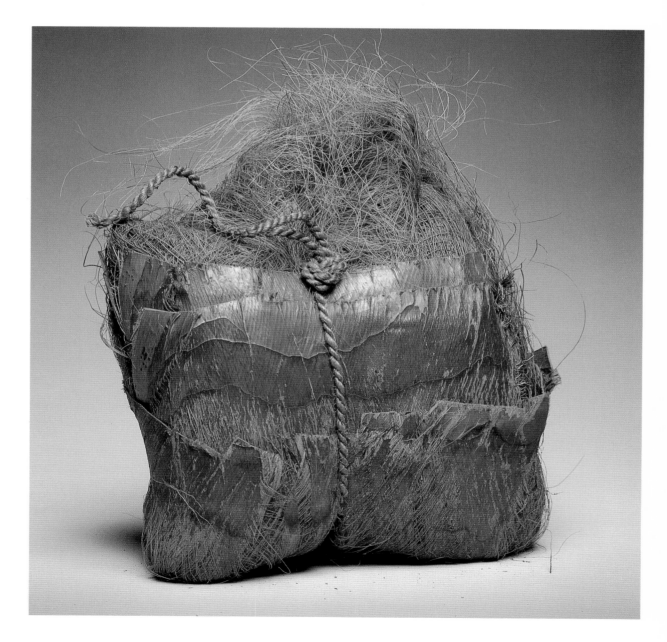

Untitled
1985
Cotton wadding, palm fibers, palm rope, and cloth; 25 x 23 x 8 cm (9⁷/₈ x 9 x 3¹/₈ in.). Collection of the artist. Photographer: Jens Bull.

allow me to feel in control of what is inside me.

It is very difficult to use materials that I am particularly fond of. I recently used palm fiber, for example, but the fiber was so beautiful that I found it difficult to work with. Yet once I decide to use a material in a work, I must find a way to somehow restrain it, to somehow make it my own. I have to take it into my hands, but I am not certain to what extent I should do this. I don't want to kill the material. If in working with the material I cannot somehow build on its inherent qualities, then my work would be without meaning. I ask myself, how can I work with a material without destroying it and yet find a way to bring it closer to myself?

There is a point when I have to make a decision, to determine whether I should go any further or not. Later, when I look at a completed work, it is apparent to me whether I stopped at a particular point to allow the materials to live or whether I stopped because I became fearful [of destroying the materials]. When I say that I want "to allow the materials to live," it sounds as though I am being deferential toward them, but it is actually more of a struggle. And this struggle itself is enjoyable and interesting for me. It is this struggle that drives

me in the creation of a work. There are times when afterwards I feel that I have been defeated by the materials. I wonder why I was unable to use a material to its full extent or why I hadn't gone into more depth. It is not that I am dissatisfied but that I can clearly see my inner weaknesses.

When I am working to create something, it is ego that motivates me. Pure ego. Without it I would probably be satisfied to live an ordinary life and wouldn't need to work as an artist. But there is part of me that simply won't fit into the normal pattern of life, and it is this that forces me to create works of art. Still I don't have the same type of power that Western artists do. I am rather envious of Western artists for the intense expression of ego, or self, that I sense in their works. I am overwhelmed by their power of expression since I am unable to achieve as much. I can only go about 70 percent of the way; the rest I cannot bring out. Perhaps this is because I feel a certain deference toward the material. Perhaps the work I create doesn't contain a powerful message; it is not that strong. If a work is very strong, then there is a possibility that the message could be taken in the wrong sense, opposite to what the artist intended, and it might have a negative influence on viewers.

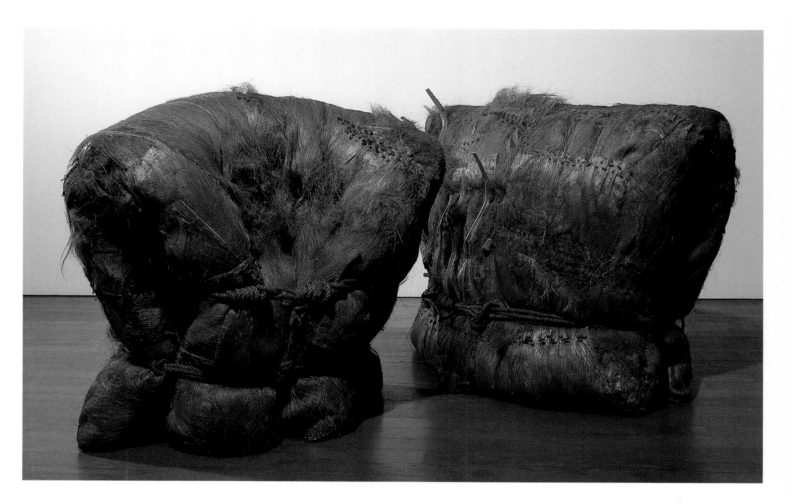

Untitled (details)
1987
Palm fiber, palm rope,
cotton, and urethane
foam; two of seven pieces,
range of sizes 50 x 90 x
115 cm (19⅝ x 35⅜ x 45¼
in.) to 112 x 120 x 210 cm
(44⅛ x 47¼ x 82⅝ in.).

Collection Gunma
Prefectural Museum of
Modern Art. Photog-
rapher: Tadasu
Yamamoto.

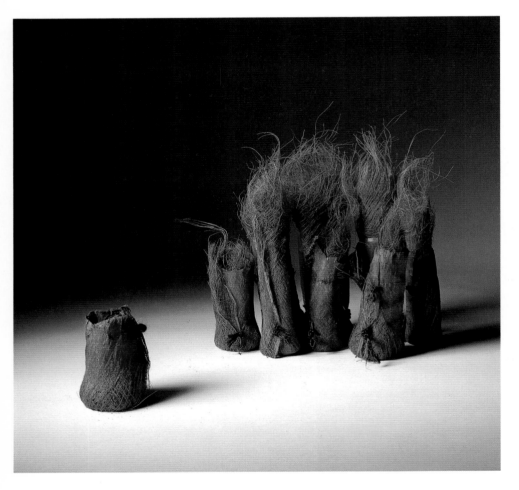

I hope that viewers respond to something in my work that goes deeper than the superficial levels of shape and color. I am not certain whether it should be called life or not, but there should be a flow of something—some kind of communication—that flows from the work to the viewers. Although I would certainly be pleased if viewers appreciated the forms and colors that I use, it is this other level that I think is most important. If I felt a great responsibility for something and was working as an artist for this reason, then I wouldn't want to create works that are "beautiful" or "comfortable." It is not that I think such works are bad but that I personally wouldn't want to be making such things. The power of expression inherent in something has nothing to do with such things as beauty. Rather I think true beauty is related to the compelling force of the desire to live. It has to do with life.

■

Untitled
1988
Palm fiber; range of
heights 10–15 cm (4–6
in.), each diameter 7 cm
(2¾ in.). Collection of
the artist. Photographer:
Jens Bull.

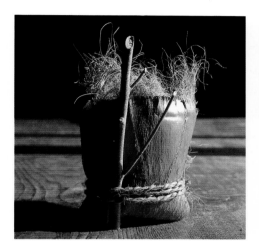

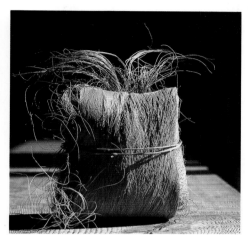

Above and right:
Untitled (details)
1989–90
Palm fiber, palm rope,
cotton, wood, and goat's
hair; twenty-three pieces,
range of sizes 22 x 7 x 7
cm (8⅝ x 2¾ x 2¾ in.) to
50 x 30 x 16 cm (19⅝ x 11¾
x 6¼ in.).
Collection of the artist.

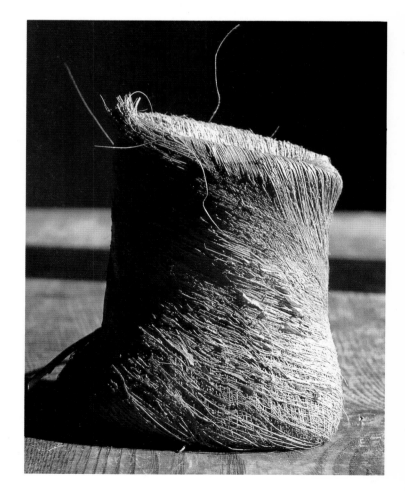

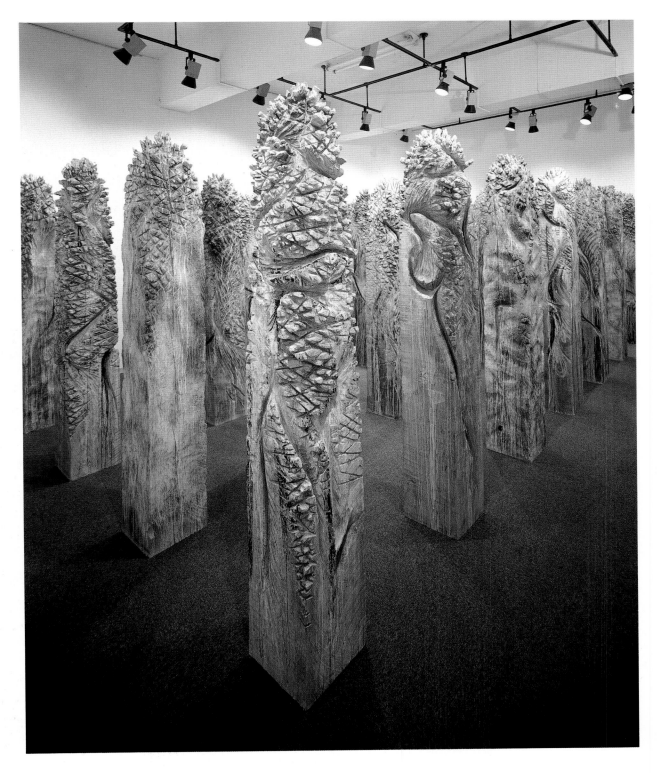

Shigeo Toya

Woods
Installation view,
Satani Gallery, Tokyo
1987
Wood and acrylic;
twenty-eight pieces, each
213 x 30 x 30 cm (83⅞ x
11¾ x 11¾ in.). Collection
Neue Galerie-Sammlung
Ludwig, Aachen.
Photo courtesy of Satani
Gallery, Tokyo; photog-
rapher: Hiromu Narita.

I was a shy child, afraid even to go to school.
I would run away, trying to avoid encoun-
ters, hiding in the back room of our house or
in the mountains. I had such a fear of death.

There are two ways to ease such fears.
One is to become used to the idea. The other
is to escape from it. Both these approaches
were mixed in my mind.

I felt oppressed by the society around
me. I felt I was being watched by the
community. Art became a form of freedom
for me, a form of free individualist ex-
pression, a way of escape from this world.

I was not much influenced by contem-
porary or postwar American art. I studied it,
but it never really moved me. I liked
classical art. I was interested in Pompeii, in
the sculptures of Pompeii, which were
actually human bodies unearthed from the
city. This image of Pompeii has remained
very important in my work to this day. I
try to visualize how the space around me
would be filled with ash and how I would
suffocate. My body would dissipate, but
the shape of my body would remain like a
fossilized surface. This is an interesting image
but at the same time a frightening one. In
the beginning I tried to express this image of
a hollowed-out figure in my work.

The sculpture I made during my first
two years at university was based on the
work of French artists, such as [Auguste]
Rodin, [Emile-Antoine] Bourdelle, and
[Aristide] Maillol. The professors at Japanese
universities studied in France and taught
that type of work. They emphasized the crea-
tion of powerful forms with solid struc-
ture, the creation of forms that correspond
to the structure of the human body. It is
the kind of solid, rigid, inner structure found
in all Classical and European sculpture.
When I was making figurative sculpture, my
works had surfaces that were as solid as
armor, but they remained empty inside. This
was quite different from the process of
constructing from the center, which was what
I had been taught at school.

I began to study Japanese sculpture
after I came into contact with Mono-ha. The
first modern Japanese sculptors were art-
ists such as Kotaro Takamura (1883–1956),
who went to France to study under Rodin.
Rodin taught Takamura to create works
in which the force of life emerged from
within. Takamura's father had been a
sculptor during the Meiji period, but to the
son the father's work seemed decorative
and superficial. After criticizing his father's
work, Takamura began a series of fish
carvings. These were of the type of fish that
have no scales, mostly catfish, so he suc-
cessfully created works that expressed mass.

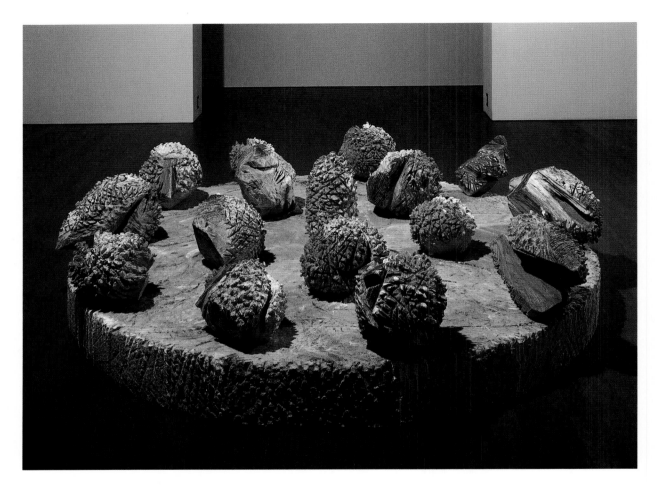

Range of Mountains
Installation view,
Hara Museum ARC,
Gunma Prefecture
1985
Wood, paper, acrylic, and
pastel; 70 x diameter
250 cm (27½ x 98⅜ in.).
Collection Taito Ward.
Photographer:
Tadasu Yamamoto.

Next he tried to carve a carp, but since carp are covered in scales, he was forced to use a chisel to pattern scales all over the surface of the work. The result was very decorative, similar to the work he had criticized his father for creating. Takamura agonized over its difference from what he had learned from Rodin. While he criticized Japanese sculpture for having this sort of [surface] element, I try to view it in a more positive light.

I was also interested in a younger sculptor, Heihachi Hashimoto (1897–1935), who followed a style all his own. All over the surface of a sculpture of a girl he carved flower petals in relief. In terms of European sculpture the petals would be considered

meaningless since they interfered with the expression of an energetic mass. I was interested in Hashimoto because he did not care about such things. In his book *Pure Sculptural Theory* he wrote that the motifs and themes of sculpture are invisible phenomena. This seemed fresh to me since I had never heard of a theory of sculpture that was concerned with such things. I felt his approach had something in common with mine in that both deal with something that is ineffable. So I started a series of "invisible" sculptures and once did an exhibition entitled *Pompeii*. In this series I worked to "excavate" things that had been buried in plaster.

In my image of Pompeii I would be

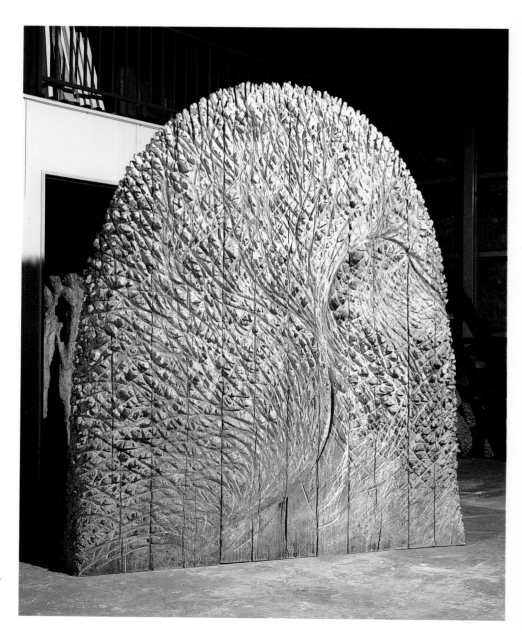

Woods
1986
Wood and acrylic; 220 x
180 x 30 cm (86⅝ x 70⅞ x
11¾ in.). Private collec-
tion, Japan. Photo courtesy
of Satani Gallery,
Tokyo; photographer:
Tadasu Yamamoto.

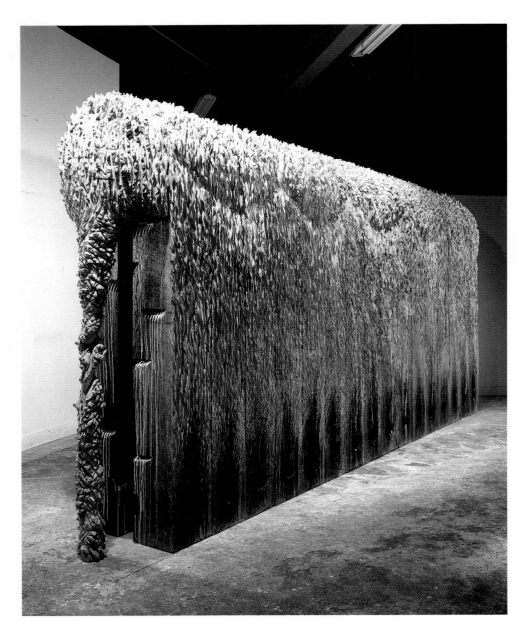

Death of Woods
1989
Wood and acrylic; 230 x
560 x 62 cm (90½ x 220½
x 24⅜ in.). Collection
of the artist. Photo
courtesy of Satani Gallery,
Tokyo; photographer:
Tadasu Yamamoto.

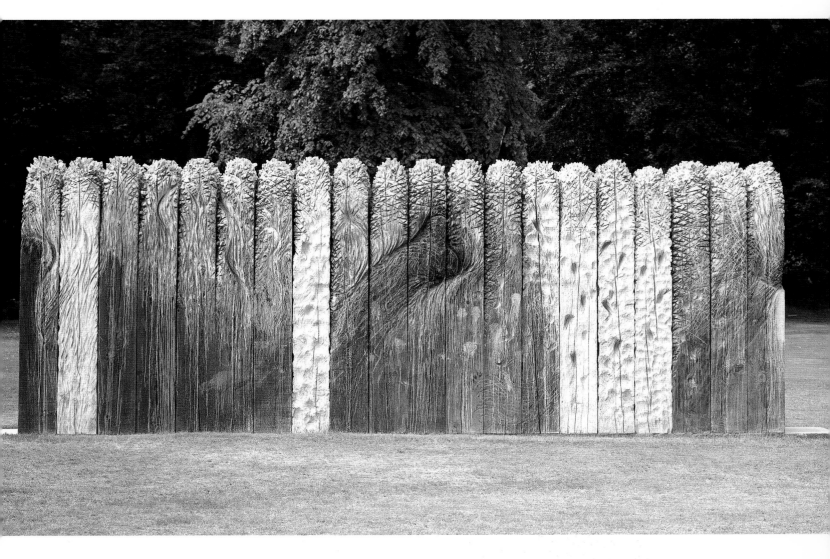

Animal Track I
Installation view, 20ste
Biënnale Middelheim-
Japan, Antwerp
1989
Wood and acrylic; 230 x
610 x 60 cm (90½ x 240⅛
x 23⅝ in.). Collection
of the artist. Photo
courtesy of Satani Gallery,
Tokyo; photographer:
Frans Claes.

buried in the space and become nothing. The space and I would be inverted, and my now hollow, empty existence would drift upon the integumentary husk between the outer mass and inner emptiness. I began to think that creation was similar to excavation.

About the same time I was working on a series of sculptures that I set on fire. This series and the "excavated" sculptures are similar in that they both deal with how a surface—the boundary between a space and an object—moves.

I have been working on my current Woods series for about five years. I prefer working with wood because I like the way it responds when I work with it. Wood has small openings in its surface; these contain air, water, and other substances. It is not just one material. Stone may **contain** many elements as well, but to me it seems monotonous, uniform. With stone you must have a clear image in your mind and work from a fairly detailed plan. I start out with a vaguer image and develop it as I go along. For this approach stone would be too hard. While my

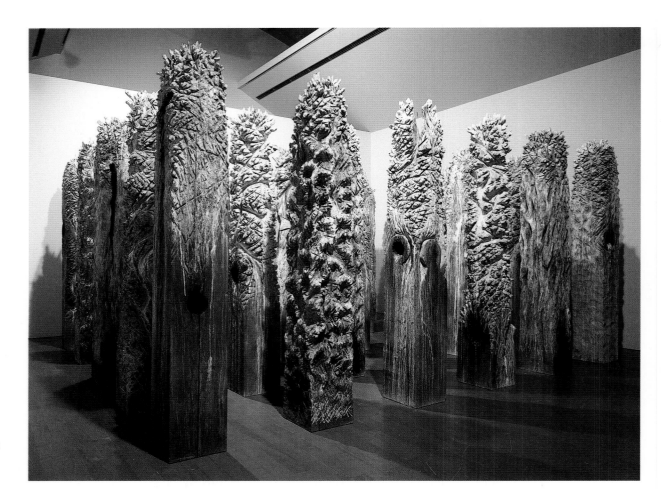

Woods II
Installation view,
Hara Museum ARC,
Gunma Prefecture
1989–90
Wood, acrylic, and wood
ash; thirty pieces, each
220 x 31 x 31 cm (86⅝ x
12¼ x 12¼ in.). Collection
of the artist.
Photographer: Tadasu
Yamamoto.

consciousness of my work is very strong,
my consciousness of surface is stronger than
my consciousness of shape. While I have
certain meanings or ideas in mind, these ideas
don't always result in definite shapes. I
search for a form while working with the ma-
terial. You have form and you have mean-

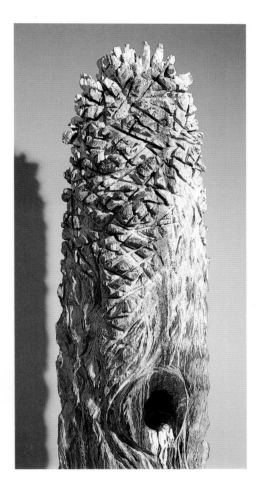

Woods II
Installation view (detail),
Hara Museum ARC,
Gunma Prefecture
1989–90
Wood, acrylic, and wood
ash; thirty pieces, each
220 x 31 x 31 cm (86⅝ x
12¼ x 12¼ in.). Collection
of the artist.
Photographer: Tadasu
Yamamoto.

ing. In minimal art there is a clear and definite relationship between form and meaning, but I tend to wander between them; this is the essence of my work. I want my work to be a place of encounter with something that is greater than I am.

Sculpture only exists as an icon when it has some relationship to religion. Yet even before sculptures became icons, there were places that were regarded as special. Sculpture came into existence as people used stones to mark these places; the stones gradually assumed meanings of their own. They became icons.

This sort of thing has been an influence on my work. The type of place where a stone might be set has a power, a sort of spir-

itual attraction for the people who would see the site or be connected with it in some way. The forms that mark such places could be called presculpture, shapes that predate sculpture. They are an animistic form. I want to give shape or surface to this presculpture, though in my work I have deliberately avoided the creation of Western-style icons and the method of constructing a work from the center outward.

I probably would not feel a sense of pressure from the space around me if I were not living in Tokyo, but when I walk through Tokyo I imagine the city filled with ash and becoming a ruin. Sometime in the distant future I would dig up these ruins. In my work I am not expressing an image of a lush forest filled with life, but a dead forest, a lost forest. My work is like a burial ceremony for a forest. In a sense it is a form of purification. Burial ceremonies are not for the dead but a way for the living to possess death, to define and humanize it, to accept it. The image in my work, then, is that of a person living in a city such as Tokyo. If I were living in the middle of a forest in the mountains, I doubt that I could ever have created such work.

■

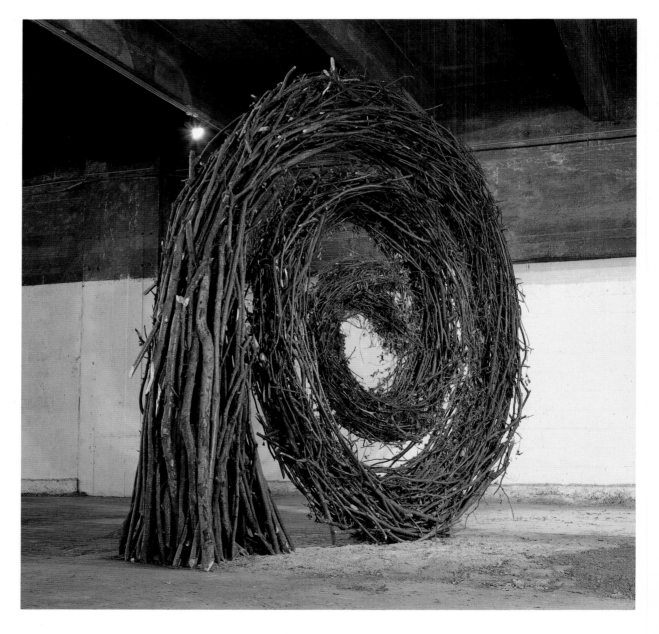

Kimio Tsuchiya

I live in Matsudo, about thirty minutes from Tokyo by car. When I moved there seven or eight years ago, the area was surrounded by dense forests. Until recently it had never seemed doubtful that I might live surrounded by the green of trees, but development has destroyed the natural environment so quickly that it sometimes felt as though I myself was being destroyed. As the trees were cut, I began to question this holocaustlike behavior and to wonder if I could somehow use this wood. That is when I began collecting the remnants of this destruction.

I don't feel that there is any great difference in the value of a human life compared with the life of a tree, but the human ego is such that people feel free to cut whatever trees they wish, to destroy trees they have no use for. Seeing this attitude in Japan, and in other parts of the world as well, raises serious questions about human behavior. In using wood, I am questioning where we come from and where we are going, what it is to live and what it means to die.

Although I could use fine wood to create a work—and there are many sculptors who do—I have no desire to. The wood I use is wood that cannot be used for construction or for traditional sculpture. It is wood that may have been beautiful when alive but,

once cut, is thought to have only the potential to rot and decay. This wood has no commercial value, so it is just broken up and plowed under by bulldozers to get it out of the way. Watching this I feel as though the bulldozer is plowing into my own flesh. It is as though the wood is a part of myself, as though the wood has the same level of life force: I am living and the tree is living. Wood is not just matter. Maybe this is just how I feel, but there seems to be some kind of complex relationship, a closeness. I have been using such wood for many years, and it doesn't rot; it is strong and depending on how it is used, various things can be made from it.

Everyone loved the beautiful green of Matsudo when it was a forest, but now that the trees have been cut and the wood has begun to decay, people think how ugly and terrible it is. I don't like this type of human egocentrism. Even when a tree has been cut, it is still a tree. Even when the wood begins to decay, it is still wood. Even when it burns to ash, as ash it still has life. It is from this point that I want to consider and create art.

Wood is such a material that even if I were to hang a branch on the wall, it would become a form of art, though it would not be interesting. It would be better to leave the

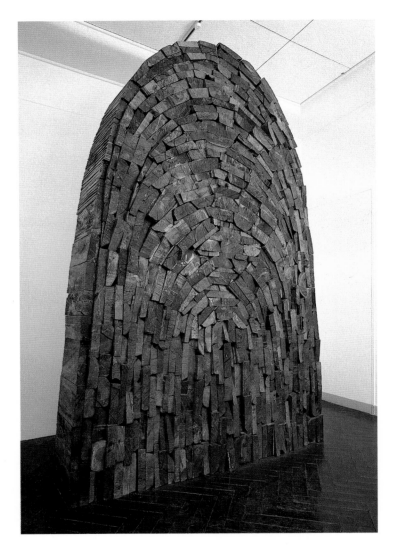

Memory No. 2
Installation view, "Hara Annual VII," Hara Museum of Contemporary Art, Tokyo
1987
Oak; 300 x 250 x 60 cm (118⅛ x 98⅜ x 23⅝ in.).
Collection of the artist.
Photographer: Shunji Takanabe.

tree alone since it is beautiful as it is. If I am to use wood then, I would rather create my own secondary, optional forms. So, for example, in the type of semicircular work I showed at the Hara Museum (1987), I boldly used the tree's former, natural shape to create my own secondary form. By *secondary form* I don't mean a mathematically correct form—such as a semicircle drawn with a compass—but a semicircle or circle or square that exists within me.

Viewers are free to make whatever interpretation of my work they wish, but I am not simply interested in presenting wood, and it would be disappointing if I were seen merely as a wood sculptor. My work in wood has its own drama. There is a stone garden at Ryoanji temple in Kyoto. I like this garden and have been there more than ten times. To me this Muromachi-era [1392–1568] garden represents circles, squares, and triangles: the garden itself is a square, its stones are triangles, and the visitors form a circle. While this may be taken as a uniquely Japanese or religious perspective, I believe that each individual has these basic forms within. In my work I want to question what these simple shapes are.

Recently I have been using driftwood from Tokyo Bay, wood that has been tossed around by typhoons for thirty or forty years. I have been collecting this wood piece by piece and assembling it in semicircular and wavelike forms. With these works in particular I feel that I have been able to express the life of wood. Life still remains in this wood, and I try to becomes engaged with that life force. This wood is like human bones; I gather this discarded wood, and reassembling it, I give the wood a new life, a new soul.

There is a basic difference between Western and Japanese artists. I feel that there is a very clear difference between artists who,

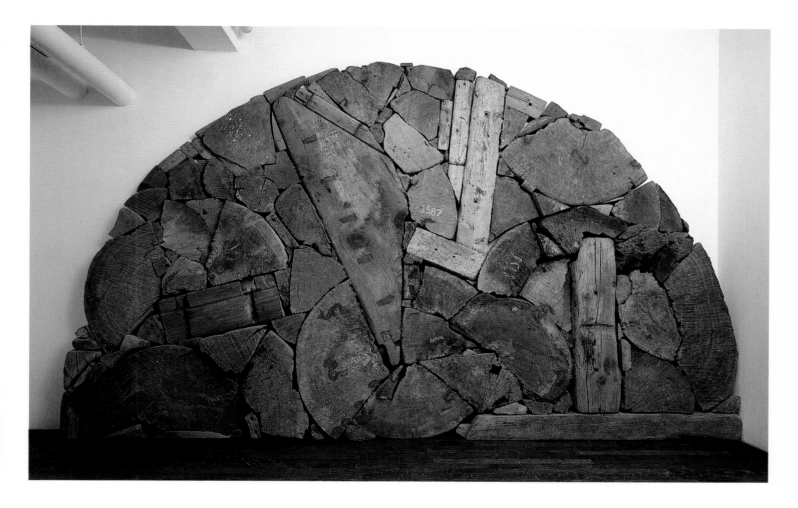

Horizon Line
1988
Tokyo Bay driftwood;
270 x 450 x 50 cm (106¼ x
177⅛ x 19⅝ in.).
Collection of the artist.
Photographer:
Shunji Takanabe.

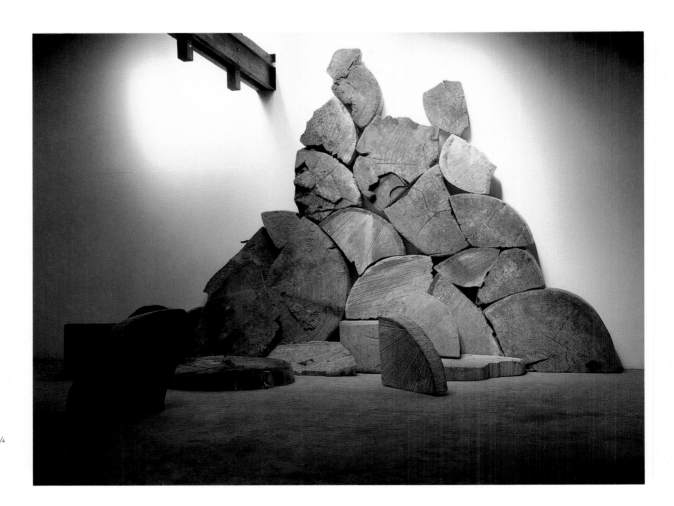

Landscape
Installation view,
Moris Gallery, Tokyo
1987
Tokyo Bay driftwood;
280 x 500 x 400 cm (110¹/₄
x 196⁷/₈ x 157¹/₂ in.).
Collection of the artist.
Photographer:
Shunji Takanabe.

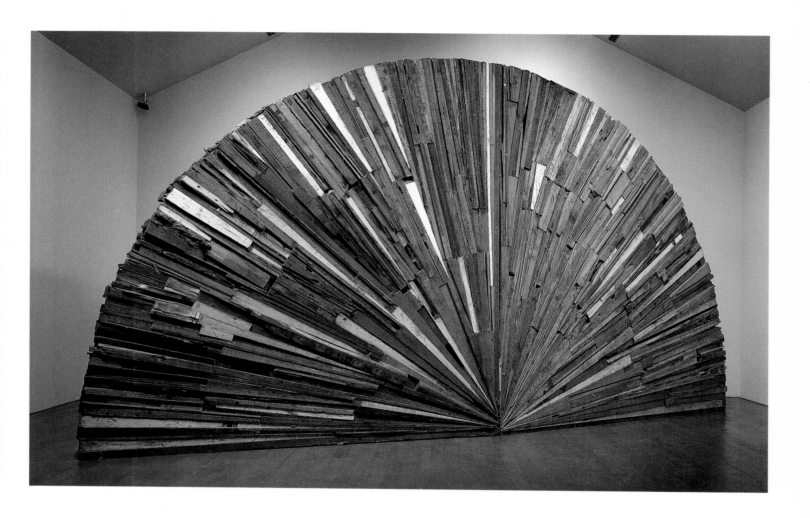

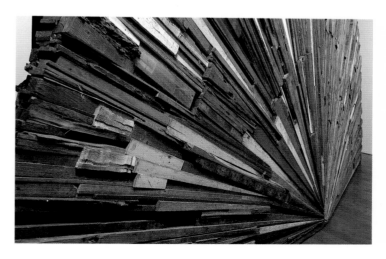

Silence
Installation view and
detail, Hara Museum
ARC, Gunma Prefecture
1990
Used wood, driftwood,
and old magazines; 300 x
580 x 100 cm (118⅛ x
228⅜ x 39⅜ in.).
Collection of the artist.
Photographer:
Tadasu Yamamoto.
This work was made
possible by a grant from
the Lannan Foundation.

like me, have selected nature as a sort of theme. Westerners, when looking at nature, see it as a threat. Humanity is always seen as being in opposition, as though there is a history of confrontation with nature. Yet while there is a concept of nature as a potentially threatening force in Japan, the Japanese still attempt to bring nature into their lives. In Europe, for instance, looking at a stone house, the distinction between inside and outside is very clear. But in Japan there is very little separating them. Natural light enters the traditional Japanese house through a single layer of *shoji*. If that single layer is removed, the inside of the house becomes the outside. The typical veranda also gives the impression of drifting between inside and outside, and in Japanese gardens, it is hard to differentiate between what is natural and what is human effect.

The growth rings of trees are beautiful in design, but their meaning goes deeper. They represent the history of the tree, the history of humanity, and therefore the history of the earth. I feel I must show this deeper level in my work. I was once given a piece of wood that was about fifteen hundred years old. I'm only thirty-four, so compared with this tree, I'm still just a child. As I counted the rings, I kept thinking, "This was when I was born. This was when the atomic bomb was dropped at Hiroshima [1945]. This was when the war began [1941]. This was the Meiji era [1868–1912]. This was the Edo period [1615–1868]. This was a time when Japanese culture underwent great changes." We have learned these things at school, but this piece of wood had witnessed all of these changes in silence. I felt this change of time in those growth rings. It makes me wonder how people can cut down such valuable trees without hesitation.

It is impossible to see a whole tree; a tree actually lives underground as much as above ground. So what we call nature is actually something very much on a surface level. I use wood in order to reexamine my deeper thoughts about trees, wood, and life. I would like it if people could feel the essence of a tree—the essence of life—from my work. While I don't particularly want to make statements about how people should live, I hope they might learn to understand and feel something about wood. Through this experience they will be able to visit a forest, to breathe fresh air, to think about nature on more than just a surface level, to feel a unity between their own lives and those of trees, unity with nature and the need for nature and humanity to exist together.

■

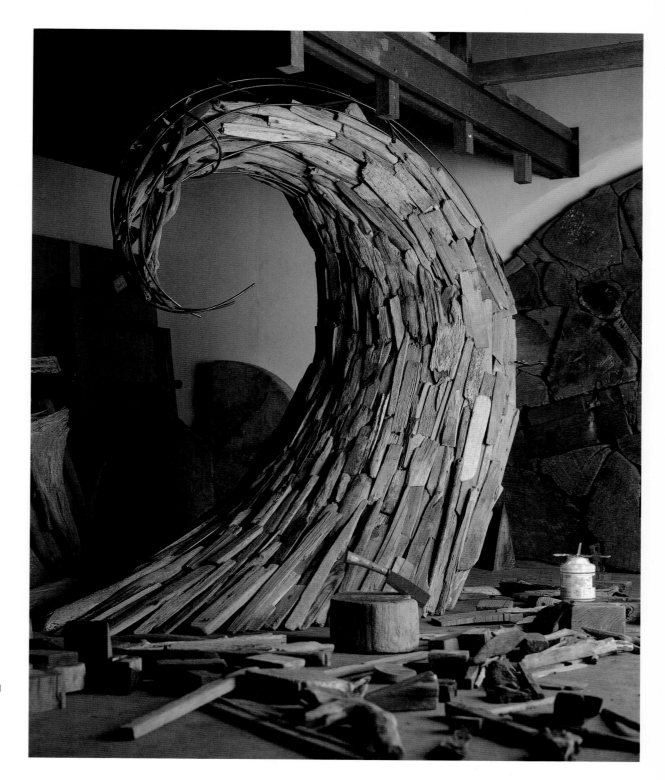

Premonition
Installation view,
Moris Gallery, Tokyo
1988
Tokyo Bay driftwood and
iron; 270 x 300 x 200 cm
(106¼ x 118⅛ x 78¾ in.).
Collection Moris Gallery,
Tokyo. Photo courtesy
of the artist; photog-
rapher: Shunji Takanabe.

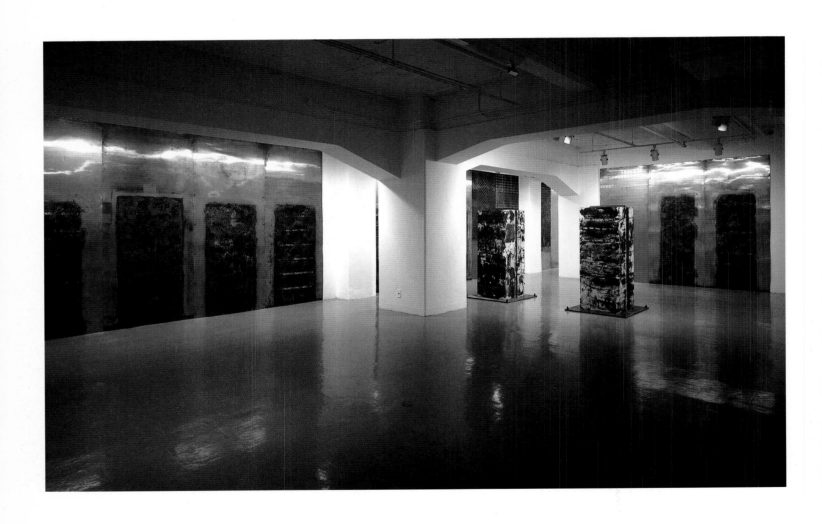

Isamu Wakabayashi

My reasons for choosing art school were not very clear. My reason for choosing sculpture, however, was very simple: it was perhaps the best way to prepare for a job making cars or airplanes. This is probably a trivial reason, but I certainly thought it was the best reason. For several years after art school, I wandered around doing a bit of this and that. I was interested in many things, and about ten years passed this way.

Gradually I began to focus on sculpture and drawing, and increasingly my work became limited to a very narrow range. One work would serve as foundation for the next; years would pass, and an older work might reemerge to influence newer ones.

At that time there were very few examples of iron sculpture in Japan. We saw iron sculpture in magazines, work like that by the British artist [Reginald] Butler, and of course there was [Alexander] Calder. Although I was familiar with iron as a material—I had seen things made from steel, for example, various types of machinery—I had virtually no experience working with it, of trying to file or cut it.

I am saying *iron*, but [at first] it was the type of iron that was used for cans. This was the only kind of iron available, and I planned to cut cans and spread them open, then use this as a material. There was printing on these cans, and a friend and I tried to strip and scrape it off, but that was really difficult, so we burned it instead. After burning, the paint adhered to the iron, and we ended up with thin plates of blackish iron. When we started to work on the metal, using a file, the brilliance of the iron began to show through. This had for me an extraordinary appeal. I fit small pieces together by soldering and other methods, then covered a wood form with them. Beyond a concern for the actual form—and sculpture is necessarily involved with form— the fascination with this metal became the focus of my work.

From this point thinness became important. I think my work designing auto bodies had an influence: a car is essentially closed in, but in actuality is very thin. I was learning about the density of things, the density that is associated with shapes, even in extremely thin things. Later I began to work with thicker pieces of iron and different iron products: plates, rods, pipes. My work gradually changed from thin to thick, from delicate to heavy. Next I began to think about mass. I made iron into a mass and carved it, which is similar to carving wood or stone.

When I carved or filed iron, a new aspect would show through—I found this thrill-

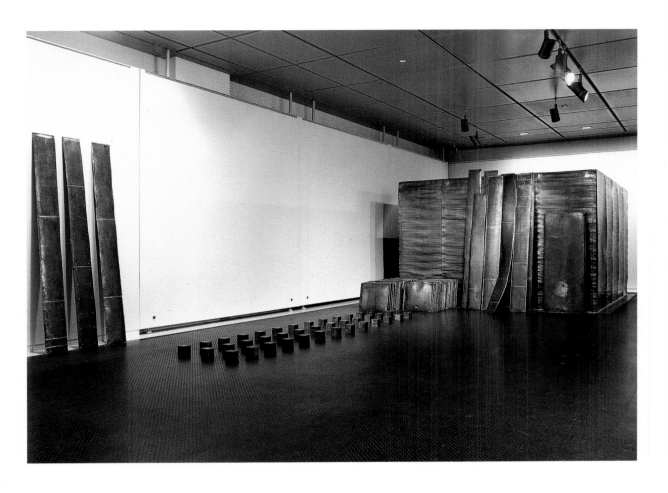

**Possession · Atmosphere ·
Oscillation—Outskirts
of a Forest**
1981–84
Iron, lead, paper, and
wood; room: 257 x 506.3
x 414.8 cm (101⅛ x 199⅜
x 163¼ in.). Collection
Akira Ikeda Gallery,
Tokyo. Photographer:
Yoshitaka Uchida.

Right:
**Study IV–VII for Oscillating
Scale and/or Collection
of Springs Renewed**
(second stage)
1977
Wood, iron, and lacquer;
27 x 92 x 183.5 cm
(10⅝ x 36¼ x 72¼ in.).
Collection Tokyo Metro-
politan Art Museum.
Photographer: Yoshitaka
Uchida.

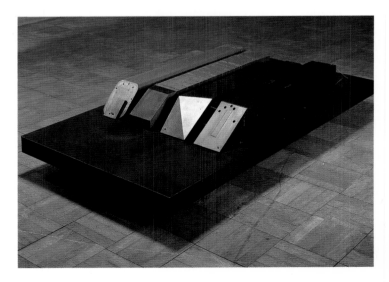

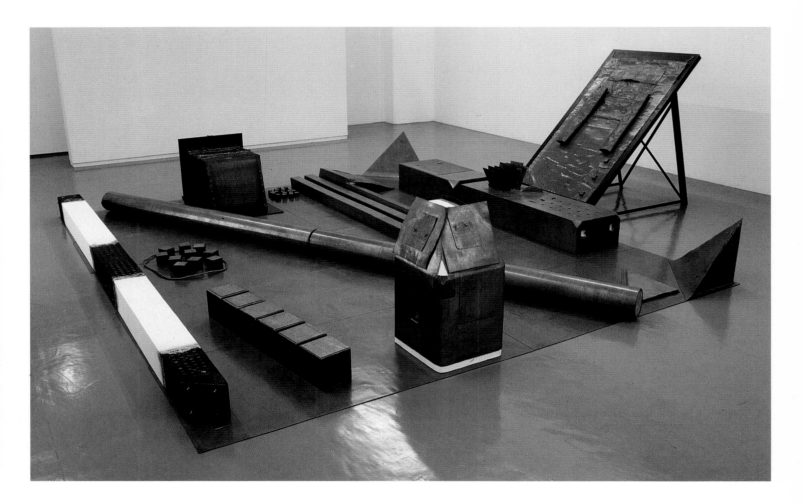

**Something Belonging to the
Green in the Air I**
1982
Lead, iron, and wood;
lead plate: 400 x 474.5 cm
(157½ x 186¾ in.).
Collection Aichi Prefec-
tural Government. Pho-
tographer: Yoshitaka
Uchida.

ing—but soon it would begin to rust, some-times the same day; by evening the as-pect that you worked hard to bring out would have rust on it. So the issue of what to do about the rust emerged. In the begin-ning I thought of trying to stop the rust, [but then I realized that] rust is one of the es-sential qualities of iron. Historically rust has been considered a disadvantage, the weak point of iron, but [a sculptor] using iron must look at the entirety of its nature, and the issue of what is "good" or "bad" about that nature is really just a human prob-lem. You can also think of your attitude toward iron as one of its essential qualities.

One problem that has arisen for me as an artist is that iron is not something that you make yourself. While you can be in-volved with stone or wood in their most ele-mental forms, with iron you are generally forced to use factory-made products, such as pipes and sheeting. Somehow this is one aspect of working with iron that remains un-satisfying for me. Yet if you look at the entire nature of iron, this problem can be solved to a certain extent. Iron has an ex-tremely long cycle, much longer than that of water. If you look at each part of this cycle, in other words, the short spans that constitute the cycle, it is just in one of these spans that you as an artist can become

involved. Isn't this what making art means? Isn't making a work also part of this cycle?

I became very interested in gardens when I was working on a project for the Takanawa Museum in Karuizawa. In making a garden, the primary concern is the space: how can I make this space mine? While creating a garden involves many types of work, first the space must be divided. But where and how should it be divided?

When you create a garden, you do not create something that is complete. If you plant a tree, in a year it will have grown. In five years its shape may have changed. After several decades it may wither and die. If I use earth to make a mountainlike shape, the rain will gradually wash it away.

When you first create a space, you try to find a balance by keeping these factors in mind: one part will move in a certain way, another part may begin to sink, and another may disappear. Still there needs to be some sort of starting line that is based on the thoughts, concerns, and sensibilities of the person creating the work. Then there is no alternative but to leave the rest to something else.

There are things that stop in the space and things that pass through it. People enter and then leave, passing through. If you

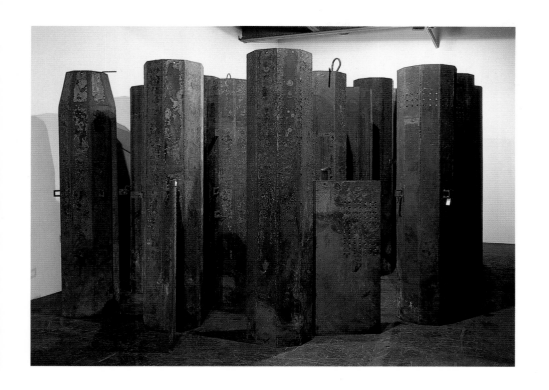

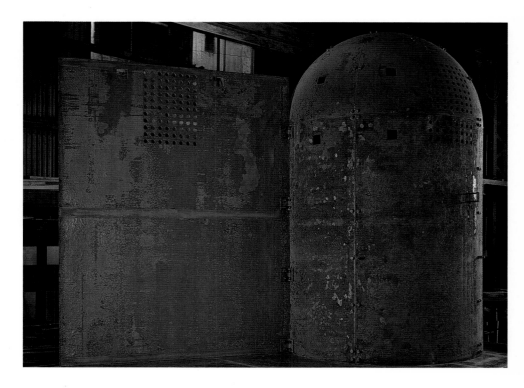

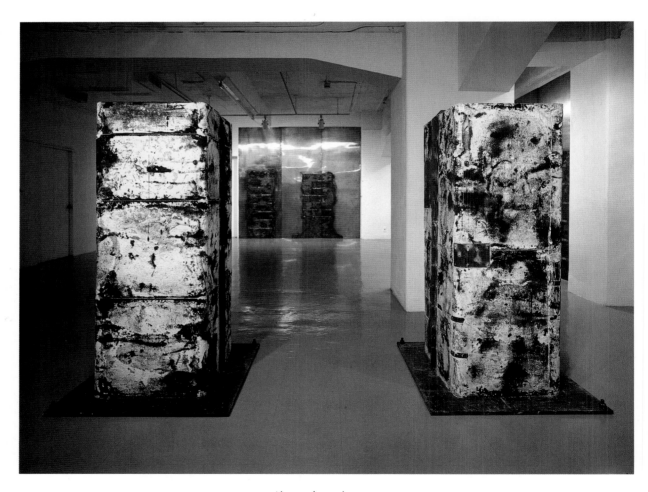

Above and opposite:
**Sulfuret Garden—
A Distant Imagery**
Installation views
(details), Akira Ikeda
Gallery, Tokyo
1989

Copper, sulfur, and steel;
copper drawings: eighteen
pieces 252 x 100 cm (99¼
x 39⅜ in.), eight pieces
268 x 100 cm (105½ x 39⅜
in.); sulfur columns: 151 x
54 x 64.5 cm (59½ x 21¼
x 25⅜ in.); steel bases: 85

x 92 cm (33½ x 36¼ in.).
Collection Akira Ikeda
Gallery, Tokyo.
Photographer:
Tadasu Yamamoto.

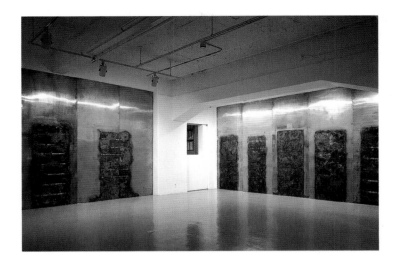

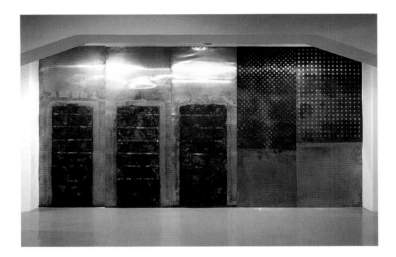

think about this, you realize that it is not possible for something to continue indefinitely in an original condition or form. In terms of what the artist does, I slightly rearrange one part or change the shape or simply take one part and move it somewhere else. If there is such a thing as a greater cycle of existence, I become involved with a moment or a part of that cycle. Perhaps it is a unique Japanese way of thinking. In Buddhist terms this would be described as the "coexistence" with materials. However, I don't think that [materials] can be described as being alive.

When I was a child, a fire destroyed my house and a factory next door. My family was in a business that used cotton, and in the warehouse next door there were things like salt, oil, matches, and sulfur. The charred remains of that building and those materials became an indelible memory, an experience that has strongly affected my vision of materials.

The form that the sulfur takes in *Sulfuret Garden—A Distant Imagery* is that of cotton bales, and this form is seen on the copper drawings that surround the room. The copper plates themselves have no association with the fire, but my work long ago with copper engraving suggested some of the uses of copper. Since 1977 I have used copper plates in many of my works.

When I started to make the masses of sulfur for this work, I happened to have several copper plates in my studio and used them to create a mold. There was a chemical reaction, however, and the surface of the sulfuric mass turned a beautiful dark blue. I used the same chemical reaction to create the copper drawings for this work. This is not like a drawing on top of the material, like using paint on canvas, but a change in the actual material itself that becomes the drawing.

■

Exhibition Histories and Bibliographies

compiled by Kiyoko Mitsuyama with the assistance of Yoko Uchida, Rie Oshima, Yuko Yoshida, Kasumi Morimura, Toshiko Tsushima, Naoko Matsumoto, Mariko Himeta, and Stan N. Anderson

Japanese titles have been translated into English. Titles originally in English have been so indicated.

Exhibition catalogues are designated in each artist's exhibition history by the symbol ■. The catalogue is in the language of the country of exhibition unless otherwise indicated.

Koichi Ebizuka

1951
Born in Yokohama City, Kanagawa Prefecture
1979
Received M.F.A. from Tama Art University, Tokyo

Solo exhibitions
1975
Tokyo: Tamura Gallery
1976
Yokohama: Muon
1977
Tokyo: Tamura Gallery
1978
Tokyo: Tokiwa Gallery
1979
Tokyo: Tamura Gallery

1980
Tokyo: Hakudotai Gallery; Tokiwa Gallery
1981
Nagoya: Gallery Westbeth ■

Tokyo: Gallery Yo; Tama New Town, Nagayama Danchi No. 4 Park
1982
Nagoya: Gallery Westbeth ■

Tokyo: Parco Gallery Spoon ■; Galerie Tokoro; Gallery White Art
1983
Tokyo: Gallery Yo ■
1984
Nagoya: Gallery Westbeth ■

Tokyo: Newz; Galerie Tokoro
1985
Tokyo: Gallery Act ■; Newz; Gallery Space 21
1986
Tokyo: Newz; Galerie Tokoro ■
1987
Kobe: Toa Road Gallery

Nagoya: Gallery Westbeth

Tokyo: Galerie Tokoro
1988
Tokyo: Gallery Lunami; Galerie Tokoro ■ (Japanese, English)
1989
Tokyo: Galerie Tokoro ■ (Japanese, English)

Group exhibitions
1970
Tokyo: Borontei
1975
Tokyo: Tama Art University, "'T' Seminar Exhibition: Self-Expression"; Tamura Gallery, "'T' 8 Exhibition"
1976
Tokyo: Maki Gallery

1978
Tokyo: Tama Art University, "'T' Seminar Exhibition: Can You Make an Artwork Which Is Not Art?"

Urawa: Touden Gallery, "Image of Image"
1979
Taegu, Korea: "5th Taegu Contemporary Art Festival"

Tokyo: Kinokuniya Gallery, "Self-Purification: Blank to Blank"

Urawa: Saitama Kaikan, "Angle of Incidence and Angle of Reflection"

Yokohama: Kanagawa Prefectural Gallery
1980
Paris: Centre Georges Pompidou, "Operation Equinox '80"

Tokyo: Kinokuniya Gallery, "Self-Purification: Melody Created by Wave Motion"; Gallery Lunami, "Planning Project '80"

Yokohama: Gallery Shiba, "Self-Purification: Knitting Point—Knitted Point"
1981
Nagoya: Gallery Westbeth, "Westbeth Art Exhibition"

Tokyo: Hara Museum of Contemporary Art, "Hara Annual 11" ■ (Japanese, English); Tama Art University, "'T' Seminar Exhibition"; Gallery Yo, "'81 Final"
1982
Nagoya: Gallery Westbeth, "Westbeth Art Exhibition"

New York: Space Wa, "Photo Express from Tokyo, Japan, 1982"

Tokyo: Kinokuniya Gallery, "Glance and Inclination"; Ikebukuro Seibu, "1st Sculpture Today" ■; Tama Art University, Hachioji, "The 57th Year of Showa Special Exhibition at Tama Art University" ■

Yokohama: Civic Gallery, "The 18th 'Artists Today' Exhibition: November Steps" ■
1983
Nagoya: Gallery Westbeth, "Westbeth Art Exhibition 1983"

Tokyo: Gallery Lunami, "'83 Exhibition: 20th Anniversary of [Gallery] Lunami" ■

Toyama: Museum of Modern Art, "A Panorama of Contemporary Art in Japan—Sculpture" ■

Tsu: Mie Prefectural Art Museum, "Exhibition of the Contemporary Art of a New Generation" ■
1984
Nagoya: Gallery Westbeth, "Art '84" and "Art in Westbeth"

Tokyo: Hillside Gallery, "SD Review 1984"; Kinokuniya Gallery, "From Mechanism, From Ornament" and "The Moment of Metamorphosis"; Newz, "Newz Week"; Gallery Yo, "Vivid Fragments: Infinity and Chaos" ■ (Japanese, English)
1985
New York: Franklin Furnace/Tokyo: Fuji TV Gallery, "Artists' Books—Japan"

Taegu, Korea: Soo Gallery

Tokyo: Gallery Act, "Drawings by Three Artists"; Newz, "Obake-Yashiki '85"

Yokohama: Kanagawa Prefectural Gallery, "Contemporary Sculpture in Japan—Wood" ■
1986
Kofu: Yamanashi Prefectural Museum of Art, "Try Art: The 6th Small Art Exhibition"

Nagoya: ICA, "Contemporary Art—Dialogue with Asia, A Message from Japan"

New Delhi: Lalit Kala Academy, "6th Triennale India 1986"

Tokyo: Gallery TOM, "Exhibition for the Blind: Stone and Wood"

Yokohama: Ohkurayama Memorial Hall, "Kanagawa/ Art: A Dialogue on Peace"
1987
São Paulo: "XIX Bienal Internacional de São Paulo" ■

Tokyo: Axis Gallery, "Tokyo Tower Project Show"; Newz, "Newz Box Exhibition 1986"; Seibu Museum of Art, "Art in Japan since 1969: Mono-ha and Post Mono-ha" ■ (Japanese, English); Studio 200, "Tamabivents (Tama Art University 50th Anniversary Events): Making Material into Music, Making Music into Material"

Toyama: Museum of Modern Art, "Dialogue with Beauty '87"
1989
Dhaka, Bangladesh: Shilpakala Academy, "The 4th Asian Art Biennale Bangladesh 1989" ■ (Bengali, English)

Tokyo: Maison Franco-Japonaise, "Exposition des affiches de la Maison Franco-Japonaise et des oeuvres selectionées pour le 2ème Concours"; Soh Gallery, "Creative Aspects" ■
1990
Yokohama: Kanagawa Prefectural Gallery, "Contemporary Sculpture in Japan III: Transformation of Material and Space"

Bibliography

By the artist
1977
"The Koichi Ebizuka Exhibition: 'Box-E-Reflex—Assimilation.'" *Bijutsu Techo* 425 (October): 308.
1979
Comment in *Bijutsu Techo* 449 (May): 267.

"Personal View: Antonio Gaudí, 1852–1876." *Sho* 1:28–35.
1980
"Personal View: Antonio Gaudí/Casa Vicens." *Sho* 2:151–56.

"Weaving of Ideas and Architecture: Rudolf Steiner." *Nippon Dokusho Shinbun*, October 27.
1982
"Contemporary Art and the 'November Steps' Exhibition." *Akarengakara* 3 (November/December): 6.
1983
"Personal View: Antonio Gaudí/Casa Mila." *Sho* 4:58–64.
1985
"The Box as a Standard Measuring Instrument." *Bijutsu Techo* 548 (August): 102–3.

"From Matter to Material to Mechanism." *Tama Art University Research Bulletin*, no. 2:200–1.
1986
"Concerning Site." In *'86 Guide to World Art Competitions* (Atelier, special edition [April 25]): 8.
1988
"Sanai Dream Center." In *SD (Space Design)* 282 (March): 23–28.

"Thinking about Art by Making It." In *Yokohama Museum Citizens' Studio Survey Report*, 20–23. Yokohama: Citizens' Studio Study Group.
1989
Comment in *Light Art Gallery*, 85. Tokyo: Libroport.

About the artist
1979
Hirai, Ryoichi. Review in *Bijutsu Techo* 443 (January): 250–61.

Kitazawa, Noriaki. Review in *Bijutsu Techo* 451 (July): 217–20.

Lee, Ganso. "The Artists Who Are Searching After the Future" (in Korean). *Kukan* 147 (September): 72–79.
1980
"Special Report: Glass Tracing, Development in Space." *Bijutsu Techo* 470 (September): 65.
1981
"Exploring Space inside a Box." *Chunichi Shinbun*, July 24.

"Focusing on New Artists, Finding New Trends." *Asahi Shinbun*, December 26.

Tanaka, Kojin. "'Hara Annual 11': An Experiment with a Naive Sensitivity." *Mainichi Shinbun*, December 1, evening edition.

Thoren, Barbara. "'Hara Annual 11'" (in English). *The Japan Times*, November 29.
1982
"Art Review." *Asahi Shinbun*, June 16, evening edition.

"Stealthily Creating an Imaginary Space." *Mainichi Shinbun*, August 16, evening edition.

Tanaka, Kojin. "Koichi Ebizuka: Creating a Separate Space." *Sogetsu* 144 (October): 100–2.

Yonekura, Mamoru, and Seiichi Hoshino. "An Undulating Sculptural World." *Gendai Chokoku* 65 (November): 2–13.
1983
Exhibition review in *Mainichi Shinbun*, April 7.

Mizusawa, Tsutomu. Review in *Bijutsu Techo* 512 (July): 196–98.
1984
Akatsu, Tadashi. "A Clearly Conscious System for Liberating Materials." *Komei Shinbun*, July 7.

"Koichi Ebizuka and Toshiyuki Hishinuma, Higashi Hachimantai Kicho Mountain Villa." *SD (Space Design)* 243 (December): 20.

Maki, Fumihiko, and Hajime Yatsuka. "SD Review: Concerning the Works Accepted for Exhibition." *SD (Space Design)* 243 (December): 6–13.

Nakamura, Hideki. *Vivid Fragments: Infinity and Chaos*, 112–25. Tokyo: Sugiyama Shoten.

"Planned Grandeur." *Asahi Shinbun*, June 13.

Tanaka, Kojin. "The Real Nature of the Surface Is Revealed from Behind." *Atelier* 690 (August): 91–93.

_____ . "Revealing a Mysterious Negative Space." *Mainichi Shinbun*, June 12.

1985

Nakamura, Hideki. "Kikikaikai/Kikikaikai [Strange wooden objects, fun and delight]: The 'Contemporary Sculpture in Japan—Wood' Exhibition." *Bijutsu Techo* 542 (April): 118–24.

Yonekura, Mamoru. "The Unique Creative Ability of Japanese Artists Working in Wood Sculpture: Comments on 'Contemporary Sculpture in Japan—Wood,' The Connection with Japan's Drifting Spiritual History." *Asahi Shinbun*, February 13, evening edition.

1986

"Art Show Opens amidst Controversy" (in English). *The Hindustan Times*, February 23.

Datta, Santo. "Sixth Triennale Opens Today" (in English). *The Indian Express*, February 23.

Discussion by Yoshiaki Inui, Tadayasu Sakai, Yoshiaki Tono, and Mamoru Yonekura. "Seasonal Art Review, Autumn '86: From the End of the '60s." *Mizue* 940 (autumn): 50–63.

"Koichi Ebizuka's Wood Theater." *Geijutsu Shincho* 37, no. 8 (August): 75.

Koplos, Janet. "Four Shows, Three Dimensions" (in English). *Asahi Evening News*, June 27.

"Mirolha Opens Sixth Triennale" (in English). *The Statesman*, February 23.

Nakamura, Hideki. "Perceptual and Cultural Mixed-Bloodedness Arising from Personal Surroundings." *Mainichi Shinbun*, March 19, evening edition.

New Delhi: Lalit Kala Academy. *Japan—Triennale India 1986* (in English). Tokyo: The Japan Foundation.

"Passage to Sacred Space Made with Wood." *Asahi Shinbun*, June 21.

"Return of the International Contemporary Art Exhibition." *Chunichi Shinbun*, October 5.

"Sixth Triennale Opens" (in English). *Patriot*, February 23.

Takei, Kunihiko. "Review Tokyo." *Sansai* 460 (January): 90–91.

Tanaka, Kojin. "Uncanny Space Created with Wood and Coal." *Mainichi Shinbun*, July 4, evening edition.

Tono, Yoshiaki. "Tama Art University in Contemporary Art." In *Fifty Years at Tama Art University, 1935–1985*, 158–63. Tokyo: Tama Art University.

"Triennale Awards for Two Indian Artists" (in English). *The Times of India*, February 23.

"Triennale India Prize-Winner Koichi Ebizuka." *Atelier* 712 (June): 118.

"Visits with Artists: Koichi Ebizuka—To Work As a Way of Seeing." *Bijutsu Techo* 566 (August): 158–63.

"Works from the International Exhibition Seen in Nagoya." *Bijutsu Techo* 572 (December): 12–13.

1987

"A arte japonêsa da 'Utopia versus realidade' chega neste sábado para participar da Bienal." *Jornal Paulista*, September 22.

Discussion by Yoshiaki Inui, Tadayasu Sakai, Yoshiaki Tono, and Mamoru Yonekura. "Seasonal Art Review, Autumn '87: Mono-ha and Post Mono-ha." *Mizue* 944 (autumn): 86–101.

"The Koichi Ebizuka Exhibition." *Bijutsu no Mado* 56 (June): 75.

Koplos, Janet. "States of Existence" (in English). *Asahi Evening News*, June 19.

Miki, Tamon. "Art: Art in the News." In *Japonica Encyclopedia of Current Affairs*, 1987 ed., 256–58. Tokyo: Shogakukan.

Mizutani, Takashi. "A World Related to Material." *Mainichi Shinbun*, December 11.

"Mono-ha and Post Mono-ha" (in English). *The Japan Times*, July 12.

"Muito trabalho pela arte: 19ª Bienal Internacional de São Paulo." *Jornal Paulista*, October 1.

Nakamura, Hideki. *After Expression: The Creation of Self*, 140. Tokyo: Bijutsu Shuppansha.

Nanba, Hideo. "Sculptural Evolution: The Koichi Ebizuka Exhibition." *Atelier* 726 (August): 87.

"Repression and Rhythm." *Asahi Shinbun*, July 3.

São Paulo. *Japão—XIX Bienal de São Paulo 1987* (in Portuguese and English). Tokyo: The Japan Foundation.

"São Paulo Biennale Opening on the 2nd: Four Artists and Mr. Tono from Japan." *São Paulo Shinbum*, September 23.

"Sense of Deep Submergence." *Chubu Yomiuri Shinbun*, December 15.

Silva, Arturo. "Art at Play, Art Too Serious" (in English). *The Daily Yomiuri*, July 2.

"Spring for Art: S. P. Biennale Opens." *São Paulo Shinbum*, October 3.

Takashima, Naoyuki. "Art Now: Koichi Ebizuka." *Asahi Journal* 1466 (February 27): 33.

"A vanguarda japonêsa na Bienal." *Diário Nippak*, September 23.

1988

Matsumura, Toshio. "Interaction between Wood and Coal." *Sankei Shinbun*, October 6.

Silva, Arturo. "Koichi Ebizuka: Sculpted Drawing" (in English). *The Daily Yomiuri*, November 17.

1989

"Asian Art Show Begins Tomorrow" (in English). *The New Nation*, February 28, 1–8.

Dhaka, Bangladesh: Shilpakala Academy. *The 4th Asian Art Biennale Bangladesh 1989—Japan* (in English). Tokyo: The Japan Foundation.

Koplos, Janet. "Letter from Tokyo" (in English). *Arts Magazine* 63, no. 6 (February): 109.

"Three Get Best Prizes of Asian Art Biennale" (in English). *The Bangladesh Times*, March 8, 8.

Toshikatsu Endo

1950
Born in Takayama City, Gifu Prefecture
1972
Graduated from Nagoya Junior College of Creative Art (three-year program)

Solo exhibitions
1975
Tokyo: Gallery Lunami; Sato Gallery
1977
Nagoya: Gallery U

Tokyo: Tokiwa Gallery
1978
Tokyo: Kobayashi Gallery; Sato Gallery
1979
Tokyo: Nirenoki Gallery
1980
Nagoya: Gallery U

Tokyo: Tamura Gallery
1981
Tokyo: Gallery Lunami; Gallery Parergon
1982
Tokyo: Independent Gallery
1983
Tokyo: Gallery Yo ■
1984
Nagoya: Gallery Takagi

Tokyo: Newz; Gallery Yo ■
1985
Nagoya: Gallery Takagi

Tokyo: Gallery Act; Gallery Yo ■
1986
Osaka: Gallery Haku ■

Tokyo: Gallery Yo ■
1987
Osaka: Gallery Haku

Paris: Galerie Gutharc-Ballin

Tokyo: Akiyama Gallery ■ (Japanese, English);
Gallery Yo
1988
Osaka: Gallery Haku

Paris: Galerie Gutharc-Ballin

Tokyo: Gallery Yo ■
1989
Helsinki: Nordic Arts Centre ■ (Finnish, Swedish,
English)

Nagoya: Gallery Takagi ■

Nancy: Parc de la Pépinière

Osaka: Gallery Haku ■

Shibukawa, Gunma: Concept Space

Tokyo: Akiyama Gallery, "Lotus" ■

Group exhibitions
1974
Tokyo: Tokiwa Gallery, "Paper Memorial"
1975
Nagoya: Aichi Prefectural Art Gallery, "'75 Autumn
in Nagoya"

Tokyo: Tokiwa Gallery
1977
Urawa: Saitama Kaikan, "Four Days in Urawa"
1978
Saitama: Tokorozawa Aviation Memorial Park, "'78
Tokorozawa Open-Air Exhibition" ■ (Japanese, English)

Tokyo: Gallery Lunami
1979
Tokyo: Gallery Komai

Urawa: Saitama Kaikan, "Angle of Incidence and
Angle of Reflection"
1980
Tokyo: Gallery Lunami, "Planning Project '80";
Tokiwa Gallery, "The Work Was Here"

Yokohama: Kanagawa Prefectural Gallery, "Adesugata
Hana no Ayadori"
1981
Tokyo: Gallery Lunami; Gallery Parergon

Yokohama: Kanagawa Prefectural Gallery, "State-Style" ■
1982
Tokyo: Joshibi Gallery ■; Gallery Yo, "'82 Spring
Festival"

Yokohama: Civic Gallery, "The 18th 'Artists Today'
Exhibition: November Steps" ■
1983
Tokyo: Kinokuniya Gallery; Gallery Lunami, "'83
Exhibition: 20th Anniversary of [Gallery] Lunami" ■;
Gallery Parergon, "For the Night"

Tsu: Mie Prefectural Art Museum, "Exhibition of the
Contemporary Art of a New Generation" ■

Yokohama: Civic Gallery, "From Word to Thing and
Place" ■ (Japanese, English); Kanagawa Prefectural
Gallery, "Exhibition Kai" ■
1984
Hamamatsu: Nakatajima Sand Hill, "The 4th Hamamatsu
Open-Air Exhibition 1984" ■

Tokyo: Newz, "Newz Week"; Ohara Center, "Parallelism
in Art 4: Subject—Symbol—Apparition" ■ (Japanese,
English); Gallery Yo, "Document: 'The 4th Hamamatsu
Open-Air Exhibition 1984'"

Tokyo: National Museum of Modern Art/Osaka: National Museum of Modern Art, "Metaphor and/or Symbol:
A Perspective on Contemporary Art" ■ (Japanese, English)
1985
Gifu: Museum of Fine Arts, "Art Now Gifu" ■

Hinuma, Ibaraki: "'85 Hinuma: An Aspect of Earth"

Kawasaki City, Kanagawa: IBM-Kawasaki City Gallery,
"Continuum '85 Pre-Exhibition" ■ (Japanese, English)

Kyoto: Galerie 16, "Resurrections of Allegory" ■

Melbourne: Gryphon Gallery, "Continuum '85" ■
(English, Japanese)

Tokyo: Akiyama Gallery ■; Newz; Gallery 21

Yokohama: Kanagawa Prefectural Gallery, "Contemporary Sculpture in Japan—Wood" ■
1986
Ishinomaki: Culture Center, "The Culture of Water:
An Approach through Wood" ■

Nagoya: ICA, "Contemporary Art: Dialogue with
Asia, A Message from Japan"

New Delhi: Lalit Kala Academy, "6th Triennale India
1986"

Sendai: Miyagi Museum of Art, "A Scene of Contemporary Japanese Art 3: The New Generation" ■
(Japanese, English)

Tokyo: Kaneko Art Gallery, "Vision/Dream/Image
1986"; Newz, "When Matter Penetrates the Network of
Nerves"

Tokyo/Osaka/Sapporo: Contemporary Sculpture Center,
"New Trends in Contemporary Sculpture: Ten New
Outstanding Sculptors of America and Japan"

Urawa: Museum of Modern Art, Saitama, "Black and
White in Art Today"

Yokohama: Ohkurayama Memorial Hall, "Kanagawa/
Art: A Dialogue on Peace"
1987
Honolulu: University of Hawaii Art Gallery, "The 3rd
International Shoebox Sculpture Exhibition" ■ (English)

Karuizawa: Museum of Modern Art, Seibu Takanaka,
"Art Today 1987" ■

Kassel: Museum Fridericianum, "Documenta 8" ■

New York: Salvatore Ala Gallery, "New Trends in
Contemporary Sculpture: Five Japanese Artists' Works" ■
(English)

Osaka: Gallery Haku ■

Shibukawa, Gunma: City Park, "Shibukawa Triennial
Exhibition of Contemporary Sculpture '87"

Tokyo: Hara Museum of Contemporary Art, "Hara
Annual VII" ■ (Japanese, English); Kaneko Art Gallery,
"Vision/Dream/Image 1987"; Nabis Gallery, "Drawing: In the Vicinity of Presentiment"; Newz, "Newz Box
Exhibition 1986"; Seibu Museum of Art, "Art in Japan
since 1969: Mono-ha and Post Mono-ha" ■
(Japanese, English)

Urawa: Museum of Modern Art, Saitama, "Icons in
Contemporary Art" ■ (Japanese, English)
1988
Hakushu, Yamanashi: "Summer Art Festival in
Hakushu '88"

Munich: All Art Forum Thomas München, "Aspekte
der Biennale Venedig 1988"

Tokyo: Gallery Gen, "Haiku in Drawing"; Gallery
Q + 1, "Pulse of Desire"

Venice: Corderie dell'Arsenale, "43ª Esposizione
Internazionale d'Arte 'La Biennale di Venezia':
Aperto '88" ■
1989
Antwerp: Openluchtmuseum voor Beeldhouwkunst
Middelheim, "20ste Biënnale Middelheim-Japan" ■
(Flemish, French, English)

Nagoya: ICA, "On Kawara—Again and Against:
Twenty-Three Date Paintings and Twenty-Four Prominent
Works of Japanese Contemporary Art, 1966–1989"

Osaka: Contemporary Art Center, "Osaka Contemporary
Art Fair '89"; Kodama Gallery, "Five Drawings";
National Museum of Art, "Drawing as Itself" ■ (Japanese,
English)

Tokyo: National Museum of Modern Art, "Art of the
Showa Period from the Museum Collection"
1990
Yokohama: Kanagawa Prefectural Gallery, "Contemporary Sculpture in Japan III: Transformation of Material
and Space"

Bibliography

By the artist
1975
"Towards a Wholeness of Expression." Untitled literary
magazine, 2–9.
1976
"Reading Water." Untitled literary magazine, 17–18.
1979
Comment in "Art in Progress, November 1978–March
1979: Exhibition in Tokyo." *Sho* 1:71.

"From Captivity." *Sho* 1:81–87.
1980
"Sculpture/Photograph." *Sho* 2:74–75.
1983
Comment in "The New Generation and New Style
of Contemporary Art: Statements by Forty Notable
Artists." *Bijutsu Techo* 508 (March): 60.
1984
"The Repetition of Near Despair." *Bijutsu Techo* 528
(July): 22–23, 30.

"A Story for the Eye in the Work of Shigeo Toya."
IAF-Tsushin (Institute of Art Function) 3 (February): 7–8.

1985

"The Case of a Master Carver of Takayama" and "Memorandum on Tools." In *A Craftsman's Microcosm— Work and Tools: Inax Booklet* 3:61–69.

"Continuum '85 Report." *Chubu Yomiuri Shinbun*, November 24.

1987

"A Means to Achieve a Japanese Modernism—My Paradoxical Opinion: Abandon the Westernism and Internationalism of Art." *Chubu Yomiuri Shinbun*, September 11.

"Towards a Circle." *Mizue* 942 (spring): 82–85.

About the artist

1974

Hirai, Ryoichi, and Arata Tani. Review in *Bijutsu Techo* 386 (October): 250–59.

1978

Motoe, Kunio. Review in *Bijutsu Techo* 441 (November): 239–41.

1979

Kitazawa, Noriaki. Review in *Bijutsu Techo* 455 (October): 254–55.

1980

Kishimoto, Nahoko. Review in *Bijutsu Techo* 471 (October): 219.

1982

Mizusawa, Tsutomu. Review in *Bijutsu Techo* 502 (October): 174–75.

Motoe, Kunio. "The Meaning and Quality of a Work." *Bijutsu Techo* 491 (January): 166–83.

Takagi, Shu. "Concerning Meaning: Two-Artist Exhibition of Toshikatsu Endo and Shigeo Toya." *Parfum* 43 (autumn): 26.

1983

Akita, Yuri. "The Present State of Contemporary Art 8: The Style of A Generation." *Sogetsu* 147 (April): 94–96.

"The Current State of Art Criticism: Simultaneously Striking the World of Existence and Production and the Circuitry of Consumption." *Nippon Dokusho Shinbun*, February 28.

1984

"The Japanese Character of Contemporary Art: The New Generation's View of What Is Japanese." *Atelier* 689 (July): 19–21.

Kitazawa, Noriaki. "Explanation of Cover." *Beruf* 4 (March): 8.

"The Relationship between the Landscape and 'Vessel': Toward Originality." *Atelier* 687 (May): 32–33.

1985

Nakamura, Hideki. "Kikikaikai/Kikikaikai [Strange wooden objects, fun and delight]: The 'Contemporary Sculpture in Japan—Wood' Exhibition." *Bijutsu Techo* 542 (April): 118–24.

———. "Water with Viscosity: Anti-Western Modernistic Active Human Existence Seen in Katsushika Hokusai and Toshikatsu Endo." *Seikatsu Bunka Shi* 8:3–20.

Tanaka, Kojin. "'85 Hinuma: An Aspect of Earth.'" *Mainichi Shinbun*, October 4, evening edition.

Yonekura, Mamoru. "The Unique Creative Ability of Japanese Artists Working in Wood Sculpture: Comments on 'Contemporary Sculpture in Japan— Wood,' The Connection with Japan's Drifting Spiritual History." *Asahi Shinbun*, February 13, evening edition.

1986

Chiba, Shigeo. "Japanische Kunst Heute." *Noema*, no. 5:8–11.

Discussion by Yoshiaki Inui, Tadayasu Sakai, Yoshiaki Tono, and Mamoru Yonekura. "Seasonal Art Review, Spring '86: Art and Ecology." *Mizue* 938 (spring): 36–49.

———. "Seasonal Art Review, Autumn '86: From the End of the '60s." *Mizue* 940 (autumn): 50–63.

Nakamura, Hideki. "Report from Abroad: 6th Indian Triennial—The Energy for Self-Renewal." *Bijutsu Techo* 563 (May): 113–17.

New Delhi: Lalit Kala Academy. *Japan—Triennale India 1986* (in English). Tokyo: The Japan Foundation.

Tatehata, Akira. "Ambiguous Sculpture." *Bijutsu Techo* 563 (June): 42–47.

"Visits with Artists: Toshikatsu Endo—The Ascendence of Non-Form." *Bijutsu Techo* 569 (October): 126–36.

1987

Durand, Régis. "Endo, Galerie Gutharc-Ballin." *Art Press* 117 (September).

Fujieda, Teruo. "Special Report: 'Documenta 8'—Has the Point Been Made?—Contemporary Materials." *Bijutsu Techo* 585 (September): 59–67.

Koplos, Janet. "Floating World" (in English). *Asahi Evening News*, April 10.

Nakamura, Hideki. *After Expression: The Creation of Self.* Tokyo: Bijutsu Shuppansha.

"New Trends in Contemporary Sculpture" (in English). *Artnews* 86 (November): 213–14.

Roberts, James. "Notes: Tokyo Report" (in English). *Artscribe International* 63 (May): 7–10.

Sanda, Haruo. "The Toshikatsu Endo Exhibition: A World of a New Dimension within an Iron Circle." *Mainichi Shinbun*, December 15, evening edition.

Silva, Arturo. "Flesh, Mind and No-Mind at the Hara" (in English). *The Daily Yomiuri*, March 27.

Takashima, Naoyuki. "Art Now: Toshikatsu Endo." *Asahi Journal* 1470 (March 20): 34.

Tanaka, Kojin. "'Hara Annual VII': Not a Grafting of Westernisms but a Nurturing of an Original Environment." *Mainichi Shinbun*, March 27, evening edition.

Vallombrossa, Jean-Paul. "Hara VII" (in English). *Tokyo Journal* 7, no. 1 (April): 62–63.

1988

Discussion by Shigeo Chiba, Kenjiro Okazaki, Toshikatsu Endo, and Shigeo Toya. "Considering the Today of Contemporary Sculpture." *Shinbijutsu Shinbun*, January 21.

"Endo." *Événement du jeudi* 206 (October 13–19).

Gibson, Michael. "Venice Biennale: Giving Artists the Last Word" (in English). *International Herald Tribune*, June 29.

Matsuoka, Seigo. "What to Make of Place as Place." *Bijutsu Techo* 601 (November): 184–87.

Mercuri, Bernardo. "Young Art—'Aperto '88': The Absent Alter-Ego" (in English). *Tema celeste* 17/18 (November/December): 51.

Minamishima, Hiroshi. Review in *Bijutsu Techo* 601 (November): 243–45.

Minemura, Toshiaki. "Contemporary Japanese Art in Today's International Arena: Finding Four Excellent Exhibitions in Paris and Milan." *Mainichi Shinbun*, November 14, evening edition.

Motoi, Masaki. Interview with Toshikatsu Endo in *Pulse of Desire*, exh. cat. (Tokyo: Gallery Q + 1).

Nanjo, Fumio. "An Idea from a Key Word—from the 'Aperto '88' Project." *Bijutsu Techo* 599 (September): 58–77.

"Paris d'hiver: Notes de voyage." *Kanal*, December: 48.

1989

"Arts: Toshikatsu Endo à Nancy." *Le Monde*, August 9.

"Artwork with a Strong Physical Presence." *Chunichi Shinbun*, October 24, evening edition.

Barten, Walter. "Japanners in Middelheim." *Kunst-kroniek*, September 18.

Bekkers, Ludo. "Japanse beeldhouwkunst sinds 1970." *Kunstforum* 103 (September/October).

Botquin, Jean-Michel, and Claude Lorent. "Modernité sculpturale." *Art et culture* (June): 47–48.

Chiba, Shigeo. *Departures from the History of Contemporary Art.* Tokyo: Shobunsha.

"De la Pépinière aux prémontrés Endo . . . à bâtons rompus." *Le Républicain lorrain*, August 19.

Discussion by Toshikatsu Endo, Katsura Funakoshi, Shigeo Toya, and Toshiaki Minemura. "Artists Fluttering Out into the World." Parts 1, 2. *Gallery* 46 (February): 10–19; 47 (March): 10–19.

Discussion by Yoshiaki Inui, Tadayasu Sakai, Yoshiaki Tono, and Mamoru Yonekura. "Seasonal Art Review, Autumn '87: Mono-ha and Post Mono-ha." *Mizue* 944 (autumn): 86–101.

"Été de la sculpture: Endo tout feu tout flammes." *Le Républicain lorrain*, August 20.

Gillemon, Daniele. "Promenade au bois: Pas de loup au Middelheim." *Le Soir* (Brussels), July 5.

"Hedendaagse Japanse beeldhouwers in Middelheim." *Gazet van Antwerpen*, June 14.

Huylebroeck, Paul. "Vijftien Japanners naar Antwerpse Biënnale." *Gazet van Antwerpen*, May 10.

"Japanische moderne Gast der Biennale Middelheim." *Der Kontact*, June: 27–28.

Koplos, Janet. "Through the Looking Glass: A Guide to Japan's Contemporary Art World" (in English). *Art in America* 7 (July): 98–107.

Leboeuf, P. "L'été de la sculpture: Endo fête les quatre éléments." *Est-Républicain*, August 18.

Meuris, Jacques. "Middelheim-Japon: Europalia est lancé!" *La Libre* (Brussels), July 7.

"Middelheim-Biënnale vijftien deel-nemers." *Gazet van Antwerpen*, June 14.

Mizutani, Takashi. "Rapport with a Primal World: The Toshikatsu Endo Exhibition." *Mainichi Shinbun*, October 27, evening edition.

Moulin, François. "L'insaisissable [été] de la sculpture." *Est-Républicain*, August 20.

Nanjo, Fumio. "Japanese Contemporary Art Highlighted on the International Stage." *Asahi Shinbun*, January 16, evening edition.

Nardon, Anita. "Anvers: La fête." *Le Drapeau rouge* (Brussels), July 4.

O'Brien, Rodney. "Celebrant of Fire, Water, and Earth" (in English). *The Japan Times Weekly*, April 8.

Poitevin, Jean-Louis. "Paris promenades." *Kanal*, October: 95.

Saloranta Moilanen, Marja. "The Magic Circle" (in Finnish). *Uusi Suomi*, April 23.

Sanda, Haruo. "Plastic Arts Striving for Breath in Nature: Belgium's 'Contemporary Japanese Sculpture Exhibition.'" *Mainichi Shinbun*, July 31.

———. Review in *Bijutsu Techo* 611 (July): 217–19.

———. "The Toshikatsu Endo Exhibition: Compressed Operation beyond Individuality." *Mainichi Shinbun*, April 10, evening edition.

Schröte, Gisela. "Magische Präsenz." *Handelsblatt* (Düsseldorf) 144, July 28–29.

"Sculpture Endo . . . scopie à la Pépinière." *Est-Républicain*, August 17.

"Sure-Footed Progress Partaking of the Spirit of the Age: The Toshikatsu Endo Exhibition." *Asahi Shinbun*, November 4, evening edition.

Tarantino, Michael. "Art from Japan" (in English). *The Bulletin*, August 10.

Tatehata, Akira, and Hiroshi Minamishima. "A Raw, Vibrant Art: Show It to the World." *Nikkei Art* 12 (September): 163–68.

Valjakka, Timo. "Ei länttä ei itää." *Helsingin sanomat*, April 19.

Van Oudenhove, Madeleine. "Les expositions d'été Europalia-Japon '89." *Gazet van Antwerpen*, June 30.

Verhoye, Bert. "Japan in Middelheim." *Kunst de vrijdag cultuur*, June 16.

———. "Japan in Middelheim." *Met Laatste Nieuws*, June 16.

"De vier elementen volgens Toshikatsu Endo." *Thema*, June 14.

Chuichi Fujii

Abe Frajndlich

1941
Born in Nara Prefecture
1962
Completed woodcarving course at Nara Prefectural Craft Training Center

Solo exhibitions
1971
Nara: Prefectural Culture Center
1976
Osaka: Imabashi Gallery
1977–1980
Osaka: Shinanobashi Gallery (four exhibitions)
1981
Osaka: Ban Gallery

Tokyo: Gallery Okabe
1982
Osaka: Ban Gallery
1983
Tokyo: Gallery Ueda Warehouse
1985
New York: Carpenter and Hochman

Tokyo: Gallery Ueda Warehouse
1987
Tokyo: Gallery Ueda Warehouse
1989
Tokyo: Spiral Garden

Group exhibitions
1968–1975
Tokyo: Metropolitan Art Museum, "Ichiyo-Kai Exhibition" (eight exhibitions; elected to associate membership in 1973)
1984
Gifu: Museum of Fine Arts, "The Plastic Arts of Today—Wood and Paper: A Dialogue with Nature" ■
1985
Yokohama: Kanagawa Prefectural Gallery, "Contemporary Sculpture in Japan—Wood" ■

1986
Hyogo: Prefectural Museum of Modern Art, "Art Now '86" ■ (Japanese, English)

Bibliography

About the artist
1983
"Patterns in New Culture: Adventurous Individuals 3: Strength and Endurance, A Dedicated Man of Few Works." *Nippon Keizai Shinbun*, April 23.

"Within Roughness, Tension and Sensitivity Strive for Breath." *Komei Shinbun*, November 19.

"'?' A Wondrous Object." *Geijutsu Shincho* 408 (December): 39.
1984
Akatsu, Tadashi. "The Multiplication of Images, A Sculptural Object." *Ohararyu Soka* 398 (January): 82–83.
1985
Akutagawa, Kiyoshi. "With Wood Art Chuichi Fujii Invades New York." *Yomiuri Shinbun*, July 29, evening edition.

Brenson, Michael. "Art: Porter Paintings on Display" (in English). *The New York Times*, September 13.

Joseph, Lawrence E. "New York Reviews: Fujii Chuichi" (in English). *Artnews* 84, no. 10 (December): 124.

———. "Tokyo: Tradition vs. High Tech" (in English). *Artnews* 84, no. 9 (November): 139–40.

Kuspit, Donald. "Fujii Chuichi" (in English). *Artforum* 24, no. 3 (November): 103.

Larson, Kay. "Art." *New York Magazine* 18, no. 38 (September 30): 84.

"The Sale of Wood Art Ignored by Japanese Collectors." *Box* 65, August: 79.

Tanaka, Kojin. "The Chuichi Fujii Exhibition: Leading toward an Artificial Nature." *Mainichi Shinbun*, April 19, evening edition.

———. "The Forms of Sensitivity 8: The Common Relationships Seen in Wood." *Ikebana Ryusei* 304 (August): 36–37.

"Visits with Artists: Chuichi Fujii—The Words of Wood." *Bijutsu Techo* 546 (July): 122–28.

Yonekura, Mamoru. "The Unique Creative Ability of Japanese Artists Working in Wood Sculpture: Comments on 'Contemporary Sculpture in Japan—Wood,' The Connection with Japan's Drifting Spiritual History." *Asahi Shinbun*, February 13, evening edition.
1987
"The Chuichi Fujii Exhibition." *Shinbijutsu Shinbun*, May 21.

"Chuichi Fujii's 'Wood Art' Exhibition." *Mokuzai Kogyo Kikai Shinbun*, May 25.

Koplos, Janet. "Something Missing" (in English). *Asahi Evening News*, May 15.

Tanaka, Kojin. "The Chuichi Fujii Exhibition: A Curious Material's Sense of Absolute Existence." *Mainichi Shinbun*, May 15, evening edition.
1988
Matsueda, Itaru. "Nature as a Metaphor of Life." *Sogetsu*, special edition (autumn): 34–48.

Schaarschmidt-Richter, Irmtraud. "Chuichi Fujii." *Frankfurter Allgemeine Magazin* (December 30): 10–17.
1989
"Chuichi Fujii" (in Japanese and English). *Hara Museum Review*, autumn, 3–4.

Koplos, Janet. "Letter from Japan" (in English). *Arts Magazine* 64, no. 1 (September): 110–11.

"The Power of Nature's Unknown Potential: The Overflowing Force of Kitayama Cedar in Chuichi Fujii's Exhibition." *Mainichi Shinbun*, January 19, evening edition.

Tadashi Kawamata

© Shigeo Anzai

1953
Born in Hokkaido
1981
Received M.F.A. from Tokyo National University of Fine Arts and Music

Projects
1979
Tokyo: Tama Riverside, "By Land"
1982
Tokyo: Apartment project "Takara House Room 205"
1983
Fukuoka: Apartment project "Otemon, Wada-so"

Saitama: Apartment project "Slip in Tokorozawa"

Sapporo: Apartment project "Tetra House N-3 W-26" for Mr. and Mrs. Endo

1984
Tokyo: Kaneko Art Gallery, Tokyo Gallery, Jewelry Shop Olphe, Gallery Kobayashi: "Ginza Network"; Kawamata and PH Studio, Hillside Terrace, "Under Construction"
1985
New York: "Limelight Project"; P.S. 1, "P.S. 1 Project"
1986
The Hague: Construction site project "Spui Project"
1987
Grenoble: Construction site project for "La Maison des Squatters"

Kassel: "Destroyed Church"
1988
Kyoto: "Hienso"

Shizuoka: Construction site project, Fukuroi
1989
Kortrijk: "Begijnhof"

Toronto: Yonge Street, "Colonial Tavern Park"

Solo exhibitions
1979
Tokyo: Gallery Maki; Tamura Gallery
1980
Tokyo: Kobayashi Gallery
1981
Kyoto: Studio 37

Nagoya: ASG

Tokyo: Gallery K
1982
Osaka: Gallery Haku
1983
Fukuoka: Ten Gallery

Tokyo: Kaneko Art Gallery
1984
Paris: Galerie Farideh Cadot

Tokyo: Hillside Gallery
1985
New York: P.S. 1 Studio
1986
Tokyo: Hillside Gallery; Kaneko Art Gallery
1987
São Paulo: Galeria Unidade Dois

Tokyo: Kaneko Art Gallery
1988
New York: Storefront Gallery

Tokyo: Hillside Gallery

Group exhibitions
1979
Tokyo: National University of Fine Arts and Music
1980
Tokyo: Hara Museum of Contemporary Art, "Hara Annual 1: Vision for the '80s" ■; Metropolitan Art Museum, "Seven Scenes"; National University of Fine Arts and Music, "Ueno 80"

Yokohama: Civic Gallery, "The 16th 'Artists Today' Exhibition: Emotion and Construction" ■; Kanagawa Prefectural Gallery, "Adesugata Hana no Ayadori"
1981
Melbourne: Gryphon Gallery, "Reverberations"

Tokyo: Ohara Center, "1st 'Parallelism in Art' Exhibition"

Yokohama: Civic Gallery, "The 17th 'Artists Today' Exhibition: Wall" ■
1982
Nuremberg: Kunsthalle, "2te Internationale Jugendtriennale der Zeichnung" ■

Venice: "Arte Visive '82: La Biennale di Venezia" ■
1983
Düsseldorf: Kunsthalle, "Fünf zeitgenössische Künstler aus Japan" ■

Fukuoka: Art Museum, "Materials and Spaces" ■

Geneva: Musée d'Art et d'Histoire/Musée Rath, "Un regard sur l'art japonais d'aujourd'hui" ■

Urawa: Museum of Modern Art, Saitama, "Shape and Spirit in Wood Works" ■
1985
Asahikawa, Hokkaido: Museum of Art, "The Beauty of Wood: Between Painting and Sculpture" ■

New York: Clocktower, "National and International Studio Artists' Exhibition"; Franklin Furnace, "Artists' Books—Japan"; Storefront Gallery, "After Tilted Arc"

Paris: Jullien-Cornic Galerie d'Art, "Sculpture japonaise contemporaine" ■
1986
Hartsville, South Carolina: Cecilia Coker Bell Gallery, Coker College

Rome: Sala Uno, "Contatto: Passage Project" ■

Sendai: Miyagi Museum of Art, "A Scene of Contemporary Japanese Art 3: The New Generation" ■ (Japanese, English)
1987
Aix-en-Provence/Marseille/Grenoble: "Japon art vivant '87" ■

Kassel: Museum Fridericianum, "Documenta 8" ■

São Paulo: "XIX Bienal Internacional de São Paulo" ■

Tokyo: Seibu Museum of Art, "Art in Japan since 1969: Mono-ha and Post Mono-ha" ■ (Japanese, English)
1988
New York: World Financial Center, "The New Urban Landscape"
1989
Osaka: National Museum of Art, "Drawing as Itself" ■ (Japanese, English)

Bibliography

By the artist
1981
"Adventure in Xerography 43: The Fact That a Copy Is an Empty Form." *Graphication* 185 (November): 26–27.
1983
Comment in "The New Generation and New Style of Contemporary Art: Statements by Forty Notable Artists." *Bijutsu Techo* 508 (March): 57.

"Europe, Japan, Tokyo, and Sapporo." *Dokusho Hokkaido*, July 15.

"Spatial Construction: On Connecting with a Site."
Hokkaido Shinbun, August 27, evening edition.
1986
"'Bird's Nest' in the Midst of a City Plan: Reflections
on the Hague Project." *Mainichi Shinbun*, October
20, evening edition.

"Hague Workshop (Public Demonstration of Working
Process): Relationship with the City, Activation Through
Art." *Hokkaido Shinbun*, October 4, evening edition.
1989
"Art's New Century." *Wave* 22:56–61.

About the artist
1980
Discussion by Tadashi Kawamata and Teruo Fujieda.
"Conversation with the Present 2: On Filling Up a
Space." *Mizue* 903 (June): 76–83.

Sasaki, Mieko. "'Hara Annual' Show On" (in English).
Daily Yomiuri, December 11.

Thoren, Barbara. "The Week in Art: 'Hara Annual 1:
Vision for the '80s'" (in English). *The Japan Times*,
December 21.
1981
Akita, Yuri. "The Movement Away from Single
Systems in Art." *Bijutsu Nenkan* 476 (special edition
[January]): 20–24.

Fujieda, Teruo. "'80s Art: The Emerging New Wave,
'Toward a New Way of Making': The Case of Painting."
Bijutsu Techo 475 (January): 77–85.

Hayami, Takashi. "Space Joined by Partitioning." *Mizue*
915 (June): 106–9.

Nakamura, Keiji. "The Tadashi Kawamata Exhibition:
Occupation of a Poetically Composed Space." *Yomiuri
Shinbun*, Kansai edition, October 20.

Yamaguchi, Katsuhiro. "Dwelling = Art: Questioning
Architecture and Environment." *Sogetsu* 134 (February 10): 97–100.
1982
Discussion by Kinro Imai, Akira Tatehata, and Tadashi
Kawamata. "Manipulation and Ramshackle Construction." In *The "Four Sculptures" Exhibition*, exh.
cat. (Osaka: Gallery Haku).

Nakahara, Yusuke. "This Year's Harvest in Art:
Tadashi Kawamata." *Yomiuri Shinbun*, Kansai edition,
December 17, evening edition.

Tanaka, Kojin. "Transforming of Space: A Questioning
of the Self-Explanatory." *Sogetsu* 142 (June): 104–7.

Venice: Giardini di Castello. *La Biennale di Venezia
1982—Giappone* (in Italian and English). Tokyo: The
Japan Foundation.
1983
Akatsu, Tadashi. "An 'Artwork' Appears in the Middle
of a House." *Mizue* 926 (spring): 130–33.

Hayami, Takashi. "The Meaning of Site in Room
Installations." *Ikebana Ryusei* 278 (June): 28–31.

Minemura, Toshiaki. "Parallel Art Discussion 1: Behind
the Surface." *Kikan Art* 102 (spring): 92–98.

Miyamoto, Ryuji. "Slip in Tokorozawa." *Toshijutaku*
190 (August): 145–46.

Obigane, Akio. "What is the 'Materials and Spaces'
Exhibition?" *Nishi Nippon Shinbun*, February 23, evening
edition.

——— and Shingo Yamano. Review in *IAF-Tsushin
(Institute of Art Function)* 2 (February): 1–14.

Saint-Gilles, Amaury. "Art: People and Places"
(in English). *Mainichi Daily News*, May 28.

Sato, Tomoya. "Art as Footwork." *Dokusho Hokkaido*
68, October 15.

Schenker, Christoph. "Im Reich der 'Leere.'" *Kunst-
forum* 58 (February): 120–30.

Tanaka, Kojin. "'The Form and Spirit of Wood'
Exhibition: Inheritance from Traditional and Contemporary Art in the Implements of Daily Life." *Mainichi
Shinbun*, March 12, evening edition.

Yoshide, Fumi. "An Installation Which Denies
Being a Mechanism." *Ballet and Dance/The TES Graphic* 7,
no. 4 (September): 44–45.
1984
Akita, Yuri. "Creation of a Flexible Space with Wood."
Sogetsu 152 (February): 77–80.

Art in Japan Today II (in English), 80–83. Tokyo: The
Japan Foundation.

Asian Cultural Council. *Annual Report 1984* (in English).
New York.

Discussion by Shigeo Anzai, Seiichi Tsukada, and Tadashi
Kawamata. "Overview: The Street Corner, the Structure, and Tadashi Kawamata." *Kikan Art* (spring): 71–76.

Francblin, Catherine. "Les surprises de l'art contemporain
japonais." *Le Quotidien de Paris*, June 28.

Kondo, Yukio. "Tadashi Kawamata: A Giant
Treading on the Landscape—'Ginza Network '84.'"
Shotenkenchiku 29, no. 3 (March): 59.

National and International Studio Programs 1984–1985
(in English). New York: The Institute for Art and Urban
Resources.

Tono, Yoshiaki. "Prospects and Doubts Concerning
Contemporary Art." *AD (Architectural Digest) Japan* 2,
no. 4 (April): 8–9.
1985
Anzai, Shigeo. "Installation in Company with Practicality: The First Art Style to Appear in a Commercial
Space." *Sogetsu* 158 (February): 69–72.

Callaghan, Edward. "One Man's Junk Is Another Man's
Art" (in English). *Press*, May.

Overduin, Henk. "Culturele confrontaties met Japan."
Museumvisie (Nederlandes Museumvereniging),
December.

"'Under Construction': The Art of Tadashi Kawamata
Wrapped around Architecture." *Brutus* 104 (February 1):
140–41.
1986
Chiba, Shigeo. "Frontiers of Art 6.5: Art of the '80s:
Tadashi Kawamata." *Tokyo Shinbun*, July 10, evening
edition.

Discussion by Hideko Otake, Kengo Sumi, Setsuro
Tagami, and Tadashi Kawamata. "New York Renaissance:
One Can't Talk about New York without Considering
Art." *Toshijutaku* 227 (September): 37–43.

Discussion by Riichi Miyake and Tadashi Kawamata.
"Installation as Parasite." In *Visionary Contemporary
Architecture*, 170–81. Tokyo: Kajima Institute Publishing.

Discussion by Yoshiaki Inui, Tadayasu Sakai, Yoshiaki
Tono, and Mamoru Yonekura. "Seasonal Art Review, Autumn '86: Since the End of the '60s." *Mizue*
940 (autumn): 50–63.

Goldscheider, Cécile. "Sculpteurs japonais d'aujourd'hui."
L'Oeil, nos. 366/367 (January/February): 60–65.

Munroe, Alexandra. "A Continent Away: Japanese
Artists in NYC" (in English). *Winds*, August: 42–53.

Olivier, Ed. "Eindelijk gebeurt er eens wat." *Haagsche
Courant*, July 2.

——— . "Sloopand 'ingepakt' door Japanse kunstenaar."
Haagsche Courant, June 12.

Sanda, Haruo. "Tadashi Kawamata's Project '85:
A Free Network." *Mainichi Shinbun*, Kyushu edition,
August 7, evening edition.

Schweinebraden Freiherr von Wichmann-Eichhon,
Jürgen. "Urbaner Kraftakt und poetische Konstruktion."
Documenta Press, October 28.

Takashima, Heigo. "Tadashi Kawamata's Wooden Board
Sculptures: The Unstitching of a City Turned Upside
Down." *Nenkin to Jutaku*, February: 30–31.

Takashima, Naoyuki. "Installation as Consciousness."
Shoten Kenchiku 402 (July): 89.

Tanaka, Kojin. "Making a Metaphor for the Behind-
the-Scenes Side of the City: The Tadashi Kawamata Exhibition." *Mainichi Shinbun*, May 16, evening edition.

Van Stanten, Ingrid. "Internationale workshops zijn
aanzet tot dialoog." *Het Binnenhof*, June.

"Visits with Artists: Tadashi Kawamata—A Slightly
Odd Person and a Much Stranger Person." *Bijutsu Techo*
563 (June): 100–5.

Yamano, Shingo. "A Thinking Installation." *D-Art
Magazine* 1 (December): 18–19.
1987
Amarante, Leonor. "De pernas pro ar." *O Estado de
São Paulo*, September 11.

Anderson, Jack. "The Dance: Three Works by Childs"
(in English). *The New York Times*, May 14.

Ashton, Dore. "Document of What?" (in English).
Arts Magazine 62, no. 1 (September): 17–20.

Bilardello, Enzo. "Nove giovani giapponesi." *Corriere
della Sera*, Rome edition, January 19.

Branckert, Gisela. "Kalte Engel raunen vom Ende der
Zeit." *Deutsches Allgemeines Sonntagsblatt*, July 12.

Breerette, Geneviève. "La huitième 'Documenta de
Kassel': Les pieds dans le meuble." *Le Monde*,
June 21–22.

Buck, Ernst. "Alles ist möglich!" *Offenbach-Post*,
June 20–21.

de Candia, Mario. "Potete ancora vederle." *La Repubblica trovaroma*, January 2–8.

Christoph, Horst. "Kunstfroh durch die Stadt." *Profil* 24 (June 15).

Discussion by Yoshiaki Inui, Tadayasu Sakai, Yoshiaki Tono, and Mamoru Yonekura. "Seasonal Art Review, Autumn '87: Mono-ha and Post Mono-ha." *Mizue* 944 (autumn): 86–101.

Dunning, Jennifer. "The Stage as Element of Dance" (in English). *The New York Times*, May 11.

Freese, Uwe. "Der Geruch des Spektakulären fehlt in diesem Jahre." *Holsteinischer Courier*, July 9.

Fujieda, Teruo. "Special Report: 'Documenta 8'—Has the Point Been Made?—Contemporary Materials." *Bijutsu Techo* 585 (September): 59.

Giessler, Ursula. "Kunst kritisiert Kassel." *Saabrücker Zeitung*, June 17.

Gonçalves Filho, Antonio. "O demolidor Kawamata chega para a Bienal." *Folha de São Paulo*, September 11.

———. "Kawamata, Um Japonês muito louco." *Folha da tarde*, September 11.

Haryu, Ichiro. "Kassel 'Documenta 8' and the Outdoor Sculpture Exhibition in Münster." *Sogetsu*, September: 113–14.

Hein, Christina. "Verbindungen Schaffen." *Documenta Press*, June: 10–11.

Hollenstein, Roman. "Besinnung der Kunst auf ihre historische und soziale Dimension." *Neue Zürcher Zeitung*, June 16.

Huylebroeck, Paul. "Achtste Documenta: Als geen andere. . . ." *Zutphens Dagblad*, June 27.

Kipphoff, Petra. "Das Hohe-Fest der Beliebigkeit." *Die Zeit*, June 19.

Lottmann, Joachim. "'Documenta': Eindrücke vor der Eröffnung." *Wolkenkratzer Art Journal*, June, August: 16–20, 74–75.

Mango, Lorenzo. "Due mostre romane tornano a proporci il 'cuore tematico' dell'arte orientale." *Paese Sera*, January 5.

Marchesini, Annamaria. "Para chocar população." *Visão*, September 23.

Marmer, Nancy. "'Documenta 8': The Social Dimension?" (in English). *Art in America* 75, no. 9 (September): 128–40.

Martinho, Téte. "Arte sôbre ruínas." *Jornal da tarde*, September 12.

Micacchi, Dario. "Scultori acrobatici: Nove installatori giapponesi in mostra." *L'Unità*, January 18.

Michaelis, Rolf. "Augentheater." *Die Zeit* 27, June 26–27.

Müller, Bertram. "Lichtschein auf Horror und Poesie." *Rheinische Post* 141, June 20.

Orzenchwski, Lothar. "Die visuelle Maschine." *Hessiche-Niedersächsische Allgemeine*, June 11.

"São Paulo Biennale Opening on the 2nd: Four Artists and Mr. Tono from Japan." *São Paulo Shinbum*, September 23.

São Paulo: *Japão—XIX Bienal de São Paulo 1987* (in Portuguese and English). Tokyo: The Japan Foundation.

Schulz, Bernhard. "Bühnenbilder der Zerstreuungskultur." *Sonntagsbeilage des Tagesspiegels*, June 21.

Schwarze, Dirk. "Eingriffe in die Stadt." *Hessiche-Niedersächsische Allgemeine* 155, August 7.

———. "Die Frishe der Jugend." *Stadt Kassel*, June 24.

———. "Spuren der Documenta." *Kunstforum* 92 (December/January): 243–45.

———. "Tadashi Kawamata (Tokio): Das Gebäude öffnen." *Hessiche-Niedersächsische Allgemeine*, May 23.

Takashima, Naoyuki. "Destroyed Church." *Asahi Journal* 1492 (August 7): 30.

Waleson, Heidi. "Lucinda Childs Tiptoes toward Ballet" (in English). *New York Newsdays*, May 10.

1988

Brenson, Michael. "Kawamata: From Destruction to Construction" (in English). *The New York Times*, May 20.

Campbell, Robert. "Arts Feature: Sharkskin and Dreck" (in English). *AJ* (November 9): 94–95.

Depondt, Paul. "Een zacht geluid dringt door tot de stadsjungle." *De Volkskrant*, May 5.

Hess, Elizabeth. "Captives of Industry?" (in English). *The Village Voice*, November 15.

Horsley, Carter B. "Provocative Peek into Future" (in English). *New York Post*, October 13.

Koplos, Janet. "Mono-ha and the Power of Materials" (in English). *New Art Examiner*, June: 29–32.

———. Review (in English) in *Art in America* 76, no. 5 (May): 194–95.

Kramer, Hilton. "Sculpture Show a Lachrymose Valentine to a Bygone Era" (in English). *The New York Observer*, November 11, 11.

Levin, Kim. "Kawamata" (in English). *The Village Voice*, May 31.

McCormick, Carlo. "A Good Dose of Reality" (in English). *Paper*, October: 17.

Murakami, Kei. "Tadashi Kawamata's 'Under Construction.'" *Shokken Shinbun*, February 2.

Nakahara, Yusuke. "Contemporary Expression 4: The Painterly and the Sculptural." *Sogetsu* 181 (December): 13–20.

O'Brien, Rodney. "Shivering Timbers: Tadashi Kawamata" (in English). *Intersect*, December: 24–25.

Peters, Philip. "Tadashi Kawamata." *Artefactum* 5, no. 24 (June/August): 10–13.

Roberts, James. "Tokyo: Tadashi Kawamata" (in English). *Artscribe* 70 (summer): 89.

Smith, Roberta. "A Wide-Ranging Spread of Artists and Installations" (in English). *The New York Times*, November 4.

"Special Report: State of the Arts—Tadashi Kawamata, 'Under Construction.'" *Life Science* 243 (November): 8–13.

Sugiura, Takao. "Topics: Hienso 'Under Construction'—Tadashi Kawamata." *AC* 8:34–35.

Takashima, Naoyuki. "Invisible House Turned Upside Down, Memory As Physical Remains: Tadashi Kawamata's Hienso Project in Kyoto." *Icon* 1 (September): 44–45.

Tatehata, Akira. "Art: Tadashi Kawamata's Hienso Project." *Shotenkenchiku* 429 (September): 121.

———. "The Failure of Sculpture." *AC* 5 (March): 1–3.

"Why Art Which Looks Like a Construction Site?" *Geijutsu Shincho* 459 (March): 60–62.

Yamazaki, Hitoshi. "Scattered Eyeballs: The Optics of Tadashi Kawamata." *AC* 5 (March): 8.

Yoshiga, Yoshiyuki. "Temporary Construction and Dismantling at Hienso: Connected Traces of Tadashi Kawamata." *Sansai* 492 (September): 120–21.

1989

Aihara, Yumi. "Contemporary Art and the Galleries Which Demonstrate and Record Collaboration with a Site." *Brutus* 200 (April 1): 9.

Baufour-Bowen, Lisa. "Art in our Park" (in English). *Toronto Sun*, August 20.

Freedman, Adele. "Is It a Disturbance? Public Art? No, It's a Parasite" (in English). *The Glove and Mail*, July 15.

Genereux, Linda. "Visual Terrorism" (in English). *Metropolis* 2, no. 15 (August 31).

Hume, Christopher. "Whirlwind of Change Hits Public Art Scene" (in English). *Toronto Star*, August 25.

Phillips, Patricia C. "Added Attraction" (in English). *Artforum International* 27, no. 9 (May): 108–12.

Yanase, Kaoru. "Proposal for a New Urban Landscape." *Bijutsu Techo* 606 (March): 86–93.

Kazuo Kenmochi

1951
Born in Odawara City, Kanagawa Prefecture
1974
Received B.F.A. from Nihon University, Tokyo

Solo exhibitions
1973
Tokyo: Muramatsu Gallery; Nirenoki Gallery; Sato Gallery; Gallery Tamura
1974
Tokyo: Sato Gallery; Gallery Tamura; Tokiwa Gallery
1975
Tokyo: Gallery Maki (two exhibitions)
1976
Nagoya: Gallery U

Tokyo: Gallery Maki; Tokiwa Gallery
1977
Tokyo: Gallery Tamura; Tokiwa Gallery
1980
Düsseldorf: Galerie Maier-Hahn

Geneva: Galerie Dioptre ■
1981–1982
Tokyo: Independent Gallery
1983
Tokyo: Independent Gallery; Plan B; Tokiwa Gallery
1984
Tokyo: Independent Gallery (three exhibitions); Gallery Komai; Plan B
1986
Shibukawa: Concept Space

Tokyo: Sagacho Exhibit Space and Sagacho Bis; T2 Studio
1987
Tokyo: T2 Studio
1989
Tokyo: Sagacho Exhibit Space and Sagacho Bis

Group exhibitions
1973
Atami: Atami Park, "Park"

Tokyo: Gallery Nirenoki, "Accident in a Satisfying Space" and "Accident '73"; Gallery Sato, "Tokyo August"; Tokiwa Gallery, "Dream of Pierrot 1" and "Even Though It's Not Raining, Let's Use an Umbrella"
1977
Tokyo: Gallery Maki, "Body as a Visual Language" ■

Yokohama: Kanagawa Prefectural Gallery/San Francisco: 80 Langton Street Gallery, "Tokyo/Bay Area Exchange of Contemporary Art"
1980
Düsseldorf
1981
Düsseldorf: Hildebrand Strasse
1982
Nagoya: Akira Ikeda Gallery

Tokyo: Independent Gallery (two exhibitions)
1983
Kyoto: Iteza Gallery

Tokyo: Independent Gallery
1984
Moriyama, Shiga: Nagisa Park No. 2, "Environment and Sculpture: Lake Biwa Contemporary Sculpture Exhibition" ■ (Japanese, English)

Tokyo: Plan B, "Memory: Installation and Performance" ■
1985
Budapest: Petöfl Leisure Center, "International 'Experimental Art' Exhibition" ■ (Hungarian, English)

Kawasaki City, Kanagawa: IBM-Kawasaki City Gallery, "Continuum '85 Pre-Exhibition" ■ (Japanese, English)

Melbourne: Pinacotheca Gallery, "Continuum '85" ■ (English, Japanese)

Wakayama: Museum of Modern Art, "The 1st Biennial Exhibition of Prints in Wakayama" ■

Yokohama: Civic Gallery, "Artists Today '85: When Installations Become Form" ■; Kanagawa Prefectural Gallery, "Contemporary Sculpture in Japan—Wood" ■
1986
Budapest: Young Artists' Club/Budapest Gallery/Hilton Hotel, "International 'Arts of Today' Exhibition" ■ (Hungarian, English)

Yokohama: Ohkurayama Memorial Hall, "Kanagawa/Art: A Dialogue on Peace"
1987
Budapest: Budapest Gallery/Exhibition Hall of the Hungarian Fine Arts College/Young Artists' Club, "International 'Arts of Today II' Exhibition" ■ (Hungarian, English)

Tokyo: Ochanomizu Square Art Plaza

Utsunomiya: Tochigi Prefectural Museum of Fine Arts, "Art Document '87" ■

Yokohama: Kanagawa Prefectural Gallery, "The 1st Kanagawa Art Annual" ■
1988
Hakushu, Yamanashi: "Summer Art Festival in Hakushu '88"
1989
Chiba: Nippon Convention Center (Makuhari Messe), "The International Exhibition of Steel Sculptures, Chiba 1989: City and People, Dialogue with Steel" ■ (Japanese, English)

Hakushu, Yamanashi: "Summer Art Festival in Hakushu '89" ■

Seoul: Cheongnam Art Museum, "Message and Communication: Korea-Japan Drawing Show" ■ (Korean, English)

Tokyo: National Museum of Modern Art, "A Perspective on Contemporary Art: Color and/or Monochrome" ■

Ube City, Yamaguchi: Open-Air Sculpture Museum, "The 13th Exhibition of Contemporary Japanese Sculpture 1989" ■

Ushimado, Okayama: "The 6th Japan Ushimado International Art Festival"
1990
Yokohama: Kanagawa Prefectural Galley, "Contemporary Sculpture in Japan III: Transformation of Material and Space"

Bibliography

About the artist
1974
Hirai, Ryoichi, and Arata Tani. Review in *Bijutsu Techo* 378 (February): 205–15.
1981
Hirai, Ryoichi. "The Constant Reproduction of Impossibility." *Nippon Dokusho Shinbun*, February 9.
1983
Minemura, Toshiaki. "Parallel Art Discussion 1: Behind the Surface." *Kikan Art* 102 (spring): 92–98.
1984
Anzai, Shigeo. "Transmutable Sculpture: From the Lake Biwa Contemporary Sculpture Exhibition." *Sogetsu* 156 (October): 85–89.

Chiba, Shigeo. "Comments on the Exhibition 'Dreidimensional-aktuelle Kunst aus der Bundesrepublik Deutschland.'" *Ikebana Ryusei* 295 (November): 30–32.

"Lake Biwa Contemporary Sculpture Exhibition." *Gendai Chokoku* 85 (special issue, July): 2–11.

Masuda, Hiromi. "Sculpture in Landscape 67: Kazuo Kenmochi, *Sculpture Design.*" *Yomiuri Shinbun*, October 2, evening edition.

"Visits with Artists: Kazuo Kenmochi—Generative Transformation through Temporary Structures." *Bijutsu Techo* 534 (November): 178–85.
1985
"Installation—Real Space as Art." *Bijutsu Techo* 548 (August): 36.

Yonekura, Mamoru. "The Unique Creative Ability of Japanese Artists Working in Wood Sculpture: Comments on 'Contemporary Sculpture in Japan—Wood,' The Connection with Japan's Drifting Spiritual History." *Asahi Shinbun*, February 13, evening edition.
1986
Discussion by Yoshiaki Inui, Tadayasu Sakai, Yoshiaki Tono, and Mamoru Yonekura. "Seasonal Art Review, Spring '86: Art and Ecology." *Mizue* 938 (spring): 36–49.

Koplos, Janet. "All Things to All People" (in English). *Asahi Evening News*, November 21.

1987

Akasaka, Hideto. "Culture 1987/Art." *Asahi Journal*, April 3, 33.

Anzai, Shigeo. "Flower Arrangement for Bourdelle's Sculpture: 'Art Document '87' in the Tochigi Prefectural Museum of Fine Arts." *Ikebana Ryusei* 324 (April): 34–35.

———. "Inspiration from the Site." *Gendai Chokoku* 98 (June): 9–17.

Chiba, Shigeo. "Seasonal Review: Contemporary Art—The Increasing Interest of Westerners, The Continuing Work of Young Artists." *Tokyo Shinbun*, March 19, evening edition.

"Exhibition of Noteworthy Contemporary Art: Forty-One Works about Space, the Body, and Expression." *Utsunomiya Yomiuri*, March 3.

"Kazuo Kenmochi's Large-Scale Work: The Creation of Darkness." *Bijutsu Techo* 573 (January): 16–17.

Murata, Makoto. Review (in English) in *Flash Art* 134 (May): 95.

Takashima, Naoyuki. "Art Now: Kazuo Kenmochi." *Asahi Journal* 1462 (January 30): 37.

Takeyama, Hirohiko. "'Art Document '87.'" *Shinbijutsu Shinbun*, March 21.

Tanaka, Kojin. "'Art Document '87': Enjoyment through Audience Participation." *Mainichi Shinbun*, March 10, evening edition.

Tani, Arata. "'Art Document '87': The Pendulum of the Exhibition Space/Conformity to and Ventilation of Space." *Bijutsu Techo* 579 (May): 118–27.

———. "Special Report—Wood 2: A Material That Responds Readily to Physical Actions." *Sogetsu* 175 (December): 113–19.

1988

Corgnati, Martina. "Arte in Giappone." *Flash Art/edizione italiana*, October/November: 63–65.

Hoshino, Seiichi. "The New Generation of Contemporary Sculptors 2: Abstract Sculpture—A New Expanding Universe of Materials and Techniques." *Art Magazine* 9 (November): 190–95.

Matsuoka, Seigo. "What to Make of Place as Place." *Bijutsu Techo* 601 (November): 184–87.

1989

Abukawa, Hiromichi. "The Powerful Assertion of Oppressiveness: The Kazuo Kenmochi Exhibition." *Asahi Shinbun*, February 17, evening edition.

"A Dark Intensity: The Kazuo Kenmochi Exhibition." *Sankei Shinbun*, February 23.

Dubin, Zan. "Made in Japan: An Art Boom." *Los Angeles Times*, March 19.

"The Kazuo Kenmochi Exhibition: A Place for Generation and Degeneration." *Shinbijutsu Shinbun*, February 1.

Koplos, Janet. "Exhibition of Kazuo Kenmochi." *Atelier* 747 (May): 80.

———. "Poisonous or Passive?" (in English). *Asahi Evening News*, February 17.

———. "Through the Looking Glass: A Guide to Japan's Contemporary Art World" (in English). *Art in America* 7 (July): 98–107.

Norio, Sugawara. "The Physical Sensation of Urban Destruction: Kazuo Kenmochi—Painting as Experience." *Yomiuri Shinbun*, February 21, evening edition.

O'Brien, Rodney. "Back to Earth: Kazuo Kenmochi" (in English). *PHP Intersect*, January: 24–25.

Sanda, Haruo. "The Kazuo Kenmochi Exhibition: Surface, Construction, and an Overwhelming Odor." *Mainichi Shinbun*, February 14, evening edition.

———. Review in *Bijutsu Techo* 609 (May): 218–19.

"Sculptor Kazuo Kenmochi: A Mountain of Scrap Wood, The Expression of Self." *Nippon Keizai Shinbun*, February 13, evening edition.

Silva, Arturo. "Kazuo Kenmochi's Private Vision" (in English). *The Daily Yomiuri*, February 16.

———. "Review: Kazuo Kenmochi, Sagacho Exhibit Space" (in English). *Artcoast*, May/June: 93.

Takashima, Naoyuki. "Art Camp: Summer Festival in Hakushu '89—Contemporary Art: Blown by the Wind, Illuminated by the Sun." *Asahigraph* 3507 (September 22): 10–15.

"'The 13th Exhibition of Contemporary Japanese Sculpture': Earth and Light—A Fresh Encounter." *Mainichi Shinbun*, October 6.

Takamasa Kuniyasu

© Shigeo Anzai

1957
Born in Hokkaido Prefecture
1981
Graduated from Hokkaido University of Education
1983
Received M.F.A. from University of Tsukuba

Solo exhibitions
1983
Tokyo: Tokiwa Gallery
1984–1985
Tokyo: Kaneko Art GI (two exhibitions) ■
1986
Tokyo: G-Art Gallery; Kaneko Art Gallery ■
1988
Tokyo: Kaneko Art GI ■
1989
Tokyo: Hillside Gallery ■ (Japanese, English); Gallery Natsuka
1990
Osaka: Gallery Haku

Group exhibitions
1980
Tokyo: Metropolitan Art Museum, "The 13th International Art Exhibition, Japan (Tokyo Biennale '80)"
1982
Tokyo: Axis Gallery, "WOV"
1984
Tokyo: Kaneko Art GI, "Document '84" ■
1985
Tokyo: Kaneko Art GI, "Green as Color" ■
1986
Tokyo: Gallery Natsuka, G-Art Gallery, Ai Gallery, Independent Gallery 3, "Silent Walking"
1987
Hatano, Kanagawa: Mizunashi Riverside Park and Chuo Athletic Field, "Tanzawa Open-Air Sculpture Exhibition" ("Selected Maquettes" section, Hatano Culture Hall) ■

Seoul: Han Kuk Gallery, "Japan Impact Art Now '87" ■ (Japanese, English)

Tokyo: Kaneko Art GI, "Crossing '87"; Gallery Natsuka, "Construction"; Tamagawa Takashimaya-SC, "Art Box Exhibition" ■

Utsunomiya: Tochigi Prefectural Museum of Fine Arts, "Art Document '87" ■

Yokohama: Civic Gallery, "The 23rd 'Artists Today' Exhibition: Phases" ■ (Japanese, English)
1988
Aomori: Gappo-Park, "Aomori Expo '88 Memorial 'Contemporary Outdoor Sculpture' Exhibition" ■

Tokyo: Kaneko Art Gallery, "Store Front Project" and "Drawing/Vision/Dream 1988"; Kaneko Art GI-b, "Kaneko Art GI Gallery b Opening Exhibition"; Muramatsu Gallery, "The Critical Point in Art" ■ (Japanese, English); Gallery Natsuka, "Round 1988"; Sagacho Exhibit Space, "Clay Art '88" ■ (Japanese, English)

Yokohama: Civic Gallery, "The 24th 'Artists Today' Exhibition: Phases Multiplar Movement" ■ (Japanese, English)
1989
Fujino, Kanagawa: "Fujino Art Village—Sculpture in an Outdoor Environment"

Ibaraki: Museum of Modern Art, "Art in Ibaraki 1945–1988" ■

Osaka: Gallery Haku, "Trans-Clay Phenomenon"

Sapporo: Sakai River Basin, "Traveling around Sakai River"

Tokyo: Heineken Village, "Seven Artists, Seven Works"; Hillside Gallery, "Drawing Storehouse Exhibition"; Gallery Natsuka, "Small Size Collection"

Ube City, Yamaguchi: Open-Air Sculpture Museum, "The 13th Exhibition of Contemporary Japanese Sculpture 1989" ∎

1990

Yokohama: Kanagawa Prefectural Gallery, "Contemporary Sculpture in Japan III: Transformation of Material and Space"

Bibliography

By the artist

1987

"Concerning the Creation of an Installation Created from Burnt Earth." In *1987 Annual Bulletin on Research and Education of Art and Design of the University of Tsukuba*, 8–9.

"So the Buds May Appear in the Spring." In *Suzukake no Niwa* (Friends of the Tochigi Prefectural Museum Bulletin) 29 (March 20).

"A Study on Material to Media." In *Bulletin of the Japanese Society for the Science of Design* (Chiba: Japanese Society for the Science of Design), 112.

1988

"Concerning the Creation of an Installation Created from Burnt Earth II." In *1988 Annual Bulletin on Research and Education of Art and Design of the University of Tsukuba*, 38–39.

Statement in *New Plastic Arts 11: Creating from Sand, Stone, Soil*. Tokyo: Komine Shoten.

1989

"Clay Work: The Artist's Voice—My Earth." *Atelier* 746 (April): 106–7.

About the artist

1986

Anzai, Shigeo. "Beyond the Framework of Words and Institutions." *Sogetsu* 164 (February): 83–87.

Araki, Fusako. "Art Response Today." *Ikebana Ryusei* 310 (February): 40.

Shiota, Junichi. "Art '86." *Bijutsu Techo* 563 (June): 194–95.

1987

Akasaka, Hideto. "Culture 1987: Art." *Asahi Journal* 1510 (December 11): 32.

Anzai, Shigeo. "Flower Arrangement for Bourdelle's Sculpture: 'Art Document '87' in the Tochigi Prefectural Museum of Fine Arts." *Ikebana Ryusei* 324 (April): 34–35.

———. "Inspiration from the Site." *Gendai Chokoku* 98 (June): 9–17.

———. "Special Report: The Phase of Modernism 4: Contemporary Art—A Place for Art's Movement." *Wacoa* 7:32–33.

Profile of Contemporary Art: The Early '80s in Japan and Korea (in Japanese with sections in English). Kyoto: International Art Center.

Takaku, Tamio. "Pretenses of Grief over Warhol's Death: The Topic of 'Art Document.'" *Job* 28 (March 15).

Takashima, Naoyuki. "Art Now: Takamasa Kuniyasu." *Asahi Journal* 1485 (June 26): 37.

Tani, Arata. "'Art Document '87': The Pendulum of the Exhibition Space/Conformity to and Ventilation of Space." *Bijutsu Techo* 579 (May): 118–27.

"'The 23rd "Artists Today" Exhibition: Phases.'" *Shinbijutsu Shinbun*, November 21.

1988

Abukawa, Hiromichi. "The Feel of the Earth's Murmuring: 'Clay Art '88.'" *Asahi Shinbun*, December 16, evening edition.

Chiba, Shigeo. "Art—From Accumulation toward Evolution: A Summary of Art in 1987." *Nikkei Image Climate Forecast* 4 (April): 63–67.

"Constructing a City with a Scent of Culture: Art Purchases by the Seikan Expo Executive Offices." *Asahi Shinbun*, Aomori edition, August 26.

"'Contemporary Outdoor Sculpture' Exhibition." *Ikebana Ryusei* 343 (November): 38.

"'Contemporary Outdoor Sculpture' Exhibition's Grand Prize Winner 'Henpon Kangen' [by] Takamasa Kuniyasu." *Mutsu Shinpo*, September 2.

Fukuda, Toyoto. "Seikan Expo: A Pageant That Faces toward the Future." *Shiroikuni no Uta* 385 (September): 16–19.

"A Grand Prize for Ibaraki-Born Kuniyasu: The 'Contemporary Outdoor Sculpture' Exhibition Begins in Aomori." *Touo Nippo*, September 2.

"Human Close-Up." *Joyo Living*, September 23.

Ibaraki: University of Tsukuba. *Bulletin of the Institute of Art and Design*, 11.

Koplos, Janet. "In Kichijoji" (in English). *Asahi Evening News*, December 8.

———. "Into the Wondrous" (in English). *Asahi Evening News*, February 12.

———. "2–D to the Fore" (in English). *Asahi Evening News*, November 18, evening edition.

"A Man Who Stacked Up 100,000 Bricks." *Shukan Shincho* 1673 (August 25): 21.

Matsumura, Toshio. "Kuniyasu's Work Erodes the Gallery: 'The Critical Point in Art' Exhibition." *Sankei Shinbun*, August 18.

Murata, Makoto. "Art Today." *Ikebana Ryusei* 346 (April): 39.

Nakahara, Yusuke. "The Importance of the Relationship with the Environment: Investigating the 'Contemporary Outdoor Sculpture' Exhibition." *Touo Nippo*, September 17.

Nanba, Hideo. "Form without Story: The Takamasa Kuniyasu Exhibition." *Atelier* 734 (April): 103.

"The Opening of the 'Contemporary Outdoor Sculpture' Exhibition: Grand Prize Work 'Henpon Kangen.'" *Yomiuri Shinbun*, Aomori edition, September 2.

Perron, Joel. "'The Critical Point in Art'" (in English). *The Japan Times*, August 21.

"Pia News Network." *Pia* 324 (August 5): 267.

"A Pyramid from 2,600 Logs." *Asahi Shinbun*, Aomori edition, July 31.

"The Rich Expression of Individuality in Nature and Humanity: 'Outdoor Sculpture' Exhibition's Award-Winning Works." *Touo Nippo*, April 1.

Sanda, Haruo. "An Expression Lacking a Focal Point: 'Artists Today Exhibition: Phases Multiplar Movement.'" *Mainichi Shinbun*, November 22, evening edition.

———. "Some Endless Emission: The Takamasa Kuniyasu Exhibition." *Mainichi Shinbun*, February 9, evening edition.

"Showing Nine Powerful Works, 'Contemporary Outdoor Sculpture' Exhibition Grand Prize Winner Kuniyasu." *Mutsu Shinpo*, September 2.

Sugawara, Norio. "Various Attempts to Reach the Self: 'Artists Today Exhibition: Phases Multiplar Movement.'" *Yomiuri Shinbun*, November 16, evening edition.

Tanaka, Kojin. "Enormous Works: The Easy-Going 'Clay Art '88.'" *Mainichi Shinbun*, December 13, evening edition.

"To Start—Two On-Site Works: The 'Contemporary Outdoor Sculpture' Exhibition at Aomori Gappo Park." *Touo Nippo*, July 27.

Yamaguchi, Taiji. "Re-examining the Origin of Contemporary Art: 'Artists Today Exhibition: Phases Multiplar Movement.'" *Akahata*, November 22.

1989

Anzai, Shigeo. "Contemporary Expressions: Installation—Art That Emerges from Links with Society." *Sogetsu* 185 (August): 17–24.

Jones, Derek. "The Insane and the Creative" (in English). *Asahi Evening News*, June 9.

Kaneko, Kenji. "'Clay Art '88' Exhibition: Within the Limitations of Materials." *Design no Genba* 32 (February): 26–27.

Koplos, Janet. "Letter from Japan" (in English). *Arts Magazine* 64, no. 1 (September): 110–11.

Murata, Makoto. "Art Today: Losing One's Step." *Ikebana Ryusei* 346 (February): 39.

Nakaseko, Yoshinobu. "The Takamasa Kuniyasu Exhibition: A Proliferating Subject." *Design News* 205:60–61.

Sugawara, Norio. "A Return toward an Ascetic Nature—Ceramic Blocks Accumulated: The Takamasa Kuniyasu Exhibition." *Yomiuri Shinbun*, June 5, evening edition.

"The Takamasa Kuniyasu Exhibition." *Mainichi Shinbun*, June 5, evening edition.

"The Takamasa Kuniyasu Exhibition: A Hard-to-Attain Ecstatic Experience, An Installation from Two Four-Ton Truckloads of Bricks." *Ikebana Ryusei* 351 (July): 18–19.

"'The 13th Exhibition of Contemporary Japanese Sculpture': Earth and Light—A Fresh Encounter." *Mainichi Shinbun*, October 6.

"Viewing from Themes and Materials: The Site of Contemporary Art—Clay Work." *Atelier* 746 (April): 93–115.

Weisenfeld, Gennifer. "Takamasa Kuniyasu's Looming Logs: Wooden and Clay Structure in Hillside Gallery Leaves No Space Untouched" (in English). *The Japan Times*, June 4.

Yagyu, Fujio. "Town Development with Sculpture in Aomori: Commemorating the Aomori Expo '88." *Sansai* 496 (January): 84–90.

Emiko Tokushige

1939
Born in Yamaguchi City, Yamaguchi Prefecture
1962
Graduated from Musashino Art University; studied weaving techniques at Kawashima Weaving Factory, Kyoto
1963–65
Worked at Tatsumura Art Weaving Factory, Kyoto
1966–67
Studied at Kunsthaandværkerskolen, Denmark

Solo exhibitions
1970
Tokyo: Maruzen Gallery
1973
Tokyo: Heart Art Gallery
1975
Tokyo: Gallery Fujie; Odakyu Halc

Group exhibitions
1969
Fukuoka: Nik Gallery, "Three Textile Artists"
1971
Kyoto: National Museum of Modern Art, "New Textile Artists"
1973
Fukuoka: Nik Gallery, "Five Textile Artists"

Tokyo: Gallery Lemon
1974
Fukuoka: Nik Gallery, "Nine Textile Designers, Part 2"

1976
Kyoto: National Museum of Modern Art/Tokyo: National Museum of Modern Art, "Fiber Works: Europe and Japan"
1981
Kyoto: Gallery Maronie, "Fiber Work Miniature '81"

Linz/Vienna: "Brucknerfestes Textilkunst '81"

Tokyo: Doma Gallery; Odakyu Halc, "Mini-Object"
1982
Kyoto: Gallery Maronie/Tokyo: Wacoal Ginza Art Space/Takasaki: Gunma Prefectural Museum of Modern Art, "Fiber Work Miniature '82"

Michoacán, Mexico: Cultural Hall, "Salón Michoacano Internacional del Textil en Miniatura Japón/México"
1983
Kyoto: Gallery Maronie/Tokyo: Wacoal Ginza Art Space, "Fiber Work Miniature '83"

Otsu, Shiga: Otsu Seibu Hall/Karuizawa: Museum of Modern Art, Seibu, Takanawa, "Fiber Work"

Takasaki: Gunma Prefectural Museum of Modern Art, "Fiber Work" ■

Tokyo: Odakyu Halc, "Furniture and Floor Coverings"
1984
Kyoto: Gallery Maronie/Tokyo: Wacoal Ginza Art Space/Seoul: NA Gallery, "Fiber Work Miniature '84"
1985
Fukuoka: Prefectural Museum of Art, "Live Imagination" ■

Łódź: Centralne Muzeum Włókiennictwa/Central Museum of Textiles, "5 Mieÿdzynarodowe Triennale Tkaniny Łódź/5th International Triennale of Tapestry Łódź"
1987
Tokyo: Metropolitan Art Museum, "Fabric in Space" ■

Bibliography

About the artist
1973
Tsukasa, Shohei. "Emiko Tokushige's Rope: Braiding, Wrapping, Tying." *SD (Space Design)* 102 (March): 76–78.
1975
Ishigami, Shinpachiro. "Two Kinds of Individuality: Work by Emiko Tokushige." *SD (Space Design)* 128 (April): 72–75.
1984
Arts in Fiber/Who's Who Japan (in Japanese and English). Sapporo: Kuniko Lucy Kato.

The Gentle People of Japan: Another Guide to Japan, 120–27. Tokyo: Sun Dash.
1988
"Fiber Weaving: The Concept of Thread, A Proposition for Fabric." *Bijutsu Techo* 591 (February): 22–23.

Shigeo Toya

1947
Born in Nagano Prefecture
1975
Graduated (M.A.) from the Sculpture Department of Aichi Prefecture University of Fine Arts

Solo exhibitions
1974–75
Tokyo: Tokiwa Gallery (two exhibitions)
1976
Nagoya: Gallery U

Tokyo: Gallery Tamura
1977
Nagoya: Gallery U

Tokyo: Nirenoki Gallery
1978
Tokyo: Gallery Maki; Nirenoki Gallery (two exhibitions)
1979
Tokyo: Nirenoki Gallery; Tokiwa Gallery

Toyohashi: Gallery L
1980
Tokyo: Ai Gallery; Tokiwa Gallery
1981
Tokyo: Tokiwa Gallery
1982
Kobe: Contemporary Art Gallery ■

Nagoya: Gallery NAF

Tokyo: Ai Gallery
1983
Fukuoka: Ten Gallery

Tokyo: Ai Gallery; Kamakura Gallery ■; Tokiwa Gallery
1984
Tokyo: Ai Gallery; Newz
1985
Tokyo: Ai Gallery

1986
Seoul: Hu Gallery ■

Tokyo: Ai Gallery; Newz
1987
Tokyo: Satani Gallery, "Woods 1984–1987"
1988
Fukuoka: Ten Gallery
1989
Shibukawa, Gunma: Concept Space

Takasaki, Gunma: Concept Space R2

Tokyo: Satani Gallery; Ueno Matsuzakaya Art Gallery, "The First Fumio Asakura Award: Shigeo Toya, Sculptures and Drawings"

Group exhibitions
1975
Kyoto: Municipal Art Museum, "Exposition Kyoto Indépendants 1975"

Nagoya: Aichi Prefectural Art Gallery, "'75 Autumn in Nagoya"; Maruei, "Asahi Art Exhibition '75"

Yokohama: Kanagawa Prefectural Gallery, "Yokohama '75"
1976
Yokohama: Kanagawa Prefectural Gallery, "Documentalization," "Exhibism '76," and "Optical Illusion (Headstand after Headstand)"
1977
Kyoto: Municipal Art Museum, "Exposition Kyoto Indépendants 1977"

Urawa: Saitama Kaikan, "Four Days in Urawa"
1978
Saitama: Tokorozawa Aviation Memorial Park, "'78 Tokorozawa Open-Air Exhibition" ■
1979
Tokyo: Ai Gallery/Nagoya: Gallery Westbeth, "Exhibition August '79"

Urawa: Saitama Kaikan, "Angle of Incidence and Angle of Reflection"

Yokohama: Kanagawa Prefectural Gallery, "The Sixth Sense: Sixteen Members" ■ (Japanese, English)
1980
Tokyo: Gallery Lunami, "Planning Project '80"

Yokohama: Kanagawa Prefectural Gallery, "Adesugata Hana no Ayadori"
1981
Tokyo: Ai Gallery, "Inaugural Exhibition"; Hara Museum of Contemporary Art, "Hara Annual II" ■ (Japanese, English); Kamakura Gallery, "Try-Angle '81" ■ (Japanese, English); Ohara Center, "1st 'Parallelism in Art' Exhibition"

Yokohama: Kanagawa Prefectural Gallery, "State-Style" ■
1982
Tokyo: Joshibi Gallery ■; Kamakura Gallery ■; Tama Art University, Hachioji, "The 57th Year of Showa Special Exhibition at Tama Art University" ■
1983
Dhaka, Bangladesh: Shilpakala Academy, "The 2nd Asian Art Biennale Bangladesh 1983" ■ (Bengali, English)

Fukuoka: Art Museum, "Materials and Spaces" ■; Gallery Oishi, "Rhizome"

Hamamatsu: Nakatajima Sand Hill, "The 3rd Hamamatsu Open-Air Exhibition 1983" ■

Tokyo: Newz, "Newz Week"; Gallery Yo, "Document: 'The 3rd Hamamatsu Open-Air Exhibition 1983'"

Toyama: Museum of Modern Art, "A Panorama of Contemporary Art in Japan—Sculpture" ■

Yokohama: Civic Gallery, "From Word to Thing and Place" ■
1984
Fukuoka: Art Museum, "Memorial Show for 'Bangladesh Biennale 1983'"

Kawasaki City, Kanagawa: IBM-Kawasaki City Gallery, "Contemporary Art: Five-Person Show '84" ■ (Japanese, English)

Kyoto: Ryo Gallery, "Rhizome"

Nagoya: City Museum, "Space-Playing"

Tokyo: Newz, "Newz: Eight Artists Exhibition by Four Art Critics" ■ and "Newz Week"; Ohara Center, "Parallelism in Art 4: Subject—Symbol—Apparition" ■; Gallery Yo, "Vivid Fragments: Infinity and Chaos" ■ (Japanese, English)
1985
Kawasaki City, Kanagawa: IBM-Kawasaki City Gallery, "Continuum '85 Pre-Exhibition" ■ (Japanese, English)

Kofu: Yamanashi Prefectural Museum of Art, "The 5th Experimental Art Exhibition: Behind-the-Scenes Interpretation" ■

Kyoto: Galerie 16, "Resurrections of Allegory" ■

Melbourne: Pinacotheca Gallery, "Continuum '85" ■ (English, Japanese)

Seoul: Soo Gallery

Tokyo: Awajicho Gallery, "Six Artists"; Newz; Satani Gallery, "Radical Orthodoxy" ■

Yokohama: Kanagawa Prefectural Gallery, "Contemporary Sculpture in Japan—Wood" ■
1986
Kofu: Yamanashi Prefectural Museum of Art, "Try Art: The 6th Small Art Exhibition"

Nagano: Hotaka Town Center, "1st Azumino Contemporary Sculpture Exhibition" ■

Sendai: Miyagi Museum of Art, "A Scene of Contemporary Japanese Art 3: The New Generation" ■ (Japanese, English)

Tokyo: Ai Gallery, "Commemoration Exhibition"; Nabis Gallery, "'Dessin' at Its Emerging Moment" and "Monologue/Dialogue"

Yokohama: Ohkurayama Memorial Hall, "Kanagawa/Art: A Dialogue on Peace"
1987
Fukuoka: Prefectural Museum of Art, "Artist's Network Expanded 1987"

Kyoto: Gallery Maronie/Tokyo: Wacoal Ginza Art Space, "Three-Dimensional Miniature Works on the Wall"

Nagano: Obusedo, "Obuse Corollary: Exhibition of Contemporary Art Works 1987" ■

Shibukawa, Gunma: City Park, "Shibukawa Triennial Exhibition of Contemporary Sculpture '87"

Tokyo: Ai Gallery, "Moving Commemoration Exhibition"; Muramatsu Gallery, "Muramatsu '87 Exhibition"; Nabis Gallery, "Drawing: In the Vicinity of Presentiment"; Newz, "Newz Box Exhibition 1986"; Seibu Museum of Art, "Art in Japan since 1969: Mono-ha and Post Mono-ha" ■ (Japanese, English)
1988
Dublin: The Guinness Hop Store and the Royal Hospital, "ROSC '88" ■ (English)

Gifu: Seki City Culture Center, "Contemporary Wood Sculpture Festival" ■

Honolulu: University of Hawaii Art Gallery, "The 3rd International Shoebox Sculpture Exhibition" ■ (English)

Tokyo: Yurakucho Art Forum/Osaka: Tsukashin Hall, "Art for Touching" ■

Venice: Giardini di Castello, "43ª Esposizione Internazionale d'Arte 'La Biennale di Venezia'" ■ (Italian, English)
1989
Antwerp: Openluchtmuseum voor Beeldhouwkunst Middelheim, "20ste Biënnale Middelheim-Japan" ■ (Flemish, French, English)

New York: Arnold Herstand Gallery, "Three Sculptors"

Québec: Musée de Québec, "Territoire d'artistes: Paysage verticaux" ■

Sapporo: Sakai River Basin, "'89 Art Event in Sapporo: Traveling around Sakai River"

Tokyo: Ai Gallery, "The 70's"; Satani Gallery

Urawa: Museum of Modern Art, Saitama, "Art Exciting '89: Beyond the Today's Being" ■

Yokohama: Civic Gallery, "The 25th 'Artists Today' Exhibition: [Kame-za] Shell and Vessel, Signifying" ■
1990
Yokohama: Kanagawa Prefectural Gallery, "Contemporary Sculpture in Japan III: Transformation of Material and Space"

Bibliography

By the artist
1978
Comment in "The Shigeo Toya Exhibition." *Bijutsu Techo* 438 (September): 242.
1982
Comment in *Bijutsu Techo* 495 (April): 177.

"Concerning the Act of Carving." *Sho* 3:54–56.
1983
Comment in "The New Generation and New Style of Contemporary Art: Statements by Forty Notable Artists." *Bijutsu Techo* 508 (March): 52.

"The Kurt Schwitters Exhibition: A Trust in Painting Aroused by Fear." *Bijutsu Techo* 516 (October): 146–49.

"Where the Wind Blows." *Art Vision* 13, no. 6 (July).
1985
"Toward Another Kind of Sculpture: Hakone Impressions." *Atelier* 703 (September): 60–61.

1988

"Artist Message: 'Woods'" (in Italian and English). In *La Biennale di Venezia 1988—Giappone*, 16–17. Tokyo: The Japan Foundation.

Comment in *Atelier* 740 (October): 100.

"Current Work of Heihachi Hashimoto: Seeking a Sense of Serenity in Sculpture." *Chubu Yomiuri Shinbun*, April 22.

About the artist
1974

Hirai, Ryoichi, and Arata Tani. Review in *Bijutsu Techo* 388 (December): 226–37.

1977

Chiba, Shigeo. Review in *Bijutsu Techo* 418 (March): 249–53.

1979

Kitazawa, Noriaki. Review in *Bijutsu Techo* 452 (August): 239–43.

Motoe, Kunio. Review in *Bijutsu Techo* 445 (February): 193–204.

1980

Akita, Yuri. Review in *Bijutsu Techo* 471 (October): 207–10.

1981

Akita, Yuri. "From the Exhibition 'Parallelism in Art': Concerning Wood and Sculpture." *Mizue* 919 (October): 88–91.

Ishida, Hidehiro. "'Parallelism in Art': Starting from a Transformation of Wood." *Bijutsu Techo* 487 (October): 182–95.

Minemura, Toshiaki. "Special Report: Art in the '80s— New Wave Starts Moving in 'Our Painting' and 'Surrounding Sculpture.'" *Bijutsu Techo* 475 (January): 86–95.

Tani, Arata. Review in *Bijutsu Techo* 487 (October): 223–34.

1983

Dhaka, Bangladesh: Shilpakala Academy. *The 2nd Asian Art Biennale Bangladesh 1983—Japan* (in English). Tokyo: The Japan Foundation.

Kitazawa, Noriaki. "An Exhibition on the Sands: 'The 3rd Hamamatsu Open-Air Exhibition.'" *Bijutsu Techo* 514 (August): 147–53.

———. "The Image of a Ruin, The Ruin of an Image: Concerning Shigeo Toya." *EOS*, no. 3:94–95.

Minemura, Toshiaki. "Sculpture's New Generation: Toya Shigeo—Something Resurrected in Pompeii." *Gendai Chokoku* 78 (December): 14–21.

Mizutani, Takashi. Review in *Bijutsu Techo* 505 (January): 181–83.

Nakamura, Hideki. "Reverse Irradiation: Japan 'Object' Thought—'Vivid Fragments.'" *Ikebana Ryusei* 277 (May): 30–32.

Takagi, Shu. "Concerning the Sculpture of Shigeo Toya: A Blending of Centripetal and Centrifugal Force." *Parfum*, (spring): 26.

Tanaka, Kojin. "A Magnificence of Scale: The Shigeo Toya Exhibition." *Mainichi Shinbun*, August 5, evening edition.

1984

Akatsuka, Yukio. "Shigeo Toya: In Other Words— Sculpture's Present." *IAF-Tsushin (Institute of Art Function)* 3 (February): 2–6.

Art in Japan Today II (in English), 192–95. Tokyo: The Japan Foundation.

Endo, Toshikatsu. "A Story for the Eye in the Work of Shigeo Toya." *IAF-Tsushin (Institute of Art Function)* 3 (February): 7–8.

"The Japanese Character of Contemporary Art: The New Generation's View of What is Japanese." *Atelier* 689 (July): 19–21.

Kitazawa, Noriaki, ed. "The Chronology of Works by Shigeo Toya." *IAF-Tsushin (Institute of Art Function)* 3 (February): 17–23.

Naka, Yuko and Sadahiko. "Sculpture: From a Theory of Superfluity." *IAF-Tsushin (Institute of Art Function)* 3 (February): 9–12.

Nakamura, Hideki. "A Turning Point in the Concept of Sculpture." *IAF-Tsushin (Institute of Art Function)* 3 (February): 14–16.

———. *Vivid Fragments: Infinity and Chaos.* Tokyo: Sugiyama Shoten.

O'Brien, Rodney. "Invisible Sculpture: Shigeo Toya." *PHP* 162 (March): 46–50.

Yamagishi, Nobuo. "Sculptural Installation in a Post-Industrial Society" (in English). *Art-Network* 13 (spring): 32–35.

1985

Kitazawa, Noriaki. "Flickering and Thawing: The Work of Shigeo Toya and Kimio Tsuchiya." *Ikebana Ryusei* 305 (September): 28–29.

———. Review in *Atelier* 703.

"Visits with Artists: Shigeo Toya—A Solidified Lump of Space." *Bijutsu Techo* 549 (September): 139–45.

1986

Discussion by Susumu Koshimizu, Shu Takagi, and Shigeo Toya. "Statements in Contemporary Sculpture: Three Sculptors in Search of Sculpture." *Bijutsu Techo* 563 (June): 49–64.

Takei, Kunihiko. "Review Tokyo." *Sansai* 467 (August): 92–93.

Tanaka, Kojin. "Exciting Chain Saw Sculpture." *Mainichi Shinbun*, July 29, evening edition.

1987

Ai, Ryu. "Review Tokyo." *Sansai* 482 (November): 122–23.

Discussion by Yoshiaki Inui, Tadayasu Sakai, Yoshiaki Tono, and Mamoru Yonekura. "Seasonal Art Review, Autumn '87: Mono-ha and Post Mono-ha." *Mizue* 944 (autumn): 86–101.

———. "Seasonal Art Review, Winter '87: Looking at Duchamp, Serra, and Tonko Wall Painting." *Mizue* 945 (winter): 120–33.

Koplos, Janet. "Matter-of-Fact Mysteries" (in English). *Asahi Evening News*, September 18.

Mizushima, Hiroshi. "Affirming a Contrary Aspect: Shigeo Toya's 'Woods' Series." *Tosho Shinbun*, October 3.

Sanda, Haruo. "Coming into Contact with the Collective Memory of Mankind." *Mainichi Shinbun*, September 9, evening edition.

Takashima, Naoyuki. "Art Now: Shigeo Toya." *Asahi Journal* 1503 (October 30): 41.

1988

Anzai, Shigeo. "Venezia Biennale, International Exhibition Report 2: A Passionate Response to the Strong Work of Japanese Artists." *Sankei Shinbun*, July 21.

Beaumont, Mary Rose. "Romantic Sculpture" (in English). *Art & Design*, December/January: 75–80.

Corgnati, Martina. "Arte in Giappone." *Flash Art/ edizione italiana*, October/November: 63–65.

Delagrare, Marie. "Un événement majeur en art contemporain se prépare." *Le Soleil*, September 27.

Discussion by Shigeo Chiba, Kenjiro Okazaki, Toshikatsu Endo, and Shigeo Toya. "Considering the Today of Contemporary Sculpture." *Shinbijutsu Shinbun*, January 21.

Discussion by Toshiaki Minemura, Kenjiro Okazaki, Shigeo Toya, and Natsuo Hashimoto. "New Horizons in Contemporary Sculpture." *Gendai Chokoku* 100 (March): 2–14.

Ellidge, Mark. "Nations Talking in Too Many Tongues: Marina Vaizey at the 43rd Venice Biennale" (in English). *The Sunday Times*, June 26.

Koplos, Janet. Review (in English) in *Sculpture* 7, no. 2 (March/April): 35.

Kurabayashi, Yasushi. "Special Report, Venezia Biennale: Diversity Without Subject, The Present State of Contemporary Art." *Bijutsu Techo* 599 (September): 22–46.

McCrum, Sean. "'ROSC '88'" (in English). *Artefactum* 5, no. 26 (December/January): 52–53.

Murphy, Antoinette. "'ROSC '88'" (in English). *Exhibition Booklet for Children*, 4.

Nakajima, Liju. "This Year's Art World." *E* 298 (December): 15–19.

Obigane, Akio. Review (in English) in *Flash Art International* 738 (January/February): 135.

Sanda, Haruo. "Forest As a Metaphor of the 'Surface.'" *Mainichi Shinbun*, September 19, evening edition.

Satani, Kazuhiko. *The Job of an Art Gallery*, 259–61. Tokyo: Bijutsu Shuppansha.

Tanaka, Kojin. "Seeing Flowers As an Escape Route: Surface and Interior, Invading the Forest—The Locus of Shigeo Toya's Sculptural Art." *Ikebana Ryusei* 333 (January): 18–22.

Tatehata, Akira. "New Sculpture: Shigeo Toya." *Kikan Art* 125 (winter): 71–75.

Taylor, John Russell. "The Arts: Smaller is Beautiful" (in English). *The Times*, July 1.

Venice: Giardini di Castello. *La Biennale di Venezia 1988—Giappone* (in Italian and English). Tokyo: The Japan Foundation.

Venturoli, Marcello. "I padiglioni stranieri: XLIII Esposizione Internazionale d'Arte 'La Biennale di Venezia.'" *La Gazzetta delle Arti* 6:3–4.

1989

Abukawa, Hiromichi. "Shigeo Toya's Fumio Asakura Prize Exhibition: The Unseen World." *Asahi Shinbun*, February 8, evening edition.

Ai, Ryu. "Review Tokyo." *Sansai* 499 (April): 100–1.

Brenson, Michael. "Magdalena Abakanowicz, Jenny Lee, and Shigeo Toya" (in English). *The New York Times*, April 14.

"'Death of Woods': The Revelation of Unity." *Asahi Shinbun*, September 30, evening edition.

Discussion by Shigeo Toya and Tadayasu Sakai. "Concerning 'Death of Woods'" (in Japanese with sections in English). In *Shigeo Toya*, exh. cat. (Tokyo: Satani Gallery).

Discussion by Toshikatsu Endo, Katsura Funakoshi, Shigeo Toya, and Toshiaki Minemura. "Artists Fluttering Out into the World." Parts 1, 2. *Gallery* 46 (February): 10–19; 47 (March): 10–19.

Fendrick, Julia, "Out of the Woods: Shigeo Toya (in English). *Tokyo Journal*, February : 104–5.

Funakoshi, Antoine Mari. "Outstanding Japanese Sculptors: Europalia's Japan Festival '20ste Biënnale Middelheim-Japan.'" *Sankei Shinbun*, September 28.

———. "'20ste Biënnale Middelheim-Japan.'" *Bijutsu no Mado* 84 (November): 133, 138–39.

Gillemon, Daniele. "Promenade au bois: Pas de loup au Middelheim." *Le Soir* (Brussels), July 5.

Hogyoku, Masahiko. "The Site of Beauty: Shigeo Toya—Pursuing a Unity of Space and Object." *Nippon Keizai Shinbun*, August 26.

Huylebroeck, Paul. "Vijftien Japanners naar Antwerpse Biënnale." *Gazet van Antwerpen*, May 10.

Ide, Kazuko. "The Shigeo Toya Sculpture Exhibition: A Struggle with Materials in the Process of Carving." *Kyodo Tsushin*, September 28.

"Japanische moderne Gast der Biennale Middelheim." *Der Kontact*, June: 27–28.

Jones, Derek. "In Excavation of Self" (in English). *Asahi Evening News*, September 29.

Kondo, Yukio. "Tokyo: Shigeo Toya" (in English). *Art Coast* 1, no. 2 (May/June): 92.

Masaki, Motoi. "A Strategy toward Massive Sculpture." *Nikkei Image Climate Forecast* 10 (October): 58.

Matsumura, Toshio. "Creating a Forest." *Sankei Shinbun*, January 5.

"Middelheim-Biënnale vijftien deel-nemers." *Gazet van Antwerpen*, June 14.

Minemura, Toshiaki. "Leaving Woods to Create 'Woods'" (in Japanese and English). In *Shigeo Toya, Woods 1984–1987*. Tokyo: Satani Gallery.

———. "Shigeo Toya: Resurrection at Pompeii 1" (in Japanese and English). In *Shigeo Toya 1979–1984*. Tokyo: Satani Gallery.

Murata, Makoto. "Art Today: Shigeo Toya." *Ikebana Ryusei* 356 (December): 47.

———. "'Naturally I Like Sculpture': An Interview with Shigeo Toya before the First Asakura Sculpture Awards Commemorative Exhibition." *Pia* 338 (February 17): 253.

Nardon, Anita. "Anvers: La fête." *Le Drapeau rouge* (Brussels), July 4.

Obigane, Akio. "Shigeo Toya: Toward a New Sculpture." *Atelier* 752 (October): 44–49.

Sanda, Haruo. "The Shigeo Toya Exhibition: The Three-Layered Construction of Sculptured Falsehood and Truth." *Mainichi Shinbun*, September 19, evening edition.

Schröte, Gisela. "Magische Präsenz." *Handelsblatt* (Düsseldorf) 144, July 28–29.

"The Shigeo Toya Exhibition." *Shinbijutsu Shinbun*, November 21.

"Shigeo Toya's 'Marshland' from the 'Woods' Series." *Zocalo* (Museum of Modern Art, Saitama News) 27: 7.

Silva, Arturo. "A Good Wood Work Week" (in English). *The Daily Yomiuri*, October 5.

"Special Report: Exciting Wood Sculpture from the Standard-Bearers of the New Wave; Shigeo Toya: A Search for Identity Amid Emerging Forms in Space." *Gekkan Bijutsu* 166 (July): 33, 56–57.

Sugawara, Norio. "A Complete Image of the Forest: Shigeo Toya's Exhibition of New Works." *Yomiuri Shinbun*, September 14, evening edition.

———. "Gouging Out the Force of Nature: Shigeo Toya, Winner of the First Asakura Fumio Prize." *Yomiuri Shinbun*, February 13, evening edition.

Tarantino, Michael. "Art from Japan" (in English). *The Bulletin*, August 10.

Van Oudenhove, Madeleine. "Les expositions d'été Europalia-Japon '89." *Gazet van Antwerpen*, June 30.

Verhoye, Bert. "Japan in Middelheim." *Met Laatste Nieuws*, June 16.

Watanabe, Ei. "An Overwhelming Presence and Softness: The Shigeo Toya Sculpture Exhibition." *Akahata*, October 3.

Kimio Tsuchiya

1955
Born in Fukui City, Fukui Prefecture
1977
Graduated from Nihon University with Art Department Encouragement Prize
1981
Resided in London
1989
Received M.A. from Chelsea School of Art, London

Solo exhibitions
1984
Fukui: Gallery Space B

Tokyo: Gallery K; Kobayashi Gallery
1985
Nagoya: Love Collection Gallery

Tokyo: Kobayashi Gallery; Moris Gallery
1986
Hiroshima: Sing by Sogo

Tokyo: Moris Gallery
1987
Hiroshima: Michiko Fine Art

Shimane: Gallery Soukasha

Tokyo: Kinokuniya Gallery; Kobayashi Gallery; Moris Gallery
1988
Antwerp: Galerij Carine Campo ■

Paris: Galerie Keller ■

Tokyo: Kobayashi Gallery; Moris Gallery, "Sculpture 1984–1988" ■ (Japanese, English)

Group exhibitions
1978, 1980, 1984
Tokyo: Metropolitan Art Museum, "International Art Exhibition, Japan (Tokyo Biennale)" (three exhibitions) ■
1986
Fukui: Fine Arts Museum, "Art Today Exhibition '86 in Fukui" ■

Lausanne: "1st Art Contact"; Palais de Beaulieu, "Foire Internationale d'art contemporain"

Paris: Galerie Keller, "Quinze artistes Rue Keller"

Sendai: Miyagi Museum of Art, "A Scene of Contemporary Japanese Art 3: The New Generation" ■ (Japanese, English)
1987
Fukui: "Woodpia Fukui '87"

Nice: "Art Junction International '87"

Paris: Port d'Austerlitz, "Jeune Sculpture '87"

Tokyo: Hara Museum of Contemporary Art, "Hara Annual VII" ■ (Japanese, English)
1988
Antwerp: Galerij Carine Campo, "Artists of the Gallery"

Iwakuni City, Yamaguchi: "Iwakuni Outdoor Art Project '88 at Kintai Bridge on the Nishiki River" ■ (Japanese, English)

Tokyo: Moris Gallery, "New Year/New Arts '88" ■ (Japanese, English)
1989
Antwerp: Openluchtmuseum voor Beeldhouwkunst Middelheim, "20ste Biënnale Middelheim-Japan" ■ (Flemish, French, English); Galerij Carine Campo, "Artists of the Gallery"

Ghent: "Line Contemporary Art"

London: Chelsea School of Art, "M.A. Sculpture Exhibition"; Design Center, "Contemporary Art Fair"; Flowers East Gallery, "Mid-Year Exhibition" ■

Urawa: Museum of Modern Art, Saitama, "Art Exciting '89: Beyond the Today's Being" ■ and "The Space: Material, Tension, Vacancy in Japanese Contemporary Art" ■
1990
Yokohama: Kanagawa Prefectural Gallery, "Contemporary Sculpture in Japan III: Transformation of Material and Space"

Bibliography

By the artist
1987
"A Dialogue with Materials 9—Wood: Kimio Tsuchiya." Parts 1, 2. *Shinbijutsu Shinbun*, August 1, September 1.

About the artist
1980
Cameron, Nigel. "Master the Medium Message to Artists" (in English). *South China Morning Post*, August 14.

Saint-Gilles, Amaury. "Art: People and Places" (in English). *Mainichi Daily News*, December 20.

1982
Burn, Guy. "Japanese Contemporary Prints and Drawings" (in English). *Arts Review*, June 18.
1984
"The Kimio Tsuchiya Exhibition." *Mainichi Shinbun*, December 13, evening edition.

"Review: The Kimio Tsuchiya Exhibition." *Akahata*, December 7.

Tsuchioka, Shuichi. "Wood and Washi: Concerning Kimio Tsuchiya's Exhibition." *Fukui Shinbun*, October 14.
1985
Amaya, Nobuyuki. "As a Stimulating Device." *M-Tsushin* 5 (June): 6–11.

Ishihara, Kofu. "Seeing Kimio Tsuchiya's Exhibition: Wooden Structures Based on Careful Calculation." *Ikebana Ryusei* 305 (September): 11.

"The Kimio Tsuchiya Exhibition." *Mainichi Shinbun*, June 27, evening edition.

Kitazawa, Noriaki. "Flickering and Thawing: The Work of Shigeo Toya and Kimio Tsuchiya." *Ikebana Ryusei* 305 (September): 28–29.

Saint-Gilles, Amaury. "Art: People and Places" (in English). *Mainichi Daily News*, June 27.

Shiota, Junichi. "Art '85." *Bijutsu Techo* 549 (September): 203–5.

———. "Best Three Art Shows." *Shinbijutsu Shinbun*, December 11.

Takei, Kunihiko. "Review Tokyo." *Sansai* 455 (August): 114–15.

"The Young Generation's Admiration for History." *Fukui Shinbun*, August 4.
1986
"Culture: The Kimio Tsuchiya Exhibition." *Mainichi Shinbun*, April 10, evening edition.

Sano, Shuichi. "Listening at the Place of Creation: An Invitation to 'Fukui Art Today' 3—Kimio Tsuchiya." *Fukui Shinbun*, May 15.

Shiota, Junichi. "For an 'Art of our Age': From One-Person Shows in Tokyo 1985." *Bijutsu Techo Annual of Arts in Japan* 556 (special edition [January]): 18–19.

Tsuchioka, Shuichi. "Art to Be Seen: The 'Fukui Art Today '86' Exhibition." *Fukui Shinbun*, May 25.

———. "Doubly Interesting Contemporary Art: An Invitation to 'Fukui Art Today '86.'" Parts 1–5. *Fukui Shinbun*, May 6–10.

———. "'Fukui Art Today '86': An Exhibition at the Hands of the Viewers." *Fukui Shinbun*, April 6.

———. "'Fukui Art Today '86': From the Symposium." Parts 1, 2. *Fukui Shinbun*, May 21, 22.

———. "The Individuality of Six Artists 'Reverberates'— The Opening of 'Fukui Art Today.'" *Fukui Shinbun*, May 15.

———. "The Opening of the 'Fukui Art Today '86' Exhibition: The Appeal of Intense Individuality." *Fukui Shinbun*, May 16.

———. "Vanguard Art Overflowing with a Feeling of Strength—The 'Fukui Art Today '86' Exhibition." *Fukui Shinbun*, May 18.
1987
"Exhibition Spotlight: What to See This Month—The Kimio Tsuchiya Exhibition." *Gallery* 23 (June): 33–34.

Koplos, Janet. "Floating World" (in English). *Asahi Evening News*, April 10.

Kora. "Paris Jeune Sculpture." *Kanal*, October: 86–87.

Sano, Shuichi. "Realizing a Heroic Landscape: Woodpia Fukui's Standing Logs." *Fukui Shinbun*, April 6.

Shiota, Junichi. "Wrestling with Wood—Kimio Tsuchiya." *Ikebana Ryusei* 331 (November): 17–21.

Silva, Arturo. "Flesh, Mind and No-Mind at the Hara" (in English). *The Daily Yomiuri*, March 27.

Tanaka, Kojin. "'Hara Annual VII': Not a Grafting of Westernisms but a Nurturing of an Original Environment." *Mainichi Shinbun*, March 27, evening edition.

Tani, Arata. "Special Report—Wood 2: A Material That Responds Readily to Physical Actions." *Sogetsu* 175 (December): 113–19.

Thoren, Barbara. "'Hara Annual VII'" (in English). *The Japan Times*, April 12.

Vallombrossa, Jean-Paul. "'Hara VII'" (in English). *Tokyo Journal* 7, no. 1 (April): 62–63.
1988
Arnault, Martine. "Actualité Paris." *Cimaise* 197 (November/December): 149–50.

"Contemporary Artists' Workshop Series 8: Kimio Tsuchiya." *Ikebana Ryusei* 340 (August): 8–10.

Corgnati, Martina. "Arte in Giappone." *Flash Art/ edizione italiana*, October/November: 63–65.

"Creating an Individual Space on a Natural Stage: '88 Environmental Art Project—Iwakuni, Nishiki River, Kintai Bridge." *Asahi Shinbun*, March 25.

"Driftwood Ascending to Heaven." *Geijutsu Shincho* 462 (June): 89.

"Environmental Art at Kintai Bridge." *Yomiuri Shinbun*, January 15.

"Environmental Art Begins in the River Bed under Kintai Bridge." *Bocho Shinpo*, March 26.

"Expositions: Kimio Tsuchiya." *Le Nouvel Observateur*, September 28–29.

"Expressing the Life of Wood: Contemporary Art's Tsuchiya Exhibits in Tokyo." *Fukui Shinbun*, April 18.

Grout, Catherine. "Kimio Tsuchiya, Galerie Keller." *Art Press* 130 (November): 76.

Kwock-Silve, Sandra. "Gallery Guide" (in English). *The Paris*, October.

Minamishima, Hiroshi. "'88 Environmental Art Project: Recalling a Fever—Iwakuni, Nishiki River, Kintai Bridge." *Bijutsu Techo* 595 (June): 174–75.

Minemura, Toshiaki. "Contemporary Japanese Art in Today's International Arena: Finding Four Excellent Exhibitions in Paris and Milan." *Mainichi Shinbun*, November 14, evening edition.

Oshima, Seiji. "The Wood Sculpture of Kimio Tsuchiya: The Meeting Place of Human Labor and Nature." *Art '88* 124 (autumn): 57–62.

"Paris d'hiver: Notes de voyage." *Kanal*, December: 48.

"Review: The Kimio Tsuchiya Exhibition." *Akahata*, April 22.

Sanda, Haruo. "Thrilling Moments: The Kimio Tsuchiya Exhibition." *Mainichi Shinbun*, April 19, evening edition.

Ulmann, J.-M. "Tsuchiya: Quelle branche!" *Impact médecin*, November 24.

1989

Bekkers, Ludo. "Japanse beeldhouwkunst sinds 1970." *Kunstforum* 103 (September/October).

de Beule, R. "11. Biënnale—De hedendaagse Japanse beeldhouwkunst in samenwerking met Europalia-Japan." *Periodiek* 4 (July/August).

"Exceptional Japanese Sculptors: Europalia-Japan Festival, Middelheim-Japan Contemporary Sculpture Exhibition." *Sankei Shinbun*, September 28.

Gillemon, Daniele. "Promenade au bois: Pas de loup au Middelheim." *Le Soir* (Brussels), July 5.

Gilsoul, Guy. "Jardins japonais." *Le Vif*, June 30.

Heymans, Rika. "Alweer een zomer vol beelden." *Streven*, August/September: 991–1006.

Huylebroeck, Paul. "Vijftien Japanners naar Antwerpse Biënnale." *Gazet van Antwerpen*, May 10.

"Japanische moderne Gast der Biennale Middelheim." *Der Kontact* (June): 27–28.

"Kimio Tsuchiya" (in Japanese and English). *Hara Museum Review*, winter: 3–4.

Lefèvre, Robert. "Kimio Tsuchiya." *La Semaine d'Anvers*, June.

"Mens en kultur: Zonder ziel." *Krunch*, July 26: 68.

Meuris, Jacques. "Middelheim-Japon: Europalia est lancé!" *La Libre* (Brussels), July 7.

"Middelheim-Biënnale vijftien deel-nemers." *Gazet van Antwerpen*, June 14.

"Middelheim-Japan Contemporary Sculpture Exhibition." *Bijutsu no Mado* 84 (November): 137–39.

Middendrop, Jan. "Belgium" (in English). *Contemporania* 7 (October): 16–17.

Nardon, Anita. "Anvers: La fête." *Le Drapeau rouge* (Brussels), July 4.

Okabe, Aomi. "News from Abroad: From Paris." *Bijutsu Techo* 603 (January): 145–50.

Review in *Le Soir*, June 29.

Sanda, Haruo. "Plastic Arts Striving for Breath in Nature: Belgium's 'Contemporary Japanese Sculpture Exhibition.'" *Mainichi Shinbun*, July 31.

Schröte, Gisela. "Magische Präsenz." *Handelsblatt* (Düsseldorf) 144, July 28–29.

"'The Space: Material, Tension, Vacancy in Japanese Contemporary Art' Exhibition." *Art Magazine* 13 (March 10): 83.

Tarantino, Michael. "Art from Japan" (in English). *The Bulletin*, August 10.

"20ste Biënnale Middelheim." *WIJ*, August 25.

"20ste Biënnale Middelheim—Kimio Tsuchiya: Beelden vit twijgen en kettingen." *Het Volk*, August 12–13.

Van Oudenhove, Madeleine. "Les expositions d'été Europalia-Japon '89." *Gazet van Antwerpen*, June 30.

Verhoye, Bert. "Japan in Middelheim." *Met Laatste Nieuws*, June 16.

Isamu Wakabayashi

1936
Born in Machida-cho, Tokyo
1959
Graduated from the Sculpture Section in the Department of Art of Tokyo National University of Fine Arts and Music
1973–74
Japanese Ministry of Culture Art Fellowship, Overseas Training Program, Visiting Artist, Paris

Solo exhibitions
1959
Tokyo: Mitsugi Gallery
1965
Tokyo: Bank of Yokohama, Machida Branch
1966
Tokyo: Akiyama Gallery
1973
Kamakura: Museum of Modern Art ■ (Japanese, English)
1974
Tokyo: Mudo Garo
1975
Tokyo: Nishimura Gallery
1976
Tokyo: Miyuki Gallery
1977
Tokyo: Gatodo Gallery ■ (Japanese, English)
1978
Tokyo: Gatodo Gallery; Galerie Watari
1979
Kobe: Tor Road Gallery

Nagoya: Galerie Valeur ■

Tokyo: Gatodo Gallery ■ (Japanese, English)
1980
Tokyo: Gatodo Gallery
1982
Tokyo: Gatodo Gallery Takeshiba, "The Wall or Tremor of Air" ■; Galerie Watari
1984
Tokyo: Akira Ikeda Gallery, "Possession/Atmosphere/Oscillation—Outskirts of a Forest" ■ (Japanese, English); Gatodo Gallery Takeshiba, "Possession/Atmosphere/Oscillation" ■; Nishimura Gallery
1985
Tokyo: Gatodo Gallery Takeshiba
1986
Nagoya: Akira Ikeda Gallery ■ (Japanese, English)

Shibukawa, Gunma: Concept Space

Tokyo: Yayoi Gallery
1987
Tokyo: National Museum of Modern Art (two exhibitions) ■ (Japanese, English)
1988
Kitakyushu: Municipal Museum of Art ■

New York: Judson Art Warehouse
1989
Tokyo: Gallery AC & T

Tokyo/Nagoya/Taura: Akira Ikeda Gallery
1990
Taura: Akira Ikeda Gallery

Tokyo: Gallery AC & T; Machida City Museum of Graphic Arts

Group exhibitions
1960
Tokyo: Metropolitan Art Museum, "45th Nika Exhibition"; Mitsukoshi Department Store, Ikebukuro, "Artists in Their Twenties"
1961
Tokyo: Metropolitan Art Museum, "46th Nika Exhibition"; Seibu Department Stores Company, Ikebukuro, "2nd Contemporary Sculpture Exhibition"
1962
Tokyo: Gallery Ginza, "Group 'Kan' Sculpture Exhibition" and "Three Sculptors"; Metropolitan Art Museum, "47th Nika Exhibition"
1963
Tokyo: Gallery Ginza, "Group 'Kan' Sculpture Exhibition"; Metropolitan Art Museum, "48th Nika Exhibition"; National Museum of Modern Art, "New Generation of Japanese Sculptors"
1964
Kyoto: National Museum of Modern Art, "Contemporary Trends in Japanese Paintings and Sculptures"

Tokyo: Gallery Ginza, "Group 'Kan' Sculpture Exhibition"; Metropolitan Art Museum, "49th Nika Exhibition"
1965
Tokyo: Metropolitan Art Museum, "50th Nika Exhibition"; Tsubaki Kindai Gallery, "New Sculpture"
1966
Kyoto: National Museum of Modern Art, "Contemporary Trends in Japanese Paintings and Sculptures"

Tokyo: Keio Department Store Company, Shinjuku, "Tokyo International Art Exhibition"; Metropolitan Art Museum, "51st Nika Exhibition" and "The 7th Contemporary Art Exhibition of Japan"; National Museum of Modern Art, "New Generation in Contemporary Art"
1967
Tokyo: Central Museum, "Preview: 'The 1st Triennale India 1968'"; Metropolitan Art Museum, "The 9th International Art Exhibition, Japan (Tokyo Biennale '67)"; Muramatsu Gallery, "Restricted Expression"

Ube City, Yamaguchi: Open-Air Sculpture Museum, "The 2nd Exhibition of Contemporary Japanese Sculpture 1967"
1968
Kobe: Suma Rikyu Garden, "1st Contemporary Sculpture Exhibition at Kobe"

New Delhi: Lalit Kala Academy, "The 1st Triennale India 1968"

Tokyo: Metropolitan Art Museum, "The 8th Contemporary Art Exhibition of Japan"; Muramatsu Gallery/ Chikyudo Gallery/Gallery Nippon, "Anti-War and Liberation"
1969
Hakone: Open-Air Museum, "The 1st International Exhibition of Modern Sculpture"

Tokyo: Metropolitan Art Museum, "The 9th Contemporary Art Exhibition of Japan"; National Museum of Modern Art, "Contemporary Art: Dialogue between East and West"

Ube City, Yamaguchi: Open-Air Sculpture Museum, "The 3rd Exhibition of Contemporary Japanese Sculpture 1969"
1970
Kobe: Suma Rikyu Garden, "2nd Contemporary Sculpture Exhibition at Kobe"

Osaka: Expo '70, "International Sculptors Symposium 1969–70" ■ (Japanese, English)

Tokyo: Gallery Maeyama
1971
Hakone: Open-Air Museum, "The 2nd International Exhibition of Modern Sculpture: Image of Man in the Contemporary World"

Hyogo: Prefectural Museum of Modern Art, "One Hundred Artists of Today"

Tokyo: Gallery Maeyama
1972
Kobe: Suma Rikyu Garden, "3rd Contemporary Sculpture Exhibition at Kobe"

Tokyo: Gin Gallery, "Five Contemporary Sculptors"; National Museum of Modern Art, "Development of Postwar Japanese Art: Figurative Art"
1973
Tokyo: Metropolitan Art Museum, "The 11th Contemporary Art Exhibition of Japan: Twenty Years of Contemporary Art in Retrospective"
1975
Antwerp: Openluchtmuseum voor Beeldhouwkunst Middelheim, "13th Antwerp Biennale of Outdoor Sculpture"

Tokyo: Ao Gallery, "The Cube: Development of a Basic Form"; Nishimura Gallery, "Book/Object Exhibition"; Seibu Museum of Art, "A View of Contemporary Japanese Art"

Ube City, Yamaguchi: Open-Air Sculpture Museum, "The 6th Exhibition of Contemporary Japanese Sculpture 1975"
1976
Tokyo: Ao Gallery, "Drawings by Fifteen Sculptors"; Isetan Museum of Art, "Ten Sculptors 1976"
1977
Ube City, Yamaguchi: Open-Air Sculpture Museum, "The 7th Exhibition of Contemporary Japanese Sculpture 1977"
1978
Funabashi: Seibu Museum of Art, "Inaugural Exhibition"
1980
Fukuoka: Art Museum, "Contemporary Asian Art Show 1980"

Venice: Giardini di Castello, "39ª Esposizione Internazionale d'Arte 'La Biennale di Venezia'" ■ (Italian, English)
1981
Hakone: Open-Air Museum, "The 2nd Henry Moore Grand Prize Exhibition"

Kamakura: Museum of Modern Art, "Development of Modern Japanese Sculpture"

Karuizawa: Museum of Modern Art, Seibu, Takanawa, "Opening Exhibition"

Sendai: Miyagi Museum of Art, "A Scene of Contemporary Japanese Art"

Seoul: Museum of the Korean Culture and Arts Foundation, "Japanese Contemporary Art Exhibition: Trends in Japanese Art in the 1970s"

Tokyo: National Museum of Modern Art, "The 1960s: Decade of Change in Contemporary Japanese Art"
1982
Tokyo: National Museum of Modern Art, "Modern Japanese Art, Part 1: The 30th Anniversary Exhibition— From the Museum Collection (1945–1982)"
1983
Tokyo: Gatodo Gallery Takeshiba; Metropolitan Art Museum, "Trends in Japanese Art in the 1960s"

Toyama: Museum of Modern Art, "A Panorama of Contemporary Art in Japan—Sculpture"
1984
Otsu, Shiga: Otsu Seibu Hall, "Development of the 'Contemporary Japanese Sculpture' Exhibition Held in Conjunction with the Opening of the Shiga Prefectural Museum of Modern Art"

Yamaguchi: Prefectural Museum of Arts, "Sculpture in Modern Japan 1867–1980s"
1985
Paris: Galerie Jullien-Cornic, "Sculpture japonaise contemporaine"

Yokohama: Kanagawa Prefectural Gallery, "Contemporary Sculpture in Japan—Wood"
1986
Kyoto: Gallery Iteza, "Objects as Words"

Osaka: Tsukashin Hall, "Hanging Art"

Seoul: National Museum of Modern Art, "'86 Seoul Contemporary Asian Art Exhibition"

Tokyo: Akira Ikeda Gallery, "Dispersed Core"

Urawa: Museum of Modern Art, Saitama, "Black and White in Art Today"

Venice: Giardini di Castello, "42ª Esposizione Internazionale d'Arte 'La Biennale di Venezia'" ■ (Italian, English)
1987
Hyogo: Tsukashin Hall, "Objects Taking Leave of Matter" ■
1988
Hyogo: Tsukashin Hall, "'88 Tsukashin Annual" ■

Tokyo: Akira Ikeda Gallery
1989
Fukushima: Prefectural Museum of Art, "Contemporary Abstract Sculpture in Japan" ■

Osaka: Kodama Gallery, "5/Drawings" ■ (Japanese, English); National Museum of Art, "Drawing as Itself" ■ (Japanese, English)

Urawa: Museum of Modern Art, Saitama, "The Space: Material, Tension, Vacancy in Japanese Contemporary Art" ■ (Japanese, English)

Bibliography

By the artist
1963
"My Sculptures, Sculpture, and I: Statements by Artists in the 'New Generation of Japanese Sculptors' Exhibition." *Gendai no Me* (Tokyo: National Museum of Modern Art) 102 (April): 7.
1966
"One Piece of Modern Sculpture: People." *Geijutsu Shincho* 17, no. 5 (May): 36.

"Questionnaire Given to Artists Participating in the 'New Generation in Contemporary Art' Exhibition." *Gendai no Me* (Tokyo: National Museum of Modern Art) 135 (February): 7.

"Rodin and I." *Mizue* 47 (special edition [September]): 108–9.

"Seven Questions to a New Generation of Artists." *Bijutsu Techo* 265 (April): 120–22.
1967
"The Size of Things: Artist's Statement." *Mizue* 754 (November): 14.
1968
"Cars, Dogs, Sculpture." *Geijutsu Shincho* 19, no. 8 (August): 119.

"On Seeing Bourdelle." *Sansai* 235 (September): 50–51.
1971
"Hesitation About 'Showing': How I Was Involved in the 'Contemporary Art Exhibition.'" *Bijutsu Techo* 344 (July): 139–41.

"On Iron." *Sogetsu* 75 (March): 67–68.
1972
"Post-Print Art Thinking: The Regrets of Labor." *Print Art* 8 (November 25): 17–18.

1973

"Concerning Slopes." *Sansai* 307 (September): 49.

"On Ossip Zadkine, A Major Figure in Contemporary Sculpture: The Zadkine Retrospective Exhibition." *Mizue* 817 (April): 88–89.

"The Sculpture of Giacometti I Saw in 1973." *Sansai* 308 (October): 78.

1974

"To Egypt: Replenishment of the Vanished and the Unknown." *Bijutsu Techo* 376 (January): 168–69.

1976

"Spring Collection." In *Flotsam 1/Épaves 1*, 18. Tokyo: Hayashi Graphic Press.

"276 Copperplate Etchings." In *Ei Kyu Etchings Scale III*. Tokyo: Hayashi Graphic Press.

1977

"Brancusi's Sculpture: Visible Portion and Invisible Portion." *Mizue* 872 (November): 62–69.

"Isamu Wakabayashi Solo Exhibition, November 7–19, Gatodo Gallery." *Bijutsu Techo* 426 (November): 287.

1978

"Flooding of the Boundary River: On M. Blanchot." *Gendaishi Techo* 21, no. 11 (special edition [October]): 177–84.

"Under a Red Sky." *Gendaishi Techo* 21, no. 7 (July): 78–79.

"Who Influenced You the Most? From a Survey of 120 Artists." *Bijutsu Techo* 431 (March): 114.

1979

"Changes." In *Collected Works of Yoshida Kazuho*, vol. 2, appendix, 7–8. Tokyo: Ozawa Shoten.

"Space in Painting and Painting in Space: Touching on Matisse's Mantelpiece Decoration in the Rockefeller House." *Mizue* 886 (January): 56–63.

1980

Isamu Wakabayashi Notes 1969–1980. Handmade book.

"Ten Days in Venice." *Musabi Kyoshoso Shinbun* 12 (December): 4–5.

"The Territory of Iron." *Bungei Shunju* 58, no. 4 (April): 76.

"Transition." *Bijutsu Techo Nenkan '80* 460 (special edition [January]): 51.

1981

"Matisse and I 15." *Yomiuri Shinbun*, May 26, evening edition.

"On the Interior in the Paintings of Henri Matisse and the Interior Created by Matisse." *Gendai no Me* (Tokyo: National Museum of Modern Art) 317 (April): 4.

"Questions to Isamu Wakabayashi: 'Art' in the Steel Room." *Ryuko Tsushin* 210 (July): 84–85.

"What is Drawing? II: As a Small Part Which Does Not Understand the Whole." *Bijutsu Techo Dessin* 484 (special edition): 142–44.

1982

Flooding of the Boundary River. Tokyo: Gatodo Gallery.

"In the Midst of a Certain Landscape: Recording the Flow of Thought through the Fascinating Material of Steel While Making Sculpture." *Shin Gusho* 3 (October): 1–3.

"Notes on a Partially Broken Stone." *Yuriika* 13 (December): 74–86.

"On Landscape: A Dialogue Between Myself and Landscape." *Ohararyu Soka* 383 (October): 27.

1983

"A Piece of Art I Like." *Gendai no Me* (Tokyo: National Museum of Modern Art) 339 (February): 4.

1984

"Isamu Wakabayashi's 'Possession/Atmosphere/Oscillation': Image and Process." *Mizue* 933 (December): 82–85.

Possession/Atmosphere/Oscillation Notes. Tokyo: Gatodo Gallery Takeshiba.

1985

"On Watercolor: In the Midst of Creation." *Mizue* 936 (September): 132.

Possession/Atmosphere/Oscillation Notes (in English). Tokyo: Gatodo Gallery Takeshiba.

1986

Cooling and Heating in July. Tokyo: Yayoi Gallery.

"The Distance between the Self and Other." In *An Encyclopedia of Contemporary Design*, 201. Tokyo: Heibonsha.

"'Outskirts of a Forest: Possession/Atmosphere/ Oscillation.'" *Hermes*, no. 7 (June): 65–74.

"Pursuing the Grass." In *Ayako Yodoi: Green, Light, Arabesque*. Tokyo: Okamoto Kobo.

1989

"June 2, 1989." *Rushioru* 3 (July 30): 2–5.

About the artist

1963

Yamaguchi, Katsuhiro. "Experimental Spirit and Traditional Methods: Observations on the 'New Generation of Japanese Sculptors' Exhibition." *Bijutsu Techo* 222 (July): 9–11.

1964

Kasagi, Sueo. "Promising Artists 6: Isamu Wakabayashi." *Bijutsu Graph* 7 (July): 10.

"The Things That Support Creativity." *Mizue* 41 (special edition [September]): 73–83.

1966

Hijikata, Teiichi. "This Year's Harvest, Best Five in Art: Making an Environment Difficult for Criticism." *Asahi Shinbun*, December 16, evening edition.

Honma, Yoshio. "'The 7th Contemporary Art Exhibition of Japan,' Sculpture Section: We Need More Explosive Force—Troubled by the Decline of Figurative Sculptors Both Young and Old." *Mainichi Shinbun*, May 25, evening edition.

Horiuchi, Masakazu. "Observer's Chair: Wonderful Mistakes of Youth." *Asahi Journal* 8, no. 9 (February 27): 26.

Miki, Tamon. "Monthly Exhibition Review: Isamu Wakabayashi, January 11–17 at the Akiyama Gallery." *Bijutsu Techo* 264 (March): 123.

"New Generation in Contemporary Sculpture." *Bijutsu Graph* 15, no. 2 (February/March): 40–41.

Okada, Takahiko. "My Eyes 'Holding the Steering Wheel.'" *Gendaishi Techo* 9, no. 4 (April): 1.

Yanagihara, Yoshitatsu. "Isamu Wakabayashi (From the Gallery)." *Bijutsu Techo* 264 (March): 120–22.

Yasui, Shuzo. "The 'New Generation in Contemporary Sculpture' Exhibition." *Bijutsu Graph* (February 3): 40–41.

1967

Iijima, Koichi. "The Sculpture of Isamu Wakabayashi." *Sansai* 221 (November): 108–9.

"New Generation Looking toward the International Art Scene: Isamu Wakabayashi." *Mizue* 753 (October): 27.

Sakai, Tadayasu. "Thoughts on Isamu Wakabayashi: Thermal Dynamics of the Soul." *Sansai* 217 (July): 52–54.

1968

Iijima, Koichi. "Statements of Modern Poets 5: Calming and Being Calmed." *Shukan Dokusho Jin* 722 (April 22).

———. "Theory: What is at the Bottom of Modern Art? The Yearning for Something Like a Great Tower." *Geijutsu Seikatsu* 221 (January): 70–74.

Miyazawa, Takeyoshi. "Automobiles, Their Cannibalism, and the Riddle of the Sphinx Presented by the Artist." *Space Modulator* 30 (April).

Okada, Takahiko. "Contemporary Art and Artists 5: Isamu Wakabayashi—Deepening His Own Inner World without Concern for Fashionable Trends." *Fujin Bunka Shinbun* 586 (March 20).

1969

"The Challenge of Steel: Ten Artists from the International Iron and Steel Symposium—Isamu Wakabayashi." *Geijutsu Seikatsu* 244 (December): 63.

Haryu, Ichiro. "Troubles and Possibilities of Contemporary Art: Invitational Section of the Contemporary Art Exhibition of Japan." *Mainichi Shinbun*, May 27, evening edition.

Kato, Ikuya. "Questioning the Artist: Isamu Wakabayashi, Ninja of Steel and Fire." *Bijutsu Techo* 309 (February): 143–51.

Miki, Tamon. "This Year's Best Five in Art: Awareness of the Importance of a Specific Site." *Asahi Shinbun*, December.

1970

Kitamura, Yoshio. "The Legacy of the International Steel Symposium." *Bijutsu Techo* 326 (April): 142–57.

1971

"Dialogue 22: Isamu Wakabayashi Interviewed by Koichi Iijima." *Mizue* 802 (November): 39–51.

Nakahara, Yusuke. "Twelve Contemporary Sculptors: Isamu Wakabayashi, Invisible Sculpture." *Chuokoron* 1004 (March).

1972

Miki, Tamon. "Contemporary Japanese Artists 7: Isamu Wakabayashi, Psychological Landscape Imposed on Metal." *Ohararyu Soka* 259 (June): 69–71.

Ogawa, Masataka. "Japanese Plastic 24: Isamu Wakabayashi—Expressing the Absurdity of Machine-Civilization with Modern Materials." *Shukan Asahi* 24 (June 16): 72–73.

1973

Schaarschmidt-Richter, Irmtraud. "Neue Kunst in Japan." *Das Kunstwerk* 26, no. 5 (September): 3–38.

1974

"Concepts of Contemporary Art and Sculpture: Isamu Wakabayashi." *Bijutsu Techo* 376 (January): 140, 161–67.

1975

Haryu, Ichiro. "Unexposed Ground: The Vacuum Space of Isamu Wakabayashi." *Mizue* 849 (December): 68–75.

Kagioka, Masanori. "Isamu Wakabayashi and 'Valence.'" *Sansai* 329 (March): 58–59.

Love, Joseph. "The Week in Art" (in English). *The Japan Times*, February 2.

Nakahara, Yusuke. "Isamu Wakabayashi's Lithographs '21.34—Valence,' The Disappearance of 'Sprache.'" *Mizue* 839 (February): 104–7.

Schaarschmidt-Richter, Irmtraud. "Isamu Wakabayashi: Ein japanischer Bildhauer." *Das Kunstwerk* 28, no. 3 (May).

Tanikawa, Koichi. "Anxious Dreams Laid into Steel: Isamu Wakabayashi." In *Arabesque with Illusion: Collection of Art Writings by Koichi Tanikawa*, 37–47. Tokyo: Yamato-Bunko.

Yoshimasu, Gozo. "My Friend, Isamu Wakabayashi." *Nippon Dokusho Shinbun*, June 9.

1976

Takaragi, Noriyoshi. "Monthly Exhibition Review: Isamu Wakabayashi, Drawings." *Nippon Bijutsu* 130 (June): 129.

1977

Hijikata, Teiichi. "Isamu Wakabayashi: Compression of Experience, Solitary Musings on a Midsummer Night." In *The Collected Writings of Teiichi Hijikata*; vol. 12, *Modern Sculpture and Contemporary Sculpture*, 358–65. Tokyo: Heibonsha.

Iijima, Koichi. "A Force Joining Two Separate Things: What Is Method?" In *Tower and Blue Sky*, 176–99. Tokyo: Shorinsha.

1978

Hayashi, Takeo. "Isamu Wakabayashi's 'Notebook—Salmon's Tail' Exhibition." *Bijutsu Techo* 437 (August): 297.

Kano, Mitsuo. "Who Influenced You the Most? From a Survey of 120 Artists." *Bijutsu Techo* 431 (March): 86.

Sugawara, Takeshi. "Notes for an Essay on Isamu Wakabayashi." *Gekkan Vision* 1 (February): 72–75.

1979

Abramowicz, Janet. "The Importance of Format" (in English). *Asahi Evening News*, November 23.

Contemporary Japanese Art in Color; vol. 13, *Sculpture*, 114, 187. Tokyo: Shogakukan.

Kudo, Junichi. Review in *Bijutsu Techo* 451 (July): 221–22.

Nakahara, Yusuke. "Selecting Five Works of Japanese Contemporary Art: Masterpieces Included and Not Included in the 'Contemporary Japanese Sculpture' Exhibition." *Asahi Journal* 36 (September 21): 93.

1980

Abe, Nobuo. Review in *Bijutsu Techo* 472 (November): 227–28.

"Guide to Galleries and Exhibitions, Tokyo: The Isamu Wakabayashi Drawing Exhibition." *Bijutsu Techo* 470 (September): 244.

"Isamu Wakabayashi Drawing Exhibition: Reflecting 'Composite Eye' Thinking." *Asahi Shinbun*, September 3, evening edition.

Miyakawa, Atsushi. *Collected Works of Atsushi Miyakawa*, 505–8, 560–1. Tokyo: Bijutsu Shuppansha.

Okada, Takahiko. "Japanese Artists at the Venice Biennale: Koji Enokura, Susumu Koshimuzi, Isamu Wakabayashi." *Mizue* 903 (June): 66–73.

Venice: Giardini di Castello. *La Biennale di Venezia 1980—Giappone* (in Italian and English). Tokyo: The Japan Foundation.

Yamanashi, Toshio. Review in *Bijutsu Techo* 461 (February): 236–37.

1981

Castile, Rand. "Absorbing the Shock of the West" (in English). *Art News* 7 (September): 86–90, 92.

"The Henry Moore Exhibition: Diversification of Sculptural Concepts." *Gendai Chokoku* 49 (July): 2–13.

Kitagawa, Furamu. "Discoveries in Contemporary Art 13: Work by Unkei, Anonymous, Image of World Renewal—Matter as Time, Through [the work of] Isamu Wakabayashi." *Ryuko Tsushin* 207 (April): 84–85.

Schaarschmidt-Richter, Irmtraud. "Ausstellungs-Rückschau/Kunstbrief aus Tokyo." *Das Kunstwerk* 31, no. 1 (January): 54–55.

Tatehata, Akira. "Sculpture in Landscape 12: Isamu Wakabayashi's '3.25m Black Fly's Wing'—Darkness Full of Uncanny Tension." *Yomiuri Shinbun*, September 16, evening edition.

1982

"Isamu Wakabayashi Exhibition: On the Basis of a Sharply Observant View of Nature and Experience." *Komei Shinbun*, November 20.

"Original Urban Concept Using Sculptural Ideas in 'Flooding of the Boundary River,' An Artist's Book." *Asahi Shinbun*, April 24, evening edition.

Sakai, Tadayasu. "'Iron Seal': Isamu Wakabayashi." In *Sculpture Garden: The World of Contemporary Sculpture*, 220–57. Tokyo: Ozawa-Shoten.

Tanaka, Kojin. "The Isamu Wakabayashi Exhibition: Ground Surface Made Sacred in a Lead Room." *Mainichi Shinbun*, November 9, evening edition.

———. "The Present Situation of Contemporary Art: Consciousness of the World, Sacred Landscape Realized in the Lead Room: Isamu Wakabayashi Exhibition." *Sogetsu* 145 (December): 102–4.

Yonekura, Mamoru. "Isamu Wakabayashi Exhibition: A Window for Peering into an Inner Landscape." *Asahi Shinbun*, November 17, evening edition.

1983

"Isamu Wakabayashi, Inside or Outside?" *Bijutsu Techo* 505 (January): 208–9.

Kitamura, Yoshio. "Isamu Wakabayashi." In *The Contemporary Art World through the Eyes of an Art Reporter*, 34–35. Tokyo: Gendaikikakushitsu.

Sakai, Tadayasu. "Transformation of Thought." *Fujin no Tomo* 77, no. 2 (February): 8–9.

Schaarschmidt-Richter, Irmtraud. "Ausstellungs-Rückschau/Kunstbrief aus Tokyo." *Das Kunstwerk* 36, no. 2 (March): 55–56.

Usami, Keiji. "Toward Form 17: Something Related to the Study of Animal Behavior Which Gives Off the Smell of Lead." *Chuokoron* 5 (May): 360–61.

Yonekura, Mamoru. "Isamu Wakabayashi: Instruments of the Path." In *Individual Creativity: From the Work Site of Contemporary Art*, 356–61. Tokyo: Keishosha.

1984

Harada, Hikaru. "Commentary on Works." In *Contemporary Watercolors* 5:81. Tokyo: Daiichi Hoki Shuppan.

"Invitational Seat—Art: The Isamu Wakabayashi Exhibition Interesting in Introspective, Mysterious Way." *Sekai Nippo*, November 22.

Niimi, Takashi. "From the Collection 3: Isamu Wakabayashi at Present." *Seibu Museum of Art, Museum Report* 3 (May): 12–13.

Sakai, Tadayasu. "Present Sculpture 1: Reunion of Twenty-Five Pieces." *Kikan Art '84* 107 (August): 78–79.

———. "Small Map of a Sculptor." *Kikan Ginka Tegami* 1 (special edition [August]): 92.

Sugawara, Takeshi. "Isamu Wakabayashi Exhibition Characterized by Integration of Content and Material." *Komei Shinbun*, December 1.

Takehara, Akiko. "'Possession/Atmosphere/Oscillation': The Isamu Wakabayashi Exhibition." *Mainichi Graph* 50 (December 9): 81.

Tanaka, Kojin. "The Isamu Wakabayashi Exhibition: Heat-Emitting Substance That Robs Body Heat." *Mainichi Shinbun*, November 27, evening edition.

Yonekura, Mamoru. "Forceful Presence of Space Transcending Form: The Exhibitions of Isamu Wakabayashi, Kan Masuda, et al." *Asahi Shinbun*, December 5, evening edition.

1985

Minemura, Toshiaki. "Isamu Wakabayashi: A Dog Oozes into Earth and Time, Again." *Bijutsu Techo* 537 (January): 106–15.

Nakamura, Hideki. "Kikikaikai/Kikikaikai [Strange wooden objects, fun and delight]: The 'Contemporary Sculpture in Japan—Wood' Exhibition." *Bijutsu Techo* 542 (April): 118–24.

Sakai, Tadayasu, and Hideo Miwa. "Commentary on Works and Personal History of Artists." In *A General History of Modern Japanese Western-Style Painting and Drawing*; vol. 5, *Showa III (World War II)*. Tokyo: Kodansha.

Takashima, Heigo. "Iron: Urban Sculptural Material." In *A History of Iron*, 125–31. Metal Culture Series, no. 2. Tokyo: Asahi Shinbunsha.

Tanaka, Kojin. "The Forms of Sensitivity 6: Report from the Mountains." *Ikebana Ryusei* 302 (June): 34–35.

———. "Isamu Wakabayashi's Effort to Destroy the 'Box Garden' Concept prior to the 'Contemporary Garden.'" *Mainichi Shinbun*, September 9, evening edition.

"What Has Emerged from the Rooms of Steel and Lead: Isamu Wakabayashi's 'Possession/Atmosphere/Oscillation.'" *Kenchiku Bunka* 460 (February): 4–5.

Yonekura, Mamoru. "The Unique Creative Ability of Japanese Artists Working in Wood Sculpture: Comments on 'Contemporary Sculpture in Japan—Wood,' The Connection with Japan's Drifting Spiritual History." *Asahi Shinbun*, February 13, evening edition.

1986

"Drawing." *Atelier* 711 (May): 53–60.

"'Hanging Art,' Balance in 'Logic of Temporary Art.'" *Seibu Museum of Art, Museum Report* 28 (June): 11.

Hiraide, Takashi. "The Garden of an Observer: The Isamu Wakabayashi Exhibition." *Art* 116:79.

"Isamu Wakabayashi's 'Miniature Landscape.'" *Geijutsu Shincho* 4 (April): 32.

Minemura, Toshiaki. "I Want to See Drawings." *Art* 116:22–23.

Onishi, Katsuhiro. "Two Exhibitions in Venice." *Asahi Shinbun*, August 29, evening edition.

Sakai, Tadayasu. "A Certain Landscape: Visiting the Workshop." In *Works of Isamu Wakabayashi 1986*, exh. cat. (Tokyo: Yayoi Gallery).

———. "Far rinascere la natura." *Nuove Dimensioni*, December: 52.

———. "Overseas Report/Italy: 42nd Venice Biennale." *Bijutsu Techo* 567 (September): 150–55.

———. "Venice and Venice Biennale" (in English). *The Japan Foundation Newsletter* 14, no. 3 (October): 15–16.

Schaarschmidt-Richter, Irmtraud. "Kunstbrief aus Tokyo." *Das Kunstwerk* 39, nos. 4/5 (September): 165–69.

Taki, Teizo. "The Isamu Wakabayashi Exhibition." *Nippon Keizai Shinbun*, March 7.

"Taking an Overview of the Venice Biennale." Parts 1, 2. *Atelier* 716/717 (October/November): 84–90.

Terada, Toru. "The Selective Eye." In *Over Land and Sea*, 70–71. Tokyo: Misuzu Shobo.

Venice: Giardini di Castello. *La Biennale di Venezia 1986—Giappone* (in Italian and English). Tokyo: The Japan Foundation.

1987

Iijima, Koichi. "Who is Isamu Wakabayashi?" *Gendai no Me* (Tokyo: National Museum of Modern Art) 395 (October): 4–5.

Kondo, Yukio. "Announcing the Isamu Wakabayashi Exhibition." *Gendai no Me* (Tokyo: National Museum of Modern Art) 394 (September): 7.

Okada, Takahiko. "Capturing a Rustling Movement: An Interview with Isamu Wakabayashi." *Hanga Geijutsu* 58 (autumn): 186–93.

Tatehata, Akira. "The Logic of Possession, or A Crisis in the Sense of Otherness: Returning to the Essay of Isamu Wakabayashi." *Miru* (Kyoto: National Museum of Modern Art) 246 (December): 2–5.

———. "Owning Sculpture: The Isamu Wakabayashi Exhibition." *Bijutsu Techo* 588 (December): 170–73.

Yoshimasu, Gozo. "Like a Nest Which Birds Have Never Seen, or Like a Root Never Imagined by Trees: Visiting Isamu Wakabayashi." *Gendai no Me* (Tokyo: National Museum of Modern Art) 395 (October): 3–4.

1988

Degawa, Tetsuro. "What Resides on the Surface of Matter." *AC* 5 (March): 4–5.

Mollenkof, Peter. "Tokyo: Isamu Wakabayashi, National Museum of Modern Art" (in English). *Art News*, January: 183.

Sakai, Tadayasu. "Isamu Wakabayashi: From the Site of Creation." *Mizue* 946 (spring): 22–39.

———. "Isamu Wakabayashi: Rainbow in a Sacred Place." *Bijutsu Techo* 600 (October): 243–44.

Sanda, Haruo. "A Vivid Expression of Iron." *Mainichi Shinbun*, March 18, evening edition.

1989

Kadota, Hideo. "In the Distant Escape from Man and Nature." *Kozo* 8 (March): 1–23.

Koplos, Janet. "Letter from Japan" (in English). *Arts Magazine* 64, no. 1 (September): 110–11.

———. "Post-Industrial Landscape" (in English). *Asahi Evening News*, January 27.

Minamishima, Hiroshi. Review (in English) in *Flash Art* 147 (summer): 146.

Silva, Arturo. "Two Contemporary Masters" (in English). *Daily Yomiuri*, February 19.

Acknowledgments

Among the joys of organizing *A Primal Spirit* has been the opportunity to work with so many able colleagues dedicated to producing on two continents an event that would be a challenge even on one continent. The far-flung network of individuals whose efforts have brought this exhibition to fruition is unfortunately too large to allow me to acknowledge each one individually, but I wish to take this occasion to thank them collectively. It is a special pleasure to be able to recognize here the contributions of a few of them.

The cosmopolitan vision, enthusiasm, and openmindedness of Toshio Hara, founder and director of the Hara Museum of Contemporary Art, provided the initiative for *A Primal Spirit*. It was the idea of the venturesome Mr. Hara to invite an American curator to organize an exhibition of contemporary Japanese art for an international audience. I extend the deepest thanks to him, on behalf of the Los Angeles County Museum of Art and myself, for the opportunity to become involved in this exciting project.

I would also like to express special gratitude to Earl A. Powell III, director of the Los Angeles County Museum of Art, and museum trustees Stanley Grinstein and Richard E. Sherwood for their early and continued support of the exhibition.

Patronage, inspired by heightened global interest in Japan and its present culture, was forthcoming from a variety of enlightened benefactors. A grant from the Ise Cultural Foundation to the Hara Museum funded travel to Japan for preliminary research, and funding from the Japan-United States Friendship Commission made possible another trip to meet with the artists and select works or arrange for commissions. Another generous grant from the Japan-United States Friendship Commission to the Hara Museum supported the shipment of the artworks to the United States. Substantial grants to the Los Angeles County Museum of Art from the National Endowment for the Arts, Baring Securities (Japan) Limited, and the Lannan Foundation have enabled the realization of the exhibition and its specially commissioned projects.

At the Hara Museum, chief curator Takeshi Kanazawa lent his much appreciated insights to the planning of the exhibition and was a spirited guide in Osaka and Kyoto. Hiroko Nakayama, Yoko Uchida, and Kiyoko Mitsuyama of the Hara Museum staff accompanied me to studios, galleries, and museums in and outside Tokyo; each was a valued colleague and delightful companion. Miss Mitsuyama, moreover, served as special curatorial assistant to this project and was deeply involved in its extensive

catalogue research, the formidable challenge of translations, and the coordination of the artists' installations at the Hara Museum ARC in Shibukawa, Gunma Prefecture, where the exhibition has its debut. At the Hara Museum ARC the installations were facilitated by general manager for administration Taneo Kanawa, assistant to the director Satoshi Matsuno, and curatorial assistant Kazuko Aono. I thank them all.

At the Los Angeles County Museum of Art, Elizabeth Algermissen, assistant director for exhibitions and programs, and John Passi, head of exhibition programs, administered the exhibition and arranged its national tour with impressive efficiency. Arthur Owens, assistant director for operations, oversaw all aspects of the exhibition's production with his customary managerial agility, while promoting *esprit de corps* among his able staff. Registrar Renée Montgomery and assistant registrar Lisa Kalem coordinated the imposing task of shipping heavy sculptures and vast constructions.

Assistant objects conservator Don Menveg and senior preparator Vincent Avalos went to Japan to work closely and creatively with the sculptors to enable them to realize their ideas in the form of portable prefabricated constructions; their unusual assignment—and their adroit fulfillment of it—was one of the key elements in the organization of this exhibition.

My gratitude goes to Julie Johnston, director of membership and development, and Tom Jacobson, head of grants and foundation giving, for their dedicated and successful quest for funding. Educational material and related events were ably handled by William Lillys, head of museum education, and Lori Jacobson, assistant museum educator. Public information officer Pamela Jenkinson and assistant Anne-Marie Wagener were eloquent spokespersons for *A Primal Spirit*. Brent Saville brought his imaginative gifts to the superb installation design for this challenging exhibition. My secretary, Wendy Owen, has, as ever, proved to be more than an assistant in shepherding myriad matters to their successful resolutions.

I especially thank managing editor Mitch Tuchman for making this catalogue a reality. Susan Caroselli astutely edited the text, and Jeffrey Cohen fashioned the text and visual material into this handsomely designed book; my gratitude surpasses the written word.

The Smithsonian Institution Traveling Exhibition Service (SITES) in Washington, D.C., was involved in this project at its outset in 1985. Although SITES was unable join in the ultimate realization of *A Primal Spirit*, the project has benefited greatly from its early support. I especially wish to thank Elizabeth Driscoll Pochter, former project director at SITES and now exhibition officer at the National Gallery of Art, for her deft coordination of the early phases this undertaking.

My most heartfelt thanks go to Judith Connor Greer, project director for *A Primal Spirit* and the Hara Museum's special officer for international programs. A person of great resourcefulness, boundless dedication, and remarkable diplomacy, Judith deserves credit from all of us who were associated with this exhibition, which is as much her project as mine.

Finally, I thank the lenders to this exhibition, those museums, art dealers, and especially the artists who, out of their trust and generosity, have enabled us in the United States to learn more about contemporary art in Japan.

Howard N. Fox
Curator
of Contemporary Art
Los Angeles County
Museum of Art